Artistic Research Methodology

critical qualitative research

CRITICAL ISSUES FOR LEARNING AND TEACHING

Shirley R. Steinberg and Gaile S. Cannella
Series Editors

Vol. 15

The Critical Qualitative Research series
is part of the Peter Lang Education list.
Every volume is peer reviewed and meets
the highest quality standards for content and production.

PETER LANG
New York • Washington, D.C./Baltimore • Bern
Frankfurt • Berlin • Brussels • Vienna • Oxford

Mika Hannula
Juha Suoranta
Tere Vadén

Artistic Research Methodology

Narrative, Power and the Public

PETER LANG
New York • Washington, D.C./Baltimore • Bern
Frankfurt • Berlin • Brussels • Vienna • Oxford

Library of Congress Cataloging-in-Publication Data
Hannula, Mika, author.
Artistic research methodology: narrative, power and the public /
Mika Hannula, Juha Suoranta, Tere Vadén.
pages cm — (Critical qualitative research; Vol. 15)
Includes bibliographical references.
1. Art—Research—Methodology. I. Suoranta, Juha, author.
II. Vadén, Tere, author. III. Title.
N85.H36 707.2'1–dc23 2014000838
ISBN 978-1-4331-2667-3 (hardcover)
ISBN 978-1-4331-2666-6 (paperback)
ISBN 978-1-4539-1308-6 (e-book)
ISSN 1947-5993

Bibliographic information published by **Die Deutsche Nationalbibliothek.**
Die Deutsche Nationalbibliothek lists this publication in the "Deutsche
Nationalbibliografie"; detailed bibliographic data is available
on the Internet at http://dnb.d-nb.de/.

The paper in this book meets the guidelines for permanence and durability
of the Committee on Production Guidelines for Book Longevity
of the Council of Library Resources.

© 2014 Peter Lang Publishing, Inc., New York
29 Broadway, 18th floor, New York, NY 10006
www.peterlang.com

Printed in the United States of America

TABLE OF CONTENTS

Foreword

Recently, a colleague suggested to me that we should stop talking about the different types of knowing and admit, or even emphatically argue, that in art we are dealing with something that is "otherwise than knowing." This remark shed light on an issue that was partly clouded and partly lit: why is it important to so many that art remain art, and why are so many interested in doing research that is based on artistic activity and that takes seriously art's own way of operating, its manifestations and methods of conveying something to others, either through whispers, screams or discussions?

If we approach the issue from the point of view of the critique of knowledge, it is certain that the concentration on knowledge according to the programme of the Enlightenment has, to a certain extent, clarified, simplified and crystallised our view of how everything works. At the same time, it has removed from our vision a great number of phenomena, only because they cannot, for some reason, be introduced as objects of knowledge or as their part, as our view of knowledge is exclusive and restrictive. Exclusiveness and restrictiveness are what have given knowledge its special power: claims that cannot be either falsified or proven coherent with something that is certainly known do not qualify as knowledge.

We know from music that certain sounds are not in themselves discernible or meaningful, but their absence from among the other sounds would make these sounds dull. This image could be used to challenge the "practical razor" related to knowledge. The discussion maintained by Thomas Kuhn and Paul Feyerabend talked a lot about the beliefs according to which we tend to consider certain things to be necessary, even if we are not able to substantiate them or know about them in the critical sense. Feyerabend wanted to extend this idea to the "sine waves of knowledge": some of the phenomena that are important to people cannot be turned into knowledge, but they also cannot be left out, because what is known is believed.

Otherwise than knowing would mean a more suspicious approach to the critique of knowledge: the crucial phenomena and characteristics may be those that do not fall directly into the focus of knowledge but remain forever on the periphery of knowledge. In the short history of knowledge, we have examples of how phenomena that are considered marginal reveal themselves to be strangely important in situations in which we cannot immediately decide what is important, such as with obvious paradigm shifts. Nothing like this has happened in the last 100 years, so it seems to us that it never has. Yet before

the current rule of academic critique, people strove, each according to their needs, to reveal and conceal phenomena that were in themselves out in the open.

An obvious and indisputable agent in these operations has been the Church, which has emphasized knowledge according to its doctrine and brutally eliminated the people and phenomena that have not complied with its brand of knowledge. The State is another indisputable agent that has just as brutally forbidden the emergence of phenomena and threatened those who have striven to reveal things. The scholars have created the concept of "culture," which resembles those of the Church and the State and which, for them, does not mean the cultivation of spirit but an entity that exercises independent and autonomous power and within which all of us exist, in our entirety, and according to which we think, act and struggle. These can only be explained by the "culture" that produced them, which is suspiciously circular.

The important message of Thomas Kuhn, Michel Foucault and Paul Feyerabend has been that the representation of knowledge may be more decisive than its accuracy ("truth"). Research always requires a degree of reduction, generalisation, categorisation, naming and prioritisation of phenomena, which means that it is unwillingly doing violence to the richness and diversity of the reality out of which it is picking its phenomena. When the results of research are returned to the world, the way they are represented decides how this reading matches the potential richness and diversity of the reality to which they belong. This is particularly challenging in natural sciences, because it may happen that we do not even immediately realise how misguided the reading is, and, when we do, large-scale errors have already occurred, which is unforgivable.

In the human sciences, the disasters following representational misreadings are slowed down by the human reluctance to accept and apply knowledge. Yet it is possible that the conceptual shape of human life changes in a way that is not desirable in the long term, for example, through the practices of subordination, oppression and stigmatisation.

For these reasons, it is important that the democracy in research and knowledge becomes a reality. The Internet age has already, within knowledge, challenged learning things by heart, which was still valued 30 years ago: people dazzled others with their memory for names and their ability to spontaneously cite important sources in the middle of a conversation and to effortlessly quote the years of important events. After this ability lost its glory, many have wondered what took its place. It has been replaced with the ability to engage in a debate without constantly relating things to some previous debate, a kind of open and free forum in which the representation of things takes centre

stage. Today's dazzlers are those who have learned a particular form of representation that constantly leaves open the possibility to discuss any subject. The "serious debate" on knowledge has disappeared and we are going back to the atmosphere of ideation, creative activity and democratic insight.

The problem of the form of representation and the question of the nature of knowledge appear particularly significant. They reveal each other in a light that does not shine when the focus is on creating symbols designed to accurately capture the phenomena being studied. The illumination is not possible until the phenomena are dealt with in the real world. Regardless of the 2,500-year history of epistemology, little has been written about this double exposure and the two faces of knowledge, one of which looks into the world and the other into its reflection in the mirror, and the true nature of which we have never adequately understood, seeing it in a mirror of symbols.

Cultural studies of familiar and unfamiliar peoples, research in artistic practice, research in languages and research in beliefs and human education (or that of a dog or a canary) have shown the imaginary nature of the force that the resymbolisation of something symbolic can bring. Some meanings are usually lost in translation, and it is worth asking why move between symbolic systems, when there is always less and less of the real thing left the further we get. This is also familiar to us from psychoanalysis: when patients learn to think using the concepts of the analyst, they are both healthy and completely confused at the same time, because they now only recognise the phenomena for which they have concepts.

Otherwise than knowing never challenges the power that knowledge has established. It would be pointless to challenge the powers that be, because then you would have to justify your own motives by using the language of power. This sounds as fruitful as justifying civil rights by using concepts given by religious fanatics (sin, sacrilege, anathema, "god") or explaining to a dictator why people should have rights (peace, war, heritage, people). God's chosen ones, dictators, heads of police states and those who buy power have each created their own symbolic systems that cannot be used to represent anything that would be against them; if you choose to use this system of representation, everything turns into a defence for them.

In everyday life and its fringes, art and cultural rites, there are many practices that do not claim to be explanations but that still provide us with stories, narratives, ideas and images, which are studied quite differently in different times but that still retain some identifiably recurring features. In these, human life is often seen through myths, everyday life is realised in rites and the points of contact between man and nature are spoken of in many rich ways.

The ideas in this book stem from the frenzied thinking and discussion
going on in art universities around the world. Art is seen as the ability to
change the world, not by money or force, but by orientation, by radically
transforming the "sensible," or sensory, reality of the eye, ear, taste, touch and
smell, which unavoidably results in a change in ideas, understanding and
insight. It may be about distancing, it may be about getting closer; sometimes
it is irony or camp, sometimes it is a serious attempt to find illuminating
concepts and their verbalisations and sometimes it is the need to create new
myths or just tell stories.

Juha Varto

Preface

In this book, we discuss not so much the arts themselves but the methodology of artistic research. To put it in a nutshell, the core message of the book is as follows: artistic research ≠ art and art making. Thus we are not interested here in taking part in the well-worn discussions on the arts and art making (frequently understood as artistic creativity and originality) or their intrinsic value. Instead, we try to advance research on the arts in the academic context and for the audiences around academia, that is, to contribute to the development of the research culture of the area.

In so doing, we write about research methodologies and suitable methods for artistic research. The methodological guidelines, discussions, case studies and examples to follow are meant to provide ideas for those who want to deepen their understanding of their own artwork, in particular, and the art forms that provide the context for their work in general. In a word, our aim is to increase the awareness and reflectivity of both artists and their audiences about how to study art from the inside.

Artistic researchers have at least three intertwined jobs ahead of them. First, they need to develop and perfect their own artistic craft, creativity and conceptual thinking by doing art and thinking (conceptualizing) art, that is, developing a personal vocabulary for speaking about art and its world. In addition, they have to contribute to academia and return something to their academic colleagues by proposing an argument in the form of a thesis, thus assisting in constructing the not yet very strong academic communities around artistic research. Third, they must communicate with practising artists and the larger public, performing what we could call "audience education."

These are not easy tasks to fulfil but by no means impossible. It goes without saying that individual researchers weigh these tasks in terms of their research aims. It is natural that one task can and often must come ahead of the other two. Still, all three are essential to acknowledge and worth trying to realize.

Since our starting point is that artistic research happens for the most part as acts within artistic practices, the first task of an artist researcher—that of developing artistic and conceptual skills—is discussed throughout the book. The first part of the book forms an argument for this viewpoint. Toward the end of Chapter 5, we discuss how artistic researchers can position themselves inside the practice, and in Chapter 7, we take up the particular skill of reading and interpreting texts. All the discussions with practising researchers in Part III touch on the issue of artists' skills, but the theme is particularly dominant

in Chapters 10 and 12, which deal with explicit projects of self-education and autoethnography.

The second task, contribution to academia, is brought to the fore in Chapters 2 and 3, especially the section on verbalization in Chapter 3, which deals with the issue of how an artist can think about and approach the task of producing a written report. Also, the first part of Chapter 5 deals with the power issues of academic settings for artistic research.

The third task, audience education, is the direct target of Chapter 6, where the public role of research is discussed at length with the help of the tradition of public sociology and its classics. Of the interviews in Part III, Chapters 9 and 11 concern cases where a contribution to the larger audience is a large and self-conscious part of the artistic projects.

As is evident, the book is structurally divided into three parts. In Part I, we argue for our view of artistic research as a context-aware, historically bounded and open-ended practice, akin to the humanities and social sciences. The main metaphor is that artistic research happens inside-in: it starts inside a historical and contextual artistic practice, has an eye on the good as defined in that practice, happens as public acts that are considered parts of the practice and returns to it, to inform its continuation. We try to flesh out this view by giving both practical and philosophical arguments for why artistic research can be fruitful when it is aware of its context, is sensitive to the unique experiential (aesthetic in the wide sense of the word) possibilities given by an artistic approach and systematically takes its results to the public.

Part II deals with particular research methods and methodological questions. Chapter 4 presents a model for narrative interviews and argues for its benefits in raising both historical and individual self-awareness. Chapter 5 discusses the ever-present problem of power. The intertwinement of methodology and power is especially evident in artistic research that happens inside-in, without leaving the practice for a supposedly objective outsider perspective. Chapter 6 describes how research has been seen as a public task—a question we see especially relevant for artistic research. Finally, Chapter 7 takes up another important practical point: researchers need to read and an approach to reading.

Part III consists of interviews with people doing practice-based and artistic research. The aim is to provide more detailed snapshots of the what and the how. There is only so much that can be said in the abstract, so we feel that real-life examples are needed. This is especially because artistic research as a field could benefit from more connections and cross-fertilizations. So, we give our warmest thanks to the discussion partners—Per Magnus Johansson,

Wolfgang Krause, Esa Kirkkopelto, Mikko Kanninen and Leena Valkeapää—for their valuable insights and time.

It goes without saying that the examples chosen are not presented as ideals. They are exemplary with regard to their own situations and contexts, and this brings up an important point: the methodological decisions and choices have to be done on a case-by-case basis. As argued by the sociologist C. Wright Mills, to whom we return several times (see especially Chapter 6), every research project needs its own methodological approach. There are examples, models and guidelines, but exact duplication is not sensible beyond rare exceptions. The methodological choices leading to research methods should be as open and self-critical as the practice itself. Both can be under continuous development.

Still, methodological thinking should not be made into a fetish. The methods are there to make things easier, to enable action, not to hinder it. They are not a safe haven, but a propeller, if not for the boat then at least for the hat.

Yeah, why don't we put our Paris Hilton high heels on, hit the mean streets, and not be a disgrace to the human race!

Mika, Juha and *Tere*

Acknowledgments

We would like to express our gratitude to professor Juha Varto for inspiration to look into the questions of artistic research, in the first place, and for providing the Foreword for this book. We are also deeply grateful to the participants of the text seminar discussed in Chapter 5—Anne Sunila, Satu Ilta, Minna Heikinaho, Lena Séraphin, thank you! Finally, warmest thanks to Don Mader who did his best in order to correct our Finglish into something more readable.

PART I

FAIL AGAIN, FAIL BETTER

1. Artistic Research Inside-In

Methods? Methods of qualitative research? Or even more focused on a specific group of actors and agents: methods of artistic research? Who needs them? And why? What are they for?

This book continues the collaboration among three researchers working hands-on with students in various fields of cultural production. It is a tentative next step that follows from the previous joint effort, *Artistic Research–Theories, Methods and Practices*, in 2005. It is not an update, or a revision, but a new collection of thoughts and desires that emerge and evolve from the day-to-day acts of doing, teaching and facilitating research both in social sciences and in art universities.

To call this ongoing process a lifelong commitment would be preposterous, but nevertheless, there is evidently something intriguing and in the deepest sense challenging in the questions and issues of what is research and why and how it is supposed to be done that keeps all three of us returning to them, not as an institutional position or power game but as a self-reflective and open-ended practice.

What we return to is vividly, consciously and encouragingly a set of topics and themes that need to be labelled as productive dilemmas. They are dilemmas that should never ever be finalized or solved. They are constantly in great need of actualization—in and through the given site and situation, their locally situated discursive and physical geographies and genealogies. We return to these dilemmas because they do not leave us at peace. We also return because we enjoy the challenge—and the possibility of meeting classical issues and topics of social and human sciences again and again. In a very particular way, it is like returning to meet good old friends whom you are very fond of but at the same time who are rather annoying and even impossible to stay with. But, well, you stay, and keep on keeping on, because you have realized that you cannot get rid of them anyway.

But who does the how and what? In the inherent and internal logic of practice-based, open-ended and self-critical historical context-aware research, the one who does research does so from inside-in. The research is done inside the practice, by doing acts that are a part of the practice. This is not done within a closed-up entity but in and through the acts—conscious of their connection to the history of effects through the past, present and future—of doing the thing, that collection and recollection of acts that make and shape the practice. And, yes, one is allowed to push the envelope, to explore the limits of the practice. Thus, (this kind of) artistic research is characteristically

not research about or of but a participatory act and reflection with a strong performative element.

This participatory character leads us to a planned, but eventually discarded, subtitle for this book: "Artistic Research Methodology—It Ain't No Fun When the Rabbit's Got the Gun." The saying comes from the wonderful world of cartoons and, we would claim, is helpful here due to its focus both on the issue of perspective (who is the one doing things) and how this perspective often alternates and changes its position of articulation within the given practice—also strongly guiding how we see and approach a practice and its possibilities. The insider/outsider alternation in the perspectives is a topic often discussed in indigenous research methodology (see Tuhiwai Smith, 2012), and we will return to it in Chapter 5. To put this in another way: within a given practice, we must be both-and, both readers and writers, the ones who talk and the ones who listen, the ones who do and who are there to relate to and discuss what others in the same and similar practices are doing. It is about talking to and listening to, and arguing back—constantly willing and able to face a rebound.

Whether to call these ongoing changes of perspective (and the need to keep track of them) a "gun," or with a slightly upgraded metaphor, a "smoking gun," is a matter of taste. However, what is not a matter of taste are the consequences of the fact that the one who does things performs in and through the practice of doing the acts that constitute that practice. What this means is that the role and the self-evident authority of an outsider's position is no longer in itself relevant. Criteria for the acts of the practice stem from the practice itself in connection to its histories and present articulations. Again, here the practice is not interpreted as a cleaned-up or closed-up box but as an open-ended, internally conflictual enterprise that is always anchored within its structures.

This perspective brings with it a combination that is called the duality of freedom and responsibility. The act of doing research must have the freedom of choices and the risks that it needs to take. At the same time, the researcher has to be personally present and take the responsibility for the choices and the interpretation of the conditions of conditions and the materials that he or she gathers and talks and walks with while turning that information into a work of art of any type or any other kind of cultural product. What do we mean by conditions of conditions? The doubling is intended to highlight the fact that the conditions are themselves conditioned, which means that they are always contested, actualized, reinterpreted and so on. Taking the situation and site as something means actualizing one set of conditions and challenging, changing others and messing with the conditions of the conditions.

Freedom and responsibility: the words are big and they might sound scary, but they are real and necessary. In the previous book, this was translated and transformed into two metaphors: democracy of experiences and methodological abundance. The former, in short, states this: a priori, there is no hierarchy among different kinds or types of experience within the same site and situation. There is, in other words, no inherent inequality between interpreting the same and similar phenomena with the means, let's say, of artistic production or with the means of economical or sociological data. This leads to a plurality of takes on a reality, a plurality of traditions and values.

The latter metaphor is related to the writings of the philosopher Paul Feyerabend. With Feyerabend in *Against Method* (2010), the metaphor is turned and tuned into a slogan that is as provocative as it is productive: "anything goes." It is rather obviously usable for motives of any kind and colour. But what it says is that at the start of any process, there must be no limitations on where the process might take us. "Anything goes" is the ultimate recognition that things must stay open and potential. As a starting point, it also underlines that research hardly ever begins with a clearly clarified and stated problem, but instead, kicks off with fooling around with the matters, playing around, experimenting and trying things out (Feyerabend, 2010, p. 157).

Feyerabend's slogan is easy and open for misunderstandings if and when it is taken out of the recognizable boundaries of the acts constituting a practice. Once it is situated, anchored and embedded, and once it is seen through the lens of an identifiable practice, the demands and the gravity internal to the practice, the slogan stresses the freedom and responsibility inherent in any act of interpretation. "Being able to 'read' a certain style also includes knowledge of what features are irrelevant" (Feyerabend, 2010, p. 180). It states the necessity of embeddedness of practice-based research: how, in order for them to make sense, the acts we do have to "take place within a certain specified and historically well-entrenched framework" (Feyerabend, 2010, p. 178).

This framework has a shorthand name: context. As contextual, the research happens on a site and in a situation that never is a priori but is always in great need of being articulated, formed, discussed, maintained and renewed. It is made, not found. It is in a process, not static. It is situated, not stale.

The slogan "anything goes" is a useful symbol because it attracts both extremes. From one side, it awakens the fear of losing the illusion that there is a neutral and natural solid ground upon which our arguments are built. From the other side, it awakens the wish, so deeply anchored in our human nature, of wanting to believe that anything and everything is possible, always and

anywhere, and not only that, but also that anything and everything is great, magnificent and mesmerizing.

How do we strike a balance between the extremes? How do we keep the dilemma productive? In his critical reading of our two guiding principles, democracy of experience and methodological abundance, the godfather of methodological debate in Finland, professor emeritus Antti Eskola, states that the principles are well worth accepting as starting points: "It is not rational to exclude any form of critique or methodological principles of inquiry at the start" (Eskola & Kurki, 2004, p. 223). But in the final analysis, when different methods and approaches will be assessed, one should state clearly which ones are better than others: "One has to dare to declare the winner, for the debate does not stop here, but continues with such questions as who were the judges, and what were their principles of justification" (Eskola & Kurki, 2004, p. 223).

Declaring the winner does not mean taking final and total positions but simply stating the reasons and arguments for having been committed to one perspective, one conclusion, so that the debate can go on. As Eskola's formulation points out, the reverse side, failing to declare the winner, more often than not means disengagement with critique, turning away from the peers. We are back at the conditions of the conditions, mucking about.

This wish draws our attention to one of the most central dangers and problems of any type or kind of practice-based research. To be absolutely straightforward, it is this: everybody hates tourists. However, before going into the dangers inherent in the promise and proposition of a process-based and practice-driven research, let us shape the framework for the task—let us contextualize the issue first from a macro perspective.

For the sake of having an example of an expression of economic clarity, let us turn to a quotation from Alasdair MacIntyre (2006b), discussing the needs and necessities of the acts we act that are located within the structures where we act:

> What is most urgently needed is a politics of self-defence for all those local societies that aspire to achieve some relatively self-sufficient and independent form of participatory practice-based community and that therefore need to protect themselves from the corrosive effects of capitalism and the depredations of state power. (p. 155)

With MacIntyre (2006a, pp. 11–12), and in connection to the freedom and responsibility of a situated interpretation, we are also very effectively reminded of these two aspects of our acts: (1) what constitutes a tradition is a conflict of interpretation (here, replacing "tradition" with "practice" or any other name for long-term committed activity is not only possible but

recommended), and (2) questioning and doubting by necessity take place within the context of a tradition.

Both Feyerabend and MacIntyre serve a distinct purpose here. This is not to say that they are "used" or instrumentalised. Instead, both of them provide tools that are taken up in order to shape and make the argument for the context—serious and committed—of a practice-based research activity. Approached from another angle, they are needed to address one of the main dangers of practice-based artistic research that has demonstrated itself, happily and loudly, throughout the last decade, articulated amazingly uniformly in different universities and nations.

This danger actively despises the historicality and context-boundedness of Feyerabend's claim that "anything goes." Not that the manifestations of the dangers are either openly or subconsciously aware of Feyerabend, but their positioning has striking similarities to the slogan. Instead of Feyerabend, or any other figure of discourse, the danger is centered around the wishing well called "artistic activity." This wishing well, to follow up the vocabulary used earlier, functions as a rationalization for taking a nonattached version of freedom and, well, just leaving aside and forgetting the part of responsibility included in an act and an interpretation.

In its most naked form, this attitude is sported like this: because I am an artist, and because I need to experiment, and because all materials and possibilities are accessible and open for me, I can do anything with everything and that anything I do, because I am an artist, is, in itself, interesting and significant. Amen.

Is this a caricature? Based on individual and collective experiences during the last decade teaching art and social sciences, taking part in numerous conferences on the topic of artistic research both domestically and internationally, and reading and seeing art in discourse and practice, you would wish it would be a caricature. But it is not a full-blown reality, either. Let us say, then, that it is a very strong and often visible tendency.

The problem with this wishing well is that it is unwilling and unable to locate itself within a practice and to feel how the past, present and future of that framework for any act really does pull and push it around. To state this in another vernacular, the wishing well that everything is possible and that it would make sense to wish that anything would be possible anywhere and always is to be unable to make the distinction between what in itself is truly possible and what in itself is realistically meaningful. It is a distinction between something general and abstract and something particular and potentially singular.

Thus, it is a confrontation, not only between an act that is surface-happy and an act that is aware of its situatedness, but also a confrontation that highlights the difference between something being a potentiality and it being actualized within a discourse. The metaphor accentuated here is this: are we willing to just put on the costume or are we willing and able to really play the part?

To stay with this hurting feeling, and really using the occasion to rub it in, for real, the dangers for unattached and unbound practice-based artistic research come down to two additional issues. These are (1) saying it ain't doing it—the hope of the miracle of labelling: the often used strategy of hoping that the sheer naming of an act as something would make the act happen as that particular something, and (2) self-congratulatory feel-goodism—the belief that because what one does, one does as an artist, and, therefore, whatever one does is always in itself good and interesting.

To sum this up, it is beneficial to appropriate an old saying from the land of bumper stickers, with the idea of collecting together the 12 most dangerous words in the English language. What we get is a slogan that brings the performative drama to its peak—the dangers parked amidst and ahead of us: "I am an artist doing artistic research and I am here to help you."

Thus, while everything within the context of a situated practice might indeed be potentially possible and very much worth trying out and experimenting with, this does not mean that any act in itself is always meaningful and substantial. Sure, it could be, but there is no automatic pleasure, no guarantee of success. And well, just guessing here, this realization that not everything makes sense and is of great quality—that does suck, right? It might be even colossally unfair, but, well, it is the very difference between doing the dirty deed and pretending to do it.

This blatant naivety, too often verging on obsessive and self-congratulatory stupidity, is not only supported by false beliefs about the conditions of conditions of creative activity. It is also supported by a misunderstanding of the structures of research activity.

Here, the difference is between two versions of vertically placing that symbol of a building called a pyramid. In the first version, it stands on its head, and in the other one, its long side is on the bottom. The former stance depicts an approach that starts from one's original position and then goes on with the task of gathering and collecting everything and anything that fits or seems to fit the task—whatever the topic of the research is. This is the act of looking toward the topic with a wish for and a belief in a chance of having a 360-degree view and vision.

Contrary to this strategy of all and everything, the pyramid that looks, well, like the pyramid we are used to, locates itself in the vast land of context and works itself through the various potentialities and tries to move toward a perspective, an edited view and vision of the chosen subject and the topic that is no longer even 90 degrees, or 45, not even 25, but when done with seriousness and stamina, is able to create a focus that is aware of its larger ramifications but is talking with and saying something within 3–4 degrees.

This editing out and choosing in is an interesting enough act that comes very close to the act of telling stories. Here, a comparison, for example, with the way Paul Ricoeur (2007) conceptualized storytelling, is both attractive and productive in a critical yet constructive manner. For Ricoeur, "narrativity is to mark, organize, and clarify temporal experience" (p. 3). This is then the collecting of acts that delimits, orders and makes things explicit. Thus, the point is not to state that research and narration are the same procedures but rather to underline that the needed and wanted structural guidelines for both acts are very similar.

But, we go back to the ancient symbols that we try to reactivate for our own purposes. The former pyramid, the one having both great fun and admirable difficulty in balancing on its pointed head, is the act of mapping the terrain. It is the first, start-up step that any research must achieve and activate. But it is not research itself. There is no interpretation; there is just the beginning of a beginning, trying to fathom what needs to be understood in order to be able to distinguish what is relevant, and what is not, and well, why that is so.

The latter pyramid, admittedly having the unfair advantage of looking like we think a real pyramid should, states the need for mapping the terrain but adds the necessity of the next steps, of working through what's relevant and why—moving toward a focused and edited interpretation of the subject and the topic. It is the act of excluding, but with a set of argued-for reasons that stems from the acts of doing the practice. To repeat: research is not an act of filling the bags, the constant semihysterical including and attaching of a wide variety of interconnected perspectives. With the help of Maurice Merleau-Ponty (2004), the need to locate oneself is made clear by the facts that (1) "things we perceive make sense only when perceived from a certain point of view" (p. 499), and (2) "to be born is to be born of the world and to be born into the world. The world is already constituted, but also never completely constituted" (p. 527).

A danger connected to the wishing well, that anything in itself is both possible and meaningful, is a lack of awareness of the histories and present conditions of a given practice. This is another phenomenon in the self-image

of certain artists, often further supported by the attitude that the less one knows about the others and their works and acts in the field, the more one has a chance of linking to and digging deeper into one's pure and creative self—with less knowledge, fewer intruders, fewer influences. The acid-free irony of the ghost of a heroic genius is that it is actively used and wished for in the processes that claim to be doing research—which funnily enough, in fact, violently contradicts itself and excludes possibilities, genius and research.

When doing research, however lost and lonely, please, please, please, don't look back in anger, and please, please, please, do not be afraid of influences.

The intensified problem is not the silliness of the image of an artist as a vacuum-packed genius that still keeps haunting us. The problem is in the ease with which this image is supported by a lack of attaching oneself onto the historically bound and situated practices of which one is nominally part.

This danger is highlighted in the aspects of how much and what kind of connection to and knowledge of their context, its past, present and future, the agents claiming to be doing practice-based artistic research have. It is highlighted in the use of materials for and with the research. This is the danger of maintaining a fantasy that everything is available for one as an artistic researcher and the not so well camouflaged disgust that one feels when getting close to the other agents doing artistic research. Thus, the further away other artistic research is from oneself and one's acts of doing the practice, the better it seems to be for the self-image of a detached genius actor of make-believe research.

But, what do we do? Are there any words of advice, *bitte schön*?

The repetitive and somehow perfidious dilemma of most kinds of research is how it tends to have a strong prejudice and even abhorrence toward its own kind and its own contested histories. One of the main tasks of any type of serious and committed research is to turn this strangely beloved attitude completely around and simply force each of us to pay all the attention that we can muster to what is going on within our own field and in adjoining fields.

As a collective and structurally enforced program, this means nothing more special than to read, see, hear and discuss what others have done and are currently doing within their projects—and to do that in a repeated fashion, returning to the issue with a long-term commitment. Get together and stay together, help each other and challenge one another. The most beneficial act for any research is not to try to reach out and get something from somewhere else but to stay with and within the positions and frames of one's own practices. It is peer-to-peer, colleague-to-colleague. This means to take advantage of and to make the best use of what is already accessible and close to

oneself—instead of dreaming of something out there that can have a shiny effect but is not connected to what you are trying to do and achieve.

Reading, seeing, feeling and talking with and within one's own peer group is ridiculously underrated and must be rescued and returned to the core of any research action and activity. To do contextually aware practice-based artistic research means to come together and to stay together and (1) to recognize what are the inherent chances and challenges of one's oeuvre and genre, its contested internal logics and the strategies of its survival, and (2) to enjoy those contextual freedoms and responsibilities that come down both as openings and as restrictions and impossibilities, but, most important, as focused dilemmas to be addressed and articulated.

Research is propelled by knowing your own history and being curious about and interested in it—not because of altruistic reasons but due to the fact that without this involvement and both mental and physical investment there will be no context, no platform, no trampoline; there will be no sites and situations of give and take, push and pull. Without this acute sense and sensibility with the reinterpretation and even reenactment of the past as a plural entity, what else is there?

In one respectable sense, what we have and what we must have are links to the tools and the cases of thinking about who we are, where we are, how we are and what could we possibly do to be able to make some sense of the conditions of our currently demanding conditions. These links are relationships with writers and case studies that highlight the one notion that remarkably often is either forgotten or at least goes unrecognized. In one word, it is imagination.

The lack of imaginative drive and imaginative impressions and involvements is somehow very strange, especially within the field of artistic research. Partly, this can be connected to the tendency of more or less blindly hoping that following the normalized criteria of other versions of academic research would both provide content and solve insistent problems of authority and credibility. But forms and formats are not themselves the content, even if they are needed for the organization and presentation, and also preservation, of content. The terrible deep-seated angst in the face of the possibility of making mistakes and being laughed at is nevertheless only a partial reason. The other is the true blue classic one: ignorance. And this is ignorance, as in the state of not knowing and not really caring what has been going on through the years and the decades of experimental acts of thinking with—whether these acts now take place under the label of sociology, biology or even performances for camera.

Here is not the place to dwell on all the aspirations that the open door called social and political imagination might raise, but it is worthwhile to mention just three examples, examples that function as teasers, as appetizers that are also taken up and taken further in the chapters that follow.

Beginning with the concept of imagination, and the great need for it in any kind of serious research, we have no better head start position than the book by C. Wright Mills, dating back to the year of 1959. It is handy due to its title: *Socological Imagination*. This is what Mills was asking for and demanding, and this is also what he found achingly and acutely missing at the time. But society of what, and imagination how?

Linking Feyerabend with Mills, sociology is just one name for acts that are many, inherently plural and in conflict with one another. It is an attempt to stay with that essential notion of trying to figure out what, how, where, why and why not. There is nothing magical or mystical about it and nothing that the label in itself should cause too much attention to or admiration about. For imagination, Mills's advice is that if it intends to be anything, it must begin by making itself aware and by connecting itself to the ties between one's social context and one's current biographical situation. It has to trace and recognize connections but also contradictions within the sites where we are and try to behave the best or the worst way possible. This is the ongoing modern dilemma of a human being as a part of his or her histories and institutions, articulated within the daily structures. At its core, imagination itself is nothing more than the willingness and ability to alternate perspectives.

In the words of Mills (2000b), just to use one sound bite at this moment, social imagination "in considerable part consists of the capacity to shift from one perspective to another, and in the process to build up an adequate view of a total society and of its components" (p. 211). The unfortunate use of the word "total" should not make us worried, since what Mills means is the overall situation that we find ourselves in. Mills is careful to point out is that it is the potentiality of changing perspectives, of thinking and seeing, feeling and being with differently, that makes the distinction between a participatory researcher and a mere technician. What's more, the perspectives and their alterations are not guarantees, and they are not symmetrical but often enough characterized by inherent incongruities. Nevertheless, they are perspectives that have to be brought next to each other and to be bounced on and off each other.

Another available sound bite from the recent history of social imagination is yet another book that tells it all so beautifully in its title, a less known classic of contemporary social thinking by Robert Nisbet (1976) called *Sociology as an Art Form*. Nisbet is at pains to try to get closer to creative processes and their sustenance. Even if the results, and Nisbet's clarification, seem to be overtly

abstract and close to common knowledge, it is worth being reminded of the phenomenon of creativity. It is especially beneficial to be reminded that what creativity and imagination are as abstract forms, they are not more than, well, abstract descriptions, always in a magnificent need of specific cases and contextualisations.

What Nisbet (1976) is after is illumination of reality, which is, in sum, "exploration of the unknown and, far from least, the interpretation of physical and human worlds" (p. 11). This is, in other words, the creative imagination that is needed in any kind and type of human activity, from music to manufacturing. Nisbet argues that what unites all of these strategies is a "form and intensity of imagination, a utilization of intuition" (p. 10). This is not to say that, for example, art and science are the same, but that their separation in the name of creativity and discoveries is false. On the whole, what Nisbet was most concerned with was the need for a social scientist, not only to get rid of the naïve rituals of proof and verification but also to acknowledge creative imagination as a practice that is drawn from experience and observation.

The third sound bite follows again the logic of getting the name of a cultural product to tell what it is about. This is then perhaps—we would claim—the most effective and amazing account of what a body is and how the body is connected to a soul. What we have in mind is a short but concise book by Italo Calvino (1952/1998), *The Cloven Viscount*, originally published in Italian. To get into the nuances and the brilliant breathtaking richness of the imagination of this particularly short—not much over 100 pages, regardless of how it is designed and printed—book, you need to do the reading all by yourself.

What is sufficient here is to recall its certainly silly plot, a creative and amazingly funny plot that also is something of a wonder due to its immense clarity of both structure and language. It is about a certain unlucky viscount living in the middle ages, forced to take part in a strange unfathomable war that he returns from as halves, in body and in person. First only one half, the extremely evil and bad half, comes back to rule his possessions, but soon enough the other half, the extremely good and hyper-altruistic one, also comes into the spiel, forcing the diametrical opposites to clash and collide. The book was written within the era when bipolarity of the world was about to be shared and cherished as yet another unfulfilled totalitarian answer. And it is a reminder that when two extremes collide, everyone else around is having a pretty miserable time.

But, if Mills and Nisbet, and also Calvino—or so many others in this field of trying to make sense of who we are, where and how—would ever have been asked, they and anyone else that has a situated and embedded practice would

have underlined that there is no imagination without a sense of context, a sense of structure and a sense of the inherent limitations of any activity. And as a reminder at the end of this introduction, it is important to recall one of the pioneers of social imagination, a figure also so often forgotten that it is a shame—and also someone whose works and writings are a pleasure: Wilhelm Dilthey (1833–1911), holder of the chair of philosophy at Humboldt University.

We do not want to make too much of a fuss over the fact that it was Dilthey who came up with the inherent distinction between qualitative and quantitative research and that it was he who made the difference between the aim of explanation and understanding. However, it is also from and with Dilthey (1910/2012) that we can collect some of the main—not all, but quite a few—necessities of any and every kind of serious and long-term committed research practice. It is a short list dating from plus or minus 100 years back and counting, but it is very effective in its implications and demands.

The list should be shared here—as a pointer toward the really beneficial reasons to be cheerful. Any knowledge must be lead by the following:

- Organization
- Stability
- Coherence
- Economy of expression
- Logical consistency

These are the things that need to be taken care of. Not detached, not universally, but realized and articulated, in their particular and locally driven and bound versions, in and through the needs and challenges of the given practice. Research is then done inside-in, while reaching out and getting out of one's box in order to return to it again, not superimposed from outside but developed and taken care of from within. It is a collection of acts that are called not a progress but a never-ending self-reflective and critical, creative process.

And yes, this is then not creative as in new public management, and it is also not creative consultant prophecy. This is the act of creativity that is constantly bitten and bitten again by curiosity and the never ceasing need to wonder: what is going on? In the words borrowed from one of the pioneers of documentary filmmaking, the British John Grierson (1971), it is, as a task, as a disposition, as a promise and as a demand, about this: creative treatment of actuality.

2. Basic Formula of Artistic Research

Let us try to sum up this view of artistic research as an open-ended, historical, context-aware and narrative enterprise. The goal of the following crystallization in terms of an oversimplified equation is not to look at artistic research from above, as if trying to explain or legitimate it, but to give a basic skeleton of something that otherwise can appear rather nebulous and amoebic, also on these pages. The forms and ways of doing artistic research are genuinely open and should stay that way. Let us not lock them up or tie them down. At the same time, we want to present our view in a nutshell for two simple reasons. First, as the saying goes, if you don't stand for something, you will fall for anything. Second, while the identity of artistic research should be open and contested, we feel also that doing artistic research does not necessarily have to start from agonizing over the unclear nature and identity of the field vis-à-vis the established disciplines in science, since some sort of basic form is available and can be utilized.

As the second reason indicates, the purpose is also propagandistic. So let us borrow a formula from a master of that form of art, V. I. Lenin, who once summed up the following: "socialism = the power of soviets + electrification." Borrowing the form of the equation, we get this: "artistic research = artistic process (acts inside the practice) + arguing for a point of view (contextual, interpretive, conceptual, narrative work)" (see Table 2.1).

Table 2.1. Basic Formula of Artistic Research

Artistic Process: Acts Inside the Practice	Arguing for a Point of View (Context, Tradition, and Their Interpretation)
▪ Committed with an eye on the conditions of the practice	▪ Social and theoretical imagination
▪ Documenting the acts	▪ Hermeneutics
▪ Moving between insider and outsider positions	▪ Conceptual, linguistic and argumentative innovations
▪ Preparing works of art	▪ Verbalization

Artistic Process

Let us unpack the elements. By artistic process, we mean acts done inside the practice, as discussed earlier, acts that possibly question the conditions of that practice, push the envelope, but still are in some relevant relationship with that practice, with its internal values, goods, commitments and so on. Of course, the practice can be anything, but in the case of artistic research, the practice is in some sense artistic. (If not, we would prefer talking about practice-based research.) Here, the researcher works as an insider, as a participant in the practice, as one of its embodiments, so to speak. But that is not all. In the practice itself, one also takes a step of minimal distance toward the practice, reflecting on it and on one's acts. It is a question of semantics whether this distance-taking and reflection are a natural part of the practice itself (as someone like Aristotle implies with his concept of *phronesis* or practical wisdom in *Nicomachean Ethics* [Chapter 5, Book 6]: "Practical wisdom, then, must be a reasoned and true state of capacity to act with regard to human goods") or if we conceptualize it as taking up the position of a relative outsider. Whichever way we want to describe it, taking part in the practice, being engaged in an artistic process means moving back and forth between periods of intensive (insider) engagement and more reflective (outsider) distance-taking. The need to adopt some minimal distance is one of the reasons why artistic research often pushes the boundaries of the artistic practice in question.

This process consists of acts: performances, works of art, periods of working, drafts, plans and so on. All of this either already leaves a material track in terms of paintings, videos, photographs, audiotapes, texts, objects and so on, or can be made to do so by writing a research diary, documenting audiovisually and so on. Thus the process creates a body of material that can be used as the publicly available record of the phenomena that one wants to talk about in one's research. In reporting on the research, in making it available to others, this material provides means for arguing, showing, detailing, explicating, implying, connoting, being ironical and so on. It can also function more straightforwardly as the data of the research that is then analysed. But more often part of the analysis and theoretical thinking happens in the process itself, so the distinction between process and contextual/ conceptual work in the equation is not the distinction between data gathering and analysis.

Conceptual Work

The second part is harder to name, since it contains many elements, and none of the elements is characteristic of the overall whole as such. Let us start with contextualization. Research means taking part in a research tradition, in a discussion that has started before the particular piece of research and will continue after it. In its very basic form, contextualization means situating the research in this tradition. Often it means choosing and arguing for a particular point of view. This, in turn, often means the use of some classical texts, works or interpretations as launching pads, as tools and teammates and discussion partners in one's own endeavour. Contextualization is also another name for giving content to concepts, for the actualization of preexisting frameworks and notions. How are particular concepts—say, for example, "body"—understood and actualized in this particular research? Through this kind of work, we slide seamlessly into interpretation and imagination.

If and when the research contains a written part, if it contains some texts (including texts in the wide sense of the term), the second part contains conceptual work. We return to verbalization and writing later, but let us note here that the verbalization in an open-ended and contextualized research is itself open-ended and contextual. As a practice, it is on a par with any other type of practice: it takes skill, commitment, freedom and responsibility. And it may contain linguistic and conceptual innovations: ways of saying, ideas, notions and concepts that introduce something new (relatively speaking) into the discourse. Forming a story, however fragmented and postmodern, is a part of verbalization. Therefore, at the most general level, contextualization and interpretation mean or add up to narration. Or, vice versa: the narration of one's research findings is dependent on how one situates, interprets and conceptualizes its parts.

Let us take up a couple of important points about the equation. The separation between the two parts is not the separation between practice and theory, of data gathering and analysis. This is because practice and theory happen in both parts. Often the artistic process is motivated by an intuition that arises from some theoretical considerations. Often the process also contains outright theoretical and conceptual interventions. Likewise, the contextualizing and conceptualizing part is creative: often one finds out how one thinks about something only by and after writing it up. Or to put it another way, writing is a way of thinking and discovering things.

The separation is therefore not the distinction between the context of justification and context of discovery. In philosophy of science, these two are separated in order to point out that the way in which researchers come up

with their ideas, theories and explanations (the context of discovery) is not systematic and cannot really be made explicit, while the way in which the ideas, theories and explanations are made public, argued for and legitimated (the context of justification), can and has been systematized, so that there is some kind of agreement among scientists about how something gets to be true in a given field. But the distinction between acts in a process and contextual/ conceptual work is not this distinction, either. Justification, argument, making research available and vulnerable to criticism happens both in the process and in the contextualizing work. For instance, the artworks produced in the process may be the things that do the convincing about some interpretation made in the research.

Finally, the order of process + contextual/interpretive/conceptual work in the equation is not a temporal order, so that one comes first and the other second. Both are ongoing, both can start the research, and typically a researcher moves between the two intermittently.

Given these two sides of "inseparability"–(1) making the research public happens both through the artistic process and the contextual/conceptual work, (2) discovery and justification happen through both—maybe the basic model is better pictured as in Figure 2.1: the artistic process is the overall framework from which the research starts and to which it returns (inside-in), and it is interleaved with more or less distinct phases of contextual/conceptual work. Together these two kinds of acts form an ongoing research process, a band of pearls, that eventually may result in published works.

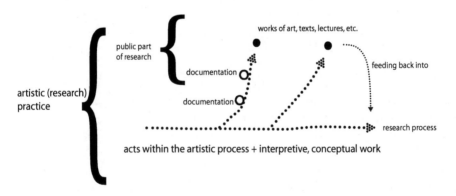

Figure 2.1. Artistic Research Practice and the Public Part of Research

The starting point, the inside from which everything starts and to which everything returns, is the contextualized practice, whatever it may be (contemporary participatory performance, modernist architecture in the Balkans, a revitalized tradition of landscape painting and so on). Inside this practice, as a part of it, the research process runs like a string of pearls, where each pearl is an act done within the particular artistic practice or an act of interpretive, conceptual labour. As such, most of the research process is private, available only to the researcher or the researchers and possible advisors, supervisors and so on, as the case may be. But part of the research process is bringing forth the public aspect of the research as works of art and texts. The documentation of the process may be either private or public, public in the case that one's argumentation in the public part demands the support of the documentation.

Finally, of course, the public parts—works of art, texts, performances, lectures and so on—that constitute the accessible part of a project of artistic research are really not separate from the process: they feed back into it, maintaining and nourishing it, questioning and even possibly jeopardizing it. But their public role should not be belittled, either. It is the public part of artistic research that gives access for other people, not only immediate peers, to be involved. The public part of artistic research is the ultimate double-edged sword: it is what feeds the angst of failure, the pain of criticism and so on, but it is also the arena where the productive dilemmas of the field to which one is committed can be actualized, where the conditions of conditions can be pushed and pulled.

3. Back to the Future: Democracy of Experiences, Methodological Abundance and Verbalization

The point of the metaphor of "democracy of experiences" is not to claim that in fact different types or areas of experience are equipotential when approaching a given phenomenon. It is certainly true that all kinds of psychological, social and economic conditioning affects how we interpret and contextualize anything we encounter. It is hard not to give greater emphasis to knowledge of physics than to knowledge of cooking when building a bridge. Hard, but not impossible. Likewise, it is hard not to use some kind of aesthetic criteria when addressing an exhibition. We habitually do, in fact, give more credence to certain types of criteria when approaching certain types of experience. Moreover, there is sometimes good reason to do so. The metaphor is not intended to deny either of these two facts.

Rather, the metaphor tries to point out that there is the possibility of putting the conditioning in brackets and of accepting that different areas of experience—also unexpected ones—may have something interesting to say. Striving toward that possibility is not frivolous play. To be pathetic: if we knew for certain what life is about, what is its so-called meaning, then we could, in principle, be sure about how to prioritize different kinds of experience and how to let one area of experience (let's say biological knowledge of survival or practical knowledge of meditation) legislate over the others. But insofar as we do not know this, we should, in principle, be open to the possibility that experience gained through meditation may challenge experience gained in the science of biology, that artistic experience may challenge international law, and so on. This is especially true in broadly speaking humanistic research settings, where one of the preconditions is to be open with regard to the question of what it means to be human.

Moreover, the metaphor relies on the belief that such a state is actual: both in various kinds of everyday experience as well as in sophisticated synaesthetic and selfless experiences, the experiential whole contains many intertwined layers with no labels indicating which aspects of the experiential whole are more important than the others. There is a skill of being sensitive and open toward this multilayered and multifaceted nature of human experience, and that skill can manifest itself in fields like art. As a skill, it can be cultivated.

As such, the metaphor of democracy of experiences is closely connected to the core principles of hermeneutics. Experience is a whole, in which you cannot change one thing without changing others—generally in an unpredictable manner. Likewise, as the principle of the hermeneutic circle points out, it is not possible to understand a part of the experience without understanding the whole, and vice versa. Consequently, a basic condition for artistic research (as broadly speaking humanistic research) is to be aware of this holistic, bottomless and endless circularity of experience.

Does this mean that artistic research should not aim at laser-precision specialization? Are artistic researchers not allowed to omit cognitive science, chemistry and health sciences just as biologists are allowed to omit art history, literature and political science? Certainly they are. Focus is as essential for research as hermeneutic sensibility. The metaphor of democracy of experiences does not operate on this level. However, it does mean that—again generally speaking—any kind of humanistic research gets better when it gets better contextualized, better embedded in the environment of the phenomenon it describes, better at displaying the complexities, tensions and even contradictions that are inherent in the phenomenon. We are back at the notions of situatedness, commitment and actualizing the context, discussed earlier.

The metaphor is intended to operate on two levels. First, it has to do with the microlevel of staying with the acts of doing research. Being committed and actualizing a context takes time. You have to be present, have to be with, alongside, by, for long periods. And in that tarrying-with, there is the possibility of attending to areas of experience that would be neglected if one would just rush by. In themselves, being present and taking time are experiential dimensions that widen perspectives. But even more than that, artistic research gives the possibility, for instance, for a sense-driven and material encounter with the world, as opposed to an abstractly intellectual one. And it is here, in the receptivity and sensitivity for the aesthetic—meaning all that is available through all the senses and the body—that democracy of experiences has its meaning in the context of research: the sensuous and the bodily are valid sources of research, as well as, say, the readings of laboratory instruments or the results of a survey.

Second, the point of the word "democracy" is to emphasise that research should not be driven (a) by what we might call physics envy, where everything is measured on the supposed rigour and success of natural science and especially modern physics, its formalism and technological advances; or (b) by ivory-tower dreams of the unquestioned sanctity of one's own field, whatever that may be. The boundaries among different disciplines, schools and

paradigms seem more and more ridiculous and contrived as one moves away from the sheltered hothouses of the academia. Again, this does not mean that differentiation or even militantly positional research would not make sense. What it means is that such partisanship happens on a more fundamental basis of democracy, where differences are negotiated and argued, not posited or given from above.

This brings us to our second favourite, methodological abundance. The notion is first intended as a simple acknowledgement of facts. Just a few decades ago, the situation in many universities and academies was that particular departments and schools had very clear ideas about what methods were the right ones. There were sometimes raging debates over methodology, but generally one worked with the limited set of tools handed down from above. But the situation has changed. Now the methodological field is wide open. Not only is a wider array of different methods used and available in any given field, but new innovative methods and ways of gathering data are being developed.

The arrival of methodological abundance can be connected to wider tendencies, such as the battle between what have been characterized as qualitative and quantitative research methods, the birth of postcolonial and subaltern studies, the development of new research methods in various fields connected to new media and so on. Together these developments have meant that the methodological field is, in academic settings, much more pluralistic than a few decades ago. The birth of artistic research has, in itself, contributed to this trend.

However, perhaps the notion of methodological abundance has a new application, too. Here and there we hear voices indicating that "the" way of doing artistic research has been found and that the age of insecurity and methodological vacillation is—or at least should be—over. While we certainly appreciate the desire and even the need for some stability in a field that is under considerable internal and external pressure, we see methodological abundance not only as a general fact but as something positive for artistic research itself.

Living in a situation of methodological abundance produces different difficulties compared to a situation of methodological scarcity. How do we orient our own methodological thinking and how do we choose a method for a piece of research when "anything goes"? One initial metaphor is that the method and the research question should fit together like a hand and a glove. The method—in general, the way of going about doing research—is going to determine what kinds of questions the research can address and possibly answer. And the other way around: if you know what kinds of questions you

need to ask, then you already know what kinds of knowledge, information and data you need, which sets you about designing the research methodology. Thus, with this pincer movement, thinking about the question and thinking about the possible ways of approaching the question, the method gets crystallized. In this way, abundance starts to be a helpful phenomenon, again.

There is, however, a possible problem with the analogy of hand and glove. The analogy presupposes a separation between form and content, between research methodology as a tool for obtaining and analysing data, and the data itself. That separation does not often describe the reality of practice-based artistic research, since, as noted earlier, it happens inside-in, by practising the practice that the research is about. For instance, let us say that one produces a work of art as a part of the research. The production, the work, the reactions to it and so on may certainly function as some kind of "data" or information for the research, but at the same time, they also involve the researcher as an insider in the particular field of art—otherwise the work could not be (recognized as) a work of art. The data is produced through an insider position, through a commitment to a practice, and its analysis also has to bring it back to that position, make it available to the committed practitioners for whom the research is meaningful. The hand and the glove are, in a sense, inseparable, or rather, they are the same thing seen from two parallel perspectives: now as a way of doing, now as a way of thinking about that doing.

This is not as odd or as radical (in comparison to received ideas of objectivity and outsider perspectives in research) as it may sound. In broadly speaking humanistic research (literature, history, philosophy and so on), it is often the case that the way of doing research and the research itself are a unified whole. Think, for example, of Plato's dialogues with their so-called Socratic method. Here the dialogue is the research, the rhetoric and method are a significant part of the content. In humanistic research, there might be materials and data and their analyses that are in a sense "objective" (such as historical records, texts and so on) and not in any way produced by the researcher. But the situation is similar to artistic research in that the ways in which the humanist argues, writes, uses rhetoric and so on, are, in fact, not external to the research but an integral part of it. Humanistic writing, like verbal reports of artistic research, offers open-ended but argued-for views that gain their traction from how relevant the views are for the practice at hand and how well they are contextualized. As Stephen Toulmin emphasised in his book *Cosmopolis* (1990, cited in Naukkarinen, 2012, p. 96), this implies the classic humanistic virtues of tolerating uncertainty and respecting the place and time-bound nature of knowledge.

In fact, in context-aware and historical practice-based research, there are two different fusions. First, there is the fusion between the doing and the thinking about the doing. One has to be an insider in a practice, one has to practice that practice, do acts internal to it, and some of these acts then function as research, as thinking about that practice. Second, the practice and the thinking have to be fused with the public part of the research, let's say a text, a research report or a PhD thesis. Here, too, the way of writing, the way of arguing, the rhetoric, the presentation, are part of the thinking, the content of the research.

In other ways, too, artistic research may learn from humanistic writing. Verbalization is one way of sharing, making things public and vulnerable, that is, systematically open for criticism. This may very well happen in ways that are at the same time open-ended and disciplined. Ossi Naukkarinen (2012) has elegantly crystallized the key points of writing humanistic research. First, verbalization is done so that other people can access the materials (openness). Second, verbalization is done by arguing for a view or a thesis. In a nutshell, this kind of research writing is open and open-ended, arguing for a view:

> The humanist openly displays the route which runs from certain starting-points to an argued-for conclusion. One must tell clearly and in an articulate language what one wants to say (about humanity), i.e., one must verbalise the core message, and reveal how that message has been arrived at. One must describe the background of the analysis and explain why people should think like the research says they should think [about the topic], one must motivate the project and explain its relevance. (Naukkarinen, 2012, p. 77)

There are several ways of doing this in writing. Again, as examples, one can think about the very different stylistic decisions by humanistic classics such as Montaigne, Auerbach, Weil or Sartre. The trick is to find a way of writing that suits not only the topic but also the researcher doing the writing.

And here we encounter an important practical matter. To say that in artistic research the doing of acts, the thinking about the acts and the writing/reporting are all intertwined and partially inseparable already sets the bar relatively high. To then add examples of classic humanistic writing is to raise the bar even higher. But to cite the examples is not to demand that everyone write a classic or produce prose that shines through the ages. Such a goal is not even reasonable, for instance, in a PhD thesis that often is intended for and stays within the attention of a severely limited audience. Even more important, the fusion between the way of writing and what one is writing about can be effected more or less directly.

There are two separate matters here. One is the fusion between doing, thinking and writing. This is, in context-aware historical artistic research, a necessity, up to a point, as it is in humanistic research, in general. One has to stay inside the practice, work inside it and bring the results back there. The rhetoric and the matter, the form and the content cannot be completely separated. The other is the fusion between the language one uses in writing and the language or semiotic universe of the phenomenon that one writes about. Here there are many variables to play with. To crudely illustrate the matter, at one extreme we have the "full monty," that is, a poetic expression where every word is necessary, and the text has been polished to maximum economy of expression: it is at the same time aphoristic and informative, a work of art in itself, so that the text does not "speak about" something but is that something. At the other extreme, we have a research report that is written in a metalanguage that talks about the phenomena that it wants to describe but does not in itself emulate what it is talking about. It is possible to write in a very fruitful and illuminative way about, say, Tolstoy, in a language that does not resemble Tolstoy's writing at all. Likewise, it is possible to write about a given artistic experience in a fruitful and illuminative way in a way that does not emulate that particular artistic experience in its sensuous or bodily qualities. Of course, both extremes, the full monty and the maximal distance (as in Brechtian alienation or distance), are very hard to do. Therefore, it may be advisable to aim at somewhere between the extremes: making sure that one's language is in overall harmony with the conditions, possibilities and new features of the phenomena one is talking about, while at the same time giving place to a metalanguage that talks about the acts and experiences of the research without trying to be those acts and experiences.

The verbalization cannot function in a register that annihilates the phenomena under discussion. Crudely, one cannot use the language of behaviourist psychology if one wants to discuss experience, or one cannot use Foucault's language of biopolitics if one wants to discuss repression. The language, its register, vocabulary, style, even grammar should be geared to accommodate relevant parts of that which one is talking about so far as is needed. There is no necessity of going for the full monty—unless, well, unless it is necessary.

In most cases, what one needs to do is relatively straightforward. Naukkarinen (2012) provided a concise list of what has to be written down:

- What is the topic and the question?
- What kind of materials (books, artefacts, interviews, etc.) are used in addressing the question?

- How are the materials used? How are they read, interpreted?
- On what viewpoints, theories and concepts is the approach based? (feminist, psychoanalytic, hermeneutic, etc.)
- Why are these viewpoints used?
- How can the results, the method, the material and the viewpoints be criticized? (p. 78)

The list holds up well in the case of artistic research, too, if we add "acts internal to the practice" to the list of possible materials. Often the methodologically crucial point is the last one: one has to anticipate criticisms and show the weak spots in one's own research. This is what it means to systematically provide access for criticism.

To return to the rabbit with the gun: research methodology, its openness and criticality, is supposed to cut both ways. From the perspective of the researcher, a research method is a way of obtaining results. It is something pragmatic, utilitarian, even in some sense a guarantee of a kind: "I did not do it; it was what my methods produced!" In this sense, the method is a trusted friend. But from the point of view of the scientific community, the method is there in order to make the research as accessible and vulnerable as possible. Utilizing a method makes the problems, limitations and mistakes in a piece of research transparent, visible: it makes it possible to criticize the research in a public and intersubjective arena. From this perspective comes the simple rule of thumb to use when worrying about whether some detail or quirk in the process of the research should be mentioned in the report: if the detail, quirk or decision makes it easier for the reader to criticize the research, then yes, you should include it!

The double-edged quality of research methodology goes even further. In principle and ideally, the methodological part of research also exists in order to make the research community accountable when it evaluates and discusses a piece of research. Research evaluation should be public and based on public criteria, especially in the case of the evaluation of master's or doctoral theses. The clearer the methodological guidelines, the easier it is also to see whether the evaluators have done their job properly. Of course, in the real world, the balance of power is heavily tilted in favour of the professors and other experts doing evaluations, but the principle is still important. If an art gallery does not want to display the works of a particular artist, there are no clear criteria of appeal. In the case of academic research, the criteria exist, at least in principle, and the clearer the methodological path in the particular piece of research, the easier it is also to hold rogue evaluators in check.

To be sure, writing in this way is a skill in itself. It needs practice. If, for instance, visual artists are sometimes despairing over the necessity of writing,

and writing well, maybe it would be good to think about turning the tables. How well would art historians or philosophers, who have been dealing with texts all their lives, be expected to visualize their findings in, say, a documentary movie? Moving from one medium of expression to another is not easy. The difficulties are genuine, the practice needed considerable.

There are models and examples that one can emulate—more of this later—but unfortunately their relevance is strictly limited. For the fusion among doing, thinking about doing and making, the thinking public has a further consequence: there is no general model for verbalizing, reporting or writing this kind of research. It has to be done on a case-by-case basis, because the committed practice of the practitioner is unique, and the research question, the way of approaching it and the writing have to be influenced by the practice. The way of writing has to be devised anew every time, at least partially. Again, this is a genuine challenge and something to be aware of. It makes artistic research one notch harder. At the same time, a similar challenge awaits any artist producing art, or any humanist going about doing research, and to an extent many social scientists, and so on.

Likewise, it is good to be aware of the limits to verbalization. Different areas of experience, different sensory modalities have different qualities, and different media have different affordances for expression. When, for instance, something visual is transposed into written language, we get a reinterpretation, a description, an enactment, but not the thing itself, if for no other reason then because by writing down or reading we are already changing our experience, moving into a new situation. This never-ceasing experiential flux, the fact that, as Heraclitus put it, you cannot step into the same river twice, already means that the verbal, the written, the text is going to be a thing of its own. Even if it has to be fused with the practice and the research on the practice, it will be a thing of some independence, giving its own experiential truth that may be partly incommensurate with other situated truths. And that is what the democracy of experiences is about: the experiential truths are multiple, and any attempt at bringing them under one rule or one sign is going to produce even further versions of them. The only way of stopping this process of multiplication is violence—symbolic, institutional, physical, as the case may be. As the anthropologist David Graeber (2011) put it, violence is the only way of having an effect on other people without having to interpret what they are about, without having any communication or "imaginative identification" going on. In this sense research—trying with all the means available to make relevant interpretations, to continue the never-stopping hermeneutic circle, trying to understand what we ourselves mean and what

others mean without the presupposition of ever getting it right—is the opposite of violence.

Verbalization

Our general observation is that in the academic community of artistic researchers (i.e., those who teach and study art in the universities), there is still sometimes a relatively strong tendency to think that doing art is the same as researching an object of study. In practice, this means that one's art equals research, that is, the work of art or the process would somehow articulate itself: "I paint thus I research"; "I compose thus I research"; or, "My art speaks for itself." Well, as mentioned in the preface, we suggest you should narrate the process, too. Of course, we are not suggesting that artistic process and artistic artefacts could or should be reduced into words and concepts but only that words and concepts are necessary and needed in academic research, whether artistic or anything else.

No doubt making art can be serious research work in itself (in the conceptual sense, as mentioned in the previous section), but academic research, for a large part, refers to argumentation written with different styles and formats. Artistic research consists of a combination of art-making and word-making—both sides are needed. As we argue throughout the book, if there is a sense in which artistic research aims to be accessible, then we need to take conventional communication (written words) into serious consideration, no matter the form and content of art.

The fine line, a demarcation between the two—art making and artistic research—is as follows: in the former one can concentrate, indeed dwell fully on one's creative process. Art is sometimes believed to speak for itself (if it speaks at all). But in artistic research, one needs to tell (sometimes convince) others by writing about one's creations, ideas, processes, and sometimes even to refer to theories that have given insights (or not) to one's art-making, in order to explicate the artistic process and add to its academic and artistic value.

Explaining and explicating by writing is the first distinctive characteristic of artistic research compared to art-making; the second being the fact that artistic research is an academic activity that contributes to academic understanding of the subject and is, in turn, rewarded (in a successful case) by an academic degree.

Let us take an example related by professor Teemu Mäki in an open seminar about artistic research (Helsinki, May 2013). According to Mäki, John Coltrane and certain other famous jazz musicians couldn't, and perhaps didn't

want to talk about their music. They just wanted to play and by playing they learned. Thus there was no verbalization whatsoever. Were they doing artistic research? No, they were not, but in our view, they were playing terrific jazz music.

Thus, on one hand, there is art as technique, craft, movement, performance, ideology, aesthetics and so on, and on the other hand, artistic research as theoretical academic performance (given to academia as theses leading to degrees and diplomas). In the machinery of the university, artistic research is a part of the logic of science policies as well as the academic habits and traditions of any given moment.

However, we should not be too harsh in drawing distinctions between verbalization, or, more precisely, the use of conventional symbols of communication (speaking or written words) and other symbols and ways of communication, that is, being in and being with the world. Otherwise, we might fall into mythologizing their apparent differences. Differences there are, of course, but let us not overemphasize them. Instead, let us be open-minded and allow ourselves to think that words as well as spots on canvas, steps in the sand, silences on the backstage, or composing, playing or performing are also symbolic ways of world making, that is, ways of seeing and doing the world, sometimes even changing it.

More specifically, verbalization has the following tasks in artistic research, as Cazeaux (2008, summing up points in our previous book, Hannula, Suoranta, & Vadén, 2005, pp. 114–117) has pointed out:

- Clarify "what is being researched, why it is being researched, why it is of interest and what is the aim behind it."
- Specify "with whom the research converses, what traditions it can be considered to be linked with, and what relations it has to these different traditions."
- Justify "one's own focus and viewpoint in relation to what has been said and claimed previously."
- Adhere to "known literary styles and methods of presentation" primarily in order to avoid "narcissism and end[ing] up in an uninteresting vacuum."
- Form (at best) a fresh and substantiated conclusion.
- Cultivate the nascent field of artistic research by reflecting upon how the research extends the subject and suggesting how any future project by an artistic researcher might be informed by his or her work.

That is about all we want to say about the formalities of writing in artistic research, for, if anything, writing ought to be a creative part of an artistic research process.

The question follows: how do we write creatively? Or, is creativity a much too much celebrated virtue in research altogether? Should writing be as pragmatic and mechanistic as in certain parts of natural science in which scientists often write articles following a strict and universally recognized IMRD-pattern: first introduction (I), then methods (M), and results (R), and finally, discussion (D)? Perhaps taking writing in this almost mechanistic way could create a needed "alienation effect"–or a contrapunct–in relation to the artistic part of the research process. It could absolve the author from trying to be as good a writer as a painter, designer, composer or performer. Writing understood as a tool for communication and an academic medium can, and sometimes ought to be, enough.

That is only one option. The other is to understand writing more metaphorically and write like an essayist. The Finnish author Väinö Kirstinä (2005) said that the essay as a literary style provides "opportunities which science cannot perhaps reach. I am allowed to be subjective. I may use my own life experience. I have the right to be tricky and free. It is one of the great joys of artistic work" (p. 35). Most likely the same holds true in arts and humanities, in general, as well as in the work of an artistic researcher. What, then, are the (artistic) means to be tricky and free?

Sociologist Zygmunt Bauman, a master of the sociological essay and a refugee from Poland to the United Kingdom, once confessed that it took him a good 15 years to start to publish in English. Perhaps it has been this experience of writing in a foreign language in exile that has urged him to suggest the metaphor of thinking in travel (referring to Derrida): a writer needs to be at home in many places, owning many languages, but still always living, observing and writing as if an outsider, if not as a person *sans papiers*.

Writing in artistic research is also, and at best, a voyage into oneself and one's social surroundings from the point of view of one's art work. Without knowing oneself and the social milieu of one's artistic practices, it may happen that an artistic researcher has little to say about anything. Writing in and as travel consists of, as the Finnish poet Risto Ahti (2009) put it, a certain intellectual moment, a state of chaos, "in which words are allowed to be alive and from which anyone can discover his own language" (p. 73). However free the process of discovery and however loose the style of writing, it should be kept in mind that "the universe in which each of us lives is and cannot but be 'linguistic'–made of words," as Bauman (2000, p. 83), among many others, reminded us:

Words light the islands of visible forms in the dark sea of the invisible and mark the scattered spots of relevance in the formless mass of the insignificant. It is words that slice the world into the classes of nameable objects and bring out their kinship or enmity, closeness or distance, affinity or mutual estrangement—and as long as they stay alone in the field they raise all such artefacts to the rank of reality—the only reality there is.

An artist would rightly complain. What about my own language in my painting, in my dance, in my stage performance, in my music? Here again, we meet the problem of words and languages of arts. Perhaps it is sometimes useful to put the fundamental question aside and take a more pragmatic attitude by searching for a viable way to write about one's research or saying the same thing in a more postmodern way: to do one's research by writing.

"Should I choose a narrative form to tell the meaningful others about my research trip?" That is one fruitful option worth considering. The Nobel laureate in literature, J. M. Coetzee (2008), confessed in his semi-autobiographic essay book, *Diary of a Bad Day*, that narrative is not his style any more—he is too old to be a narrator or even to read or listen to narratives. He cannot wait for a story to evolve in his mind anymore, for a story cannot be told; it tells itself. He referred to Leo Tolstoy as a case in point. After his magnum opus *War and Peace*, Tolstoy's development took a steady decline, according to common views of the time. However, Coetzee knows his self-evaluation was different. Tolstoy probably didn't feel that he was going downhill as a writer at all, but quite the contrary; he had an experience of approaching the fundamental question: how to live?

The same holds true for other grand thinkers, too, as can be read from the testimony of Jacques Derrida (1930–2004), from what is called "The Last Interview" (2004):

It is true, I am at war with myself, and you have no idea to what extent, more than you can guess, and I say things that contradict each other, that are, let's say, in real tension with each other, that compose me, that make me live, and that will make me die. This war, I see it sometimes as a terrifying and painful war, but at the same time I know that it is life. I will not find peace except in eternal rest. Therefore I cannot say that I assume this contradiction, but I know too that it is what allows me to live, and to pose the question, effectively, that you posed, "how to learn how to live?"

Indeed, to be at war with oneself, or to write things that are in contradiction with each other, is a humanist stance par excellence. It is presumably a much needed (and hopefully cherished) virtue of those who must write to live and ask the aforementioned fundamental question.

Writing can be, and often is, a fight, a struggle with the world and the words, or with oneself, as in the case of Derrida: "I am at war with myself."

Self-doubt is also a necessary ingredient in a solid writing process, as well as in an art process; so don't be afraid when there is nothing but a blank page on your laptop screen. It happens to all of us, even the big ones. Let us quote C. Wright Mills (2000c) again, who, at this time, is struggling with his book *White Collar*:

> I can't write it right. I can't get what I want to say about America in it. What I want to say is what you say to an intimate friend when you are discouraged about how it all is. All of it at once: to create a little spotlighted focus where the alienation, and apathy and dry rot and immensity and razzle dazzle and bullshit and wonderfulness and how lonesome it is, really, how terribly lonesome and rich and vulgar and god I don't know. Maybe that mood, which I take now to be reality for me, is merely confusion which of course might be so and still worthwhile if one could only articulate it properly. (p. 136)

And do not forget the Slovenian gadfly Slavoj Žižek, who tries to avoid the writing process altogether by first making piles of notes until there are enough of them for him to skip writing and start the editing process. Of course, he is at least partly joking, but the point is that writing processes differ, and they ought to differ. At the same time, there is at least one common feature in all writing, namely, the different routines. Thus there is a lesson to be learnt: find and create your own. Here is one example:

> The typical days—and they will continue without variation—run like this: up at 7. Write an hour. Eat breakfast 8:15. Stay in room and write 'til 1 P.M. at which time lunch. Loaf an hour after that in sun Work during afternoon but not pushing, primarily reading and revising manuscript if have done well in the morning; otherwise push. Knock off about 5:30 and fool with guitar or nap until 7. Dinner at 7:15. Then play pool and ping pong for around 2 hours. Sleep at 10 o'clock. (Mills 2000c, p. 104)

The same sort of routine is followed by many, as Pentti Saarikoski, the self-proclaimed "poet of Finland" wrote: "Breakfast—two hours of writing—two hours of work outdoors—lunch—two hours of writing—coffee—an hour of work outdoor—two hours of writing—dinner—dishes—an evening" (Berner, 2000, p. 40).

But, let us be frank and realistic here. These descriptions are gross simplifications of a writer's life. They can be true in some days at some times, but they do not nearly present the reality of most of us, who work with texts and other artefacts. Who makes the breakfast and lunch? Who pays the bills and goes for the groceries? Where are the kids? Who fetches them from the day care—providing that there is day care service available? Take the three of us as an example. We have written this text in widely variable circumstances. In total, we have seven kids, and two of us have daytime jobs in different cities than our homes, even in a different country. We have other obligations and

duties in life than writing. Nowadays we take it for granted that the moments without anything else to do but write are rare, but therefore they are also sweet.

Perhaps the metalesson to be learnt is as follows: too few artistic researchers identify themselves as writers, and too many see writing as an unproblematic mirror of their outer or inner reality, although the aim would be to write academic prose that would communicate both to the academic audience and the larger public. To write about one's artistic endeavour is to know and to be conscious of what one is doing and let others know it, too. This way the writing process, like the artistic research process as a whole, can evoke a *gaya scienzia*, or as Henk Slager (2012) put it, the pleasure of research "concentrated on artistic probing, establishing connections, associating, creating rhizomatic mutations, producing assemblages, and bringing together; including that which cannot be joined" (p. 77).

PART II

NARRATIVE, POWER

AND THE PUBLIC

4. Face-to-Face, One-to-One: Production of Knowledge in and through Narrative Interviews

Question: Should each and every researcher do interviews in their specific field?

Answer: If we would rule the world, yes. Always. Not only do them, but do many kinds and varieties of them. Hitting them high and low, stating them wide and narrow. If we ruled the world, everyone everywhere would be doing more and better, more nuanced and deep-seated narrative interviews. Nobody would be able to escape both doing and giving committed and contextually informed and embedded interviews about the content of the current state of their practice.

Fortunately, this question and answer portrays a hypothetical confrontation. Luckily enough, neither we, individually or collectively, nor any others working with issues of methods, rule the world, or the field, or the faculty. Methods are tools, tools for thinking with and tools for structuring that act of thinking with. They are not monopolies, and they should not be restricted, but instead, they should carry the weight of the open-source mentality and attitude loud and proud. Methods are like our daily experiences: plural and contradictory.

That said, the argument of this chapter is nothing more and nothing less than this: there is something inherent in the potentiality of committed and situated practice-based narrative interviews that is worth taking seriously and also worth being tried out in any type of research that always returns to the specific issues of how and what kind of knowledge is produced in and through practices.

What follows is an argument in three parts:

1. Background
2. Reasons for narrative interviews
3. A practical case

Background

The task of this chapter is to address both the methodological and practical issues of conducting narrative interviews. It starts off with the background of the method, articulating the opportunities and challenges in the narrative method, with a short history of the genre of qualitative research.

There is no necessity or place here for full coverage of the genealogy of qualitative research. We do nevertheless need to be reminded of its rather short history. The cue here, as already mentioned in the introduction to the whole book, can be taken from the writings of the German philosopher Wilhelm Dilthey (1833–1911), and especially with a publication of his dating to that special year, 1900: *Entsthehung der Hermeneutik* (Dilthey, 2006), and the follow-up, a condensation of his views on the development of social sciences in the summary called *Der Aufbau der geschichtlichen Welt in den Geisteswissenschaften* (Dilthey, 2012), dating from the year 1910.

It is here—at this disjuncture—that Dilthey develops the differences between quantitative and qualitative research. Whereas the former is closely linked to and embedded in what are called the natural sciences, the latter is clearly inseparable from the history of what are known as the human or social sciences. It is from Dilthey that we have the differentiation of their respective aims: the one seeks to explain an issue, while the other aims at understanding it.

Regardless of the long backtrack of juxtaposition between these two approaches, they are not incompatible, and they do not exclude each other. However, what is at stake is both recognizing and then respecting each approach's internal logic, which is not the same but very much determined by each strategy's own presuppositions and aims. As is well known, the relationship between these two approaches has been strongly lopsided, with the quantitative method often enough being seen as a superior means of acquiring knowledge, because it is believed to be objective, neutral and universal. The point here is this: democracy of experiences. If and when both strategies are respected and given the treatment they deserve, we need to acknowledge that what makes sense within and for the one does not necessarily and automatically make sense, or is it possible, for the other one.

Therefore, there are and must always be different and distinguished strategies for different particular aims, views and visions—not to forget purposes. But please, no monopolies, and no crying out loud after them, either.

Face-to-Face, One-to-One: Narrative Interviews

It is hardly a secret that quantitative methods are also used when doing interviews. This is the model called a survey. At its core, it sets out to choose a sample from the general public or a very specific public. The strategy is not to go out and try to interview every member of the chosen public, let's say, all citizens of a city, but to choose, in accordance with clearly stated rules and criteria, a selection of, let's say, 1,000 to 1,500 people out of 1 million, who then serve as representatives for the whole. Characteristically, there is a preset list of questions that are answered and no follow-up questions asked. The result is an approximation, a survey of an aggregate that then stands for the whole, even if it is based on a very clear minority of the whole number.

The reasons for offering the most condensed description of a quantitative type of interview method is to highlight the difference with the presuppositions of a narrative interview. It is not only to make the difference between quantitative and qualitative clear and vivid but also to open up the issue of how what narrative interviews are is not in itself one solid and single thing—an issue to which we later return.

But to stay with a general view and vision of a narrative interview, its perspective is not to address or to try to address the whole. Instead of moving horizontally within the topic and theme, it tries to find ways into moving vertically, digging deeper into nuances. It does not ask what something is but how that something is, there and then (i.e., bound in space and time), in and through an individual perspective as it is perceived and conceived. It is after this: how the content of a concept, image, symbol or act is defined in a very particular and specific case and why.

This is then knowledge that is articulated in interviews done personally and face-to-face. They are focusing on the detail, not on the whole. Neither is the detail used as representative for the whole; rather, the detail is used as a means to interpret the whole, not to represent it. Thus even with narrative interviews there is potentially both the wish and the need for a synthesis, for a summary and for an interpretation of what these individual stories and voices say and mean—not generally, but in contact and connection to their own context.

One of the fields closest to the narrative interview is oral history, the long tradition of collecting materials from a wide variety of spheres of human interaction. This is a tradition that characteristically is a meeting point for professionals and committed amateurs, people working as scientists, journalists, street workers or enthusiastic laymen. Oral history goes back to the sources of anthropology and ethnology but also has a strong presence in recollecting lived experiences so that these experiences are not forgotten. This part of oral history can be linked with highly dramatic events such as the

Holocaust, and in this connection, for example, the archives sponsored by Steven Spielberg, collecting the survivor's stories of the Holocaust, provide a high-profile case.

The narrative interviews can also be aimed at very mundane but important parts of our lives, collecting stories of how we deal with loss, with hope, and for example, with work, not striving at any overall synthesis but really focusing on the acts of telling stories and sharing these stories. (There will be more about this method and its internal logic later.) One of the best known personalities of this type of journalistic, but clearly socially and historically embedded activist, was the Chicago-based Studs Terkel (see, e.g., Terkel, 2003), with his radio shows, books and conversations, ranging from issues of war to music and back again. What is remarkable with this example is its written qualities, and through them, its availability and access, and also the timeline of the acts of curiosity performed by Terkel (1912–2008), ranging over more than half a century.

As a research practice and a specified field of its own, as an umbrella term this is called narrative inquiry studies. As argued by Mills (2000b, p. 143), they start from the notion of staying with three major forces or problems, and obviously enough, their interrelated interconnections, mental and physical credits and debits. These forces are biography, history and social structures— and how they affect and intersect each other. Narrative inquiry as a strategy is a subtype of a larger field of qualitative methods, as briefly outlined earlier (see, e.g., Chase, 2005). Here, the concept of narrative is understood as a means of shaping or ordering past experiences. It is the act of telling stories, getting into particular ones, and not answering generalized questions. Chase (2005, p. 655) offered a structural clarification of the five overall features of oral narratives. These features are worthwhile listing, one by one, and as a group, to keep in mind and take with us into the cases, into the particularities of contexts and stories:

1. Orientation
2. Complication
3. Evaluation
4. Resolution
5. Coda—returning the listener to the present moment

All in all, narrative interview as a narrative inquiry is focusing on everyday experience. These are life stories—constructed out of certain wants, values, fears and needs. It is never experience (see Jay, 2006) as given, or neutral, or as the final answer, but experience as the base of constant play of leaving and

returning, getting closer and gaining distance, but always staying with it—
staying with the productive dilemma and its time and place-bound
articulations and actualizations.

Reasons for Narrative Interviews

After the recollection and reminder of the philosophical and historical
background, it is now the time to continue addressing both the necessary
presuppositions and the requirements for situated and committed narrative
interviews. This does not provide a "to-do list" of narrative interviews, but it
maps the terrain of the method as an embedded strategy of producing practice-
based knowledge.

Why? What kind of a narrative is in question? Open-ended or closed?
Linear or fragmented? Collective, one time, or a continuous encounter?
Transcribed, and by whom? Done with a voice recorder, or also with a video—
and shared and interpreted by only the ones doing the interview, or also by
others? Copyright the material or handle it as an open source disposition?
Focus on what is said and/or how it is said, and with what nuances in both
words and gestures? These are choices and alternatives that are seemingly
endless in their variations.

However, what every interview site and situation has in common is
something that makes the interview moment special—both as a potential
meeting, and more important for our context, as a unique type of production
of knowledge. It is a type of production of knowledge that also has its specific
presuppositions that we now will underline.

The starting point is the realization that we do live and love, hate and care
in a reality that is plural. It is not one but many. As its situated versions are
articulated, in connection to its past, present and future, they are taking place,
giving content to their chosen concept, symbol, act or image in and through
the social imagination of a particular structural space. It is then structural
imagination as a umbrella of a concept for taking part in the making and
sharing of the stories told and shared, taken to be important and worthwhile,
editing in and closing out in a given site.

Here, the emphasis lies on two aspects: social imagination is about stories
told and shared, also denied, but it is also about those of us who can and will
tell the stories and listen to them. It is about this and nothing else: telling
stories. But as we very well know: not every story is in itself interesting, and
not every interesting story always gets the attention that it deserves.

As a condition of a given condition of production of knowledge, a meeting of two parties in a discussion, as in an interview together, it is a coming together that is characterized through its temporality. It is a moment, not a monument. Most often but not necessarily, it takes place once in any given case, even if there are continuous meetings of interviews during many years. (Here, a magnificent case is the collection of interviews done by David Sylvester (1988) with the painter Francis Bacon, conducted more or less once about every 10 years during four decades, starting from the end of the 1950s and going on until the end of the 1980s.) As a moment, it is a meeting that is on the move. You come, you stay and you move away. Obviously, you come into the situation, from both sides, with a lot of presuppositions and also prejudices. Both sides want something, and they are there to get it. Thus, it is not a neutral or an innocent encounter.

But it is an encounter that has its unique chances and challenges. As a mode of production of knowledge, it works or falls and is disqualified based on its ability to activate and to achieve a focused intensification during that mostly one-time moment of meeting and discussing. As a production of knowledge, due to its structure as face-to-face, one-time anticipation, it is direct and it is raw. There are less elegant moments, less finalized views than, for example, when writing whatever it is one wants to say.

But hold on. Are interviews rawer, more direct instances where we can break the wall of routine to get a chance to experiment and to say something unexpected, something different, something that is not so easily produced through writing or lectures or whatever other modes of production of knowledge?

Let us take up and focus briefly on interviews that we have access to, with which we are confronted in the media daily. Interviews with politicians tend to be a drag. Something is definitely exchanged, but that something is not opening up that much. Rather, the discourse is used for everything but to be raw and to experiment. It is not there necessarily to cover up or manipulate, but at least, in the logic of lowest common denominator, to repeat the prepaid message over and over.

What about interviews with entertainers, musicians and athletes? These are often closer to parody of a give-and-take exchange than anything else. In any event, where the camera is on, interviews are always needed, but, on purpose and transparently so, they seem to be saying next to nothing. One cannot help but have the feeling that each person interviewed is completely interchangeable with the next one in line. Nothing alters from one to the next, especially in contemporary times, when this section of society has become more and more commodified and the main corporate culture has its

very clear yet often unspoken rules of what is to be said and how and what is absolutely not to be said if one still wants to be kept in the team and retain the sponsors.

This almost total predictability is not only because of the conditions of conditions of these exchanges. These conditions can be very short in time— one or two sound bites straight after winning or losing, or transparently functional in their aim of presenting a new cultural product, as in this or that record or movie that is now out, and you are motivated to go out and get it. It is not to be choreographed as the difference between something as a fake or something as real. The distinction goes back to the internal logic of each type of an interview. Where the through-and-through predetermined interview as a collection of clichés and banal descriptions of the events only wants to serve as a sidekick for a product, the deep-seated one-to-one interview that goes into the issues of what are you saying when you are saying this does something else. It is like, well, not to put too fine a point to it, the difference between fully synthetic clothing and clothing made of wool. Both can be functional and aesthetic, and serve a purpose very well, but mixing them (unless you do so deliberately) is not a good idea.

The comparison between interviews as through-and-through predeter- mined role-plays and interviews as potential sites and situations of producing raw and experimental knowledge is central here. It is never what is done but how and why it is done. This is the distinction that brings us back to the issue of what is a practice—and how to create and generate encounters with and within the participants of a given practice. Practice is the key word because it shapes a site and situation that is potentially much nearer a peer-to-peer encounter. It is a meeting where—due to a previously manifested interest and commitment to the same practice and its issues and inherent logic, whether this practice is the act of taking documentary photographs or playing ice hockey—both participants share their views and visions in order to better understand what they themselves are doing and why they are doing it. This is the act of creating a context and a moment of a collective sense of being part of the same practice and professional framework.

Therefore, the main requirement of narrative interviews is this shared interest in the same or similar topic. This is not to say that every time both sides—the interviewer and the one being interviewed—are professionals in the same field. However, it is to say—and to underline—that it is necessary that both sides share a common ground of professional knowledge and back- ground. There is some common issue that both sides are interested in taking further, opening up and arguing and also disagreeing about.

If and when the conditions for a practice-focused interview are at present, then we are indeed talking about a condition of condition, which is no longer an interview of predetermined role-play and practically cemented roles of who talks and who listens. In a narrative practice-focused interview, each side talks—and talks back again and again, insisting and enjoying it—the process of back and forth movement. As an act, it is not an act about just listening, and it is not a conversation that talks about something. It is a meeting of both being with and talking with—seriously being willing and able to get into the argument, get into the groove of a give-and-take exchange of nonsecured views and positions.

Now, interestingly enough, we are getting closer to the nuances of a demanding and potentially productive interview as a point of meeting. These are then nuances of the strategy and the game played between the parties that all of a sudden make that moment of meeting very charged and also very volatile, not to say adventurous. To appropriate that lovely soul song: it is loaded with dynamite. It is not only that we are asked to talk with, to confront both, one's own preset views and to open up for the views of the other, but also to let these changes in our positions and views take place. We are asked to reconsider and to think again—changing the balance and choosing a different perspective.

As an act of meeting, a meeting where A and B set out to discuss a topic in which they both share a documented and implicit interest and passion, and a site and situation where A effects B and B effects A, the metaphor for conceptualizing and visualizing this encounter is this: not running after but moving toward.

To repeat: the narrative interview method is to move toward, seeking a contact, a connection and a contradiction.

This is to emphasize that there is no preset truth or solid knowledge that you can hunt down or discover. You are not supposed to run after something, whatever that is, but you are asked, as is the other person in this game of give-and-take—you are asked to move toward, leaving your previous position and pose slightly but surely, and to get out of what you know and what is already established and therefore safe for you. Both sides are asked to step out of the already known and to go out and move toward each other.

Clearly, this demand is only possible to realize if and when both sides do the same: move toward. Without a doubt, this moving is and must be very slow, tentative and testing. It cannot go for the instant pleasure or the great leap, but it must move rather carefully and suspiciously—not one step at a time but a one-seventh of a step. First there is a kind of semipretending to take that step, and then a pulling back, but then again, actually making that short step

and waiting for the reaction, being ready for the next action. In another vernacular, to borrow not from a song but from the act of a certain Jari Kurri, this is called "to deke and to dangle." It is a notion that reminds us of this: enjoy the challenge of doing and repeating the act of a practice, and don't be too worried about its outcome.

This vernacular lands us with the next requirement that both pulls us down as yet another demand but is also an important productive possibility. This is to pay attention to the ways in which each party in the encounter is talking and articulating his or her views and positions. This is the idea that in a proper meeting or discussion, both sides would have a chance and would also be able to articulate their views and positions with the vernacular language that feels closest to them and that they are comfortable with. This is not the same as claiming that the language used should be neutral and without hierarchies, but it is to set the aim of creating an encounter where both sides are allowed the time and cherished attitude to talk the way they would want to talk—and not to pretend to use this or that speech pattern that he or she is not familiar and comfortable with.

This is then pointing toward the main core of a narrative interview. In this shared topic of a meeting, there is then a chance to dig deeper. The concept and words used are often the same, but the task of the encounter is to get into the nuances of what is meant by a given concept, why and how—and how do the often quite similar comprehensions of the same concept differ and why. Thus, it is not what is said, but how, and with what intonations of both content and performative it is delivered.

The demands of vernacular, and of digging deeper and going slow and moving around carefully, are in themselves close to the classical principles of hermeneutics. These are then principles that cannot be followed as strict guidelines but as principles, words and advice, that shape and make the preconditions of a meeting and also strongly colour the potential results from interviews. As principles, they are stated in the following way:

1. To allow and to encourage the other to articulate and to present his or her views and visions in his or her vocabulary, manner and vernacular.
 In short: the first task is to listen and to try to open up toward a different perspective.
2. To relate and reflect what this different view says to you about the same or similar topic and issue

In short: There should be a critical interpretation of what is said, how the context is constructed and orchestrated, and how it relates to one's own views and visions.

As an encounter, this is neither just a friendly meeting and exchange of pleasantries with each other, nor is it an antagonistic clash of dichotomies. It is, well, something in between, never exactly in the middle but constantly shifting its balance from more of a give and less of a take to more of a take and less of a give, and so on. To use another popular pastime, we could call it a kind of tennis match. In a serious encounter, we share a game plan and a physical spot for it, but the actual articulated position of the net is constantly faked, moved and manipulated. It is a meeting that leaves a trace and goes under the skin—and collides with the previously held views and visions.

Therefore, it is a meeting that characteristically is something that is supposed to change you, not dramatically, but piece by piece, bit by bit, reshuffling and reassuring. It is not only taking place over the distance of a net, but it is happening in closer contact—like the act of sparring. It is an act that is committed but not commodified. In the act of sparring, we are asked and we need to try out new things; we need to experiment and we are allowed to fail and to fail so that it does not hurt too much. It is an act that allows us to become better, more focused and able to enjoy the acts of doing the practice—and not to get crushed by the encounter.

As a result, these are focused meetings discussing the details of a practice, discussions that always take place one at a time, but very importantly then need the continuous commitment of evolving into a series of encounters, where the previous encounter informs the upcoming one and so on. During these consequent encounters discussing the practice, the participants are—not always even consciously—discussing what is the quality of that practice: what makes that act of taking a photograph better or worse and why. It gets into the real biting and caressing, burning and healing issues of what is the inherent value and the internal logic of a given practice. It also asks for current articulations of what that act of doing that practice can be and even should be, not as a single truth but as a participant in the creative act of treatment of reality, an act that is only creative, only a treatment of reality if and when it is located in the structures of where it is trying to become a place—into the gravity that pulls in and around, in and through the past, present and future: in short, what is called consciousness of the effects of history (Gadamer, 2006). It is a sense of being with and a sense of belonging that is articulated here and now.

A Practical Case

The third part of this chapter presents a case study of a narrative interview. This text, a narrative interview conducted with the psychoanalyst Per Magnus Johansson, is, in fact, also part of the book at hand (see Chapter 8)—allowing a direct comparison between the method and the results.

The discussion with Per Magnus Johansson is a typical case of a narrative interview. It is focused, very intense, highlighting the raw characteristics of a one-time, one-meeting strategy of a narrative interview that does not aim at covering it "all" but focuses on a very particular and clearly defined domain of research.

In this particular case, the method used is a version of the narrative interview that the interviewer, this time Mika Hannula, has been first studying, then doing, and later teaching since the mid-1990s. It is a very barren and reduced version of a method. Regardless of the specific topic, whether it is about self-understanding or about the content of a given practice, it basically has one main question: what do you do when you do what you do?

The main point is not this cover-it-all question but to stay with it and to follow up the answers. It is to ask, what do you actually mean by this, and why, and what for, when and how, and so forth. It is about nuances; it is about details; it is about a localized version of the content of a concept, symbol, image or act. It is about personal versions of how in a given practice, in certain circumstances, this person describes and defines both what he or she is and does. Thus, if the answer is, I paint, then the next question is, what do you paint and how? And then it goes on and on, asking what version of, let's say, expressionism, connected to what scene, and what other artists, and how has this practice developed, and so forth.

This kind of give-and-take conversation, making things work while moving along, shaping a route and digging into its own roots, is built upon a shared common ground that goes back to the experiences of working within the same or similar enough field. Thus, it takes for granted a certain good will of committing oneself to the challenge of an encounter. This commitment insists on the attitude and willingness to both ask again and to ask again in a manner that is not only affirmative and pleasant. This is the moment of distraction, the moment of friction, which is labelled as the moment of the contrapuntal. It not only aims at the moment of highlighting the dissonance between two positions and views, but it tries to convince both sides that this dissonance is worthwhile, and well, indeed, without it, there is no moment of intermediated pressure and challenge to think again and to think differently and to think ahead.

Obviously enough, these are included in the methodological presuppositions of a narrative interview. In addition to them, there is the practical part of actually facing the person and doing the thing. The technique used in this case is the one that the interviewer has used all along. It is a one-off meeting, for that one and only time. The conversation is taped, with a cassette recorder, specifically a C-cassette that runs for 90 minutes, having two 45 minute sides— like that certain casual get-together leisure time activity called football. In interviews of this sort, there is also extra time. This is played (conducted) before and after: saying hello, explaining again the whole setup, briefly and effectively, and then shaking hands before you leave and as you are just about to depart.

As a preliminary, in these cases, a lot of effort is used to convince the person being interviewed that he or she does not need to prepare for the interview and that he or she cannot prepare in any particular way. This type of narrative interview is asking the big question in order to get into the smaller side details and nuances. Somehow the advice that you cannot prepare for it does not always calm the interviewed person down. This is the site and situation between anticipating and the act of experiencing, which always causes—and is there to cause—a certain anxiety.

After the conversation, the tape is processed. It is transcribed. In this case, the interviewer, Mika, transcribed the tape himself. There are versions of the method that say that this transcription has to be done by the same person or persons conducting the interview, due to ethical reasons involving the actuality of the event. However, in this particular case, the reason for transcribing the interview personally was very practical. The act of transcribing can be very labour intensive, but it is also as effective. If and when you do it yourself, you go through the material in a very substantial and focused way, already editing the material in your head and already processing it in a very hands-on and direct way. Thus, it saves time, and it in fact also generates a certain momentum for the act of evaluation of the narratives.

However, before evaluation, there is the moment of the first results of the transcription. With up to 20 years' experience with this particular technique, the first outcome is between 15 and 25 manuscript pages, size A4, which are then sent to the interviewed person. In this case, the interviewee was allowed to make corrections and add things. During the last two decades, in this continuity, only 1 person out of over 70 has begun to completely alter the content of the conversation. As an anecdote, that person's practice was and is this: a politician.

Why? It goes back to this. It is a face-to-face moment. It is a meeting of give-and-take. There is the shared topic of interest, and there is the shared

commitment. Often enough, people say things that are much rawer, and they say much more than they would say in a written format. But they stick to it. They stick to the content and the flow of the interview because it is the character of an interview. They also let it be because if and when they would start to rewrite it all, they would go against what they in fact have just said, and then they would have to use a lot of time and energy to rewrite what the conversation should have been in their terms—and never ever get the tone and flow of an interview. Thus, if there is any significant fixing afterward, the results are no longer actual conversations; they have become something else. Not surprisingly, there is often a lot of detailed editing and focusing on the nuances of the content done in the afterwork; the purpose of this is not to try and change the character of an interview but to tune it to the max.

But what about this: what happens after the conversation is done, is transcribed, commented, edited and checked and is now ready as an effort, as a product of knowledge production? Evaluating of narrative interviews is obviously enough an act that depends on the whole frame of the project: what does it want, about what and how? Here the task is not to offer a survey of all the possible strategies open but to highlight two different routes that can be effective takes from the same root of a collected material. These two variations can be characterized as (a) telling stories and (b) constructing a synthesis.

Those who have now already taken a look at the outcome of this case, the conversation with Per Magnus Johansson in this book, are familiar with the strategy of telling stories. It is not the authentic story of that moment of the conversation. The text published here is the result of working through and editing the material that was produced in the exchange, but it is not the text itself. Telling stories is a strategy that is highly aware of the rules and anticipations of the written format of communication. It is the act of translating and transforming a verbal confrontation into a written encounter. It is an act of editing that tries to stay close and tries to stay true to the given specific tone and colour of the interaction between the persons.

Telling stories does not unravel; it does not supply proof that this is how it is, but it does tell a story. It does not analyse what is said; it believes that if and when it does contextualize itself into the fields that it is connected to, this needs to have taken place already within the act of conversation. Telling stories can be constructed as only a one-off conversation, or it can easily be a collection of conversations gathered together from the same field. Whether there is one or many of them, interviews only do what they want to do: they tell stories of how people work as professionals, in what social and political context, and how they define themselves in and through their professional practice.

The strategy of constructing a synthesis is not the opposite of telling stories, but it is a strategy that has a completely different aim and scope. The synthesis does exactly what it says it does: it aims at drawing conclusions and generalizations from the individual and in itself loose material. It aims at saying something based on the small sample of material that would have relevance for many, not all, professionals in the same field. It would not aim at getting an aggregate of the whole, but it does want to say something more than just collecting stories that are placed next to one another, and of course, one after the other.

The synthesis strategy quite predictably is one that requires a number of cases brought and done together. Here, the question immediately emerges: how many? If the focus is on choreographers in contemporary minimal and conceptual dance practice, working especially with the question of time and place, how many conversations do we need to have before it is meaningful to aim at a synthesis of the material? When following the narrative mode, for example as articulated by Bude (2000), the numbers are never that high. For a certain topic, the overall pitch is between 20 and 30, and out of these, less than 20 are realized, even moving down to 15. And depending on the follow-up strategy, especially how far into the very detailed analyses of the discourses one wants to get, the final focus can be on between four and eight cases that are then really carefully worked through.

The important presupposition that connects both strategies is the recognition and realization of the necessity to link the act of conversations to both the specific person and the particular structural location. This is what Mills (2000b) defined as sociological imagination, which stands for the act of connecting the dots, the ongoing interaction between what is happening within the individual's biography and what is going on in the structures where that biography is located then and there. However, we are missing one central instance in the interplay: a practice. This is where the biography meets the social, political, economical and historical structures—this is where it is articulated; this is where the confrontation is actualized. Not a one-off thing, but a series of acts taken become the act of doing the practice, whatever that practice is then called.

Narrative interviews, when done with the practice-based focus, are by their character situated, committed and participatory. They are acts that are talking with, thinking with—and asking each side to come along and also inviting the listeners or readers to join the act of give-and-take, talking to, talking with and talking back, arguing and disagreeing, staying with and returning back.

And for this set of both necessities and opportunities, there is something in the whole process without which it cannot even start to try to do what it

claims to be striving toward. This something is a something that has many names. It can be called curiosity, or empathy, or a certain collegial friendship and courtesy. It can be defined, as the writer Ralph Ellison (1952/2001) did through his biographical African American experience (in the 1940s and 1950s), as the structural circumstances of the inner eye, reflecting on the ability or inability to see things from different sides and perspectives, the openness or closedness for different views and visions.

This part, from the beginning of the prologue, is worth quoting:

> Nor is my invisibility exactly a matter of biochemical accident to my epidermis. That invisibility to which I refer occurs because of a peculiar disposition of the eyes of those with whom I come in contact. A matter of the construction of their inner eyes, those eyes with which they look through their physical eyes upon reality. (Ellison, 1952/2001)

What it all comes down to is an ethical proposition, or if you wish, an attitude. It is the awareness of being close, and getting closer, not losing oneself but being willing and able to get out of one's own box and one's own prejudices and presuppositions. It is not in any sense leaving them, but getting out of them for a moment and two, and then in yet another moment, altering the perspective. It is about getting out and getting back to asking what do you do when you do what you do—an act of asking that is both personal, but also collective, that is connected to a continuous day-to-day practice. It is an act that requires proximity, the constant and also quite often rather annoying face-to-face sites and situations, the constant nearness to both who we are and what do we do in our professional lives and practices.

The claim of the method of narrative interview is this: in order to get closer to these particular acts of knowledge production, let us start talking to each other. And yes, not only talking, but let us please please please pay a bit more attention to how to listen to each other, too.

5. Methodology and Power: Commitment as a Method

What Is Unique in Artistic Research?

Is there a unique argument for artistic research? Of course, artistic research can be argued for in the same way that one argues for research or science in general. Science increases our understanding, which is a value in itself, maybe it can also lead to something useful and so on. Certainly, these can be arguments for doing artistic research as well. Or artistic research can be justified by the argument that it makes better artists. By creating a deeper understanding and a body of knowledge about their work, artists can develop their artistic work, their being as artists, maybe also their function in society and so on. Yes, this is a possible argument for artistic research, too.

But these are not unique arguments: they rely on giving artistic research the authority of science or of art. We can, instead, ask if there is something to be said in favour of artistic research as such, something that does not apply to science in general or to art in general.

One possibility could be that artistic research combines some good features of research and some good features of art. This is certainly true. Artistic research has a unique position in the family of different research disciplines, a position not occupied by any other discipline. Artistic research can do stuff that other types of research cannot do, and stuff that art cannot do. (For instance, isn't it often the case that works of art included in artistic research have a different institutional status than works of art not part of research projects?) This means that there must be a unique argument for artistic research, based on the unique things it can do.

Here is a hunch, based on an analogy. Why is there so much emphasis on methodology in university studies? Why all the courses, books, examiners reputedly checking the smallest details of methodology in theses and so on? For several reasons, obviously, but one crucial reason is that what separates science from fields like religion, philosophy, technology and—yes—art, is precisely its methodology. Some would even like to claim that there is a grand scientific method that guarantees the specificity of science. No convincing explanation of what the scientific method (in singular) would be has been given. Among others, Feyerabend's famous criticism has shown that there is no methodological rule that should not be broken or has not been broken in the course of actual scientific development. Still, the special status and

authority that the sciences have are dependent on the special nature of the methods through which knowledge and understanding are gathered in them. Without their methods, the sciences would have nothing.

Ultimately, questions like "why do we teach evolution instead of creationism" or "why give money to universities instead of art institutions" and so on are answered on the basis of the scientific methods: it seems that, at least for some tasks and from some perspectives, they are superior to other methods. So right from the start, the issues of status, authority and power are connected to the issues of methodology.

Our wager is that the uniqueness of artistic research also has to do with its methods, its systematic and up-to-a-point repeatable ways of going about its business. The hunch continues in suggesting that the identity of artistic research is also connected to the particular ways in which power is present in its methodological approaches. So let us try, in a roundabout way, to circle around this "methodological uniqueness" in artistic research, not so much in order to pin it down but to have an appreciation of some of the more prominent features of the landscape.

Scenes from a University (as Narrated by Tere)

This is where we meet, in a university seminar room like any other. Depending on what has been happening in the room previously, the chairs and tables are arranged in a circle, in rows for a lecture, in groups and so on. We take places as we see fit.

We are not many. In any given northern European art university, there are not so many active doctoral students doing artistic research to begin with. Here there are some, and close by is another university. So depending on the day, we are two, three, four, up to six people in the seminar room.

The occasion is a text seminar. It is a habit of the university that teachers run seminars where selected texts are discussed. The idea is that everybody reads the text beforehand and then we gather to analyse it. The topic for the seminar is, at least initially, set by the teacher. Once the seminar gets running, the texts and the topics can be negotiated.

This time, the topic is "methodology and power," with both eyes on artistic research. It is not as simple as one would wish. There are, of course, loads of texts from Bacon to Foucault and Haraway on how power and ideology are implicated in research methodology, in general. But the bridge from those texts to artistic research, in particular, has to be imagined, built,

constructed. Artistic research itself is a moving target, taking shape as we speak.

And therein lies the rub: "methodology and power." One is immediately sensitized to questions of how research is done, in practice. Who does it? Why? How is it done? In which contexts? In which institutions? How is it published, evaluated, disseminated? Who uses it?

We are here, in the seminar room, but we are not there for identical reasons and identical purposes. I am here in order to learn about artistic research, its methodology, its contents, and then to write about what I have learned (as I am doing now). The doctoral students are also there to learn about the methodology of artistic research, in order to do it, to do artistic research. Our backgrounds are different: for me, philosophy of science, philosophy in general; for most of the students, artistic practice, being an artist, a practitioner, and doing research from that point of view. So I am talking and writing about research, while the students are doing research.

Of course, I also have the institutional role: I organize the seminar, I grade the participants if they want and need study credits, and I am paid for doing this. This already means that the scene is an example of what it talks about: methodology and power. People participating in the seminar have different institutional roles, which affects everything, subtly or not so subtly.

However, there is a deeper and more specific self-referential problem, in addition to the general and institutional power relations that are always there in a university setting. When we are talking about artistic research, the students actually doing art and doing research are in a sense the ones producing and living through the meanings, the significations and experiences that we discuss. My experience of artistic research comes from these discussions and others like it. It is in a clear sense secondary.

This situation reflects a general pattern: artists doing artistic research often have to present their research in institutional settings that are ideologically and practically governed by people who are not artists or artistic researchers. For instance, they often have to implicitly or explicitly legitimate that what they are doing is research to people for whom research paradigmatically means something else than artistic research. Even if those people are sympathetic toward artistic research, there is a clear imbalance of power that cannot but have an effect on methodological questions, too—not to speak of the practical: grants, scholarships, publications, prestige, authority, publicity and so on.

I intend to work on my experience. I intend to write something on methodology and power in artistic research. This, understandably, makes some of the students uneasy. The situation is pretty darn close to exploitation: my position as a teacher (and as a philosopher) gives me the possibility to write

and publish about what I learn through our discussions, based on their experiences. The problems of methodology and power are inscribed in the scene, in the seminar itself. To put it in a puffed-up way, "the production of knowledge," in this case the writing of this text, happens in a situation that is doubly twisted: first, by the institutional division of labour and power structures in a university; second, by the fact of nonartist researchers pretending to be experts on artistic research.

What to do? Well, at least acknowledge that this is where we are. There is no getting around it: a text seminar run by a professor is not a level playing field, no matter how beautiful the ideals of science and university education. Second, maybe draw inspiration from the sides: what does this situation of experts writing on a community that they do not belong to resemble? Where are similar problems of methodology and power encountered?

The Guild and the Sciences: Methodology as Liberator

One way of thinking about methodology and power in artistic research is to contrast them with other forms of transmitting and developing skills, expertise and knowledge. Two traditions that lie close are the guild model and the established sciences (humanities, social sciences, natural sciences). The point here is to make contrasts, and that is why the following presentation of the guild model, for instance, is not intended to be historically accurate, and the presentation of the established sciences and of the field of art is schematic and simplified.

By the guild model, we mean the traditional master-disciple form of skill acquisition that can also contain the intersubjective assessment and validation of what is learned. One way to become an accepted member of a guild was to first work as a disciple doing menial tasks, then graduating slowly to more demanding jobs and doing individual work—a path from apprenticeship to craftsman and journeyman. Finally, one could present a masterpiece, a work in the craft, to be evaluated by the masters of the guild. If the masterpiece was accepted, one could set up shop independently.

The guild system does things that art schools and universities also do. It transmits skills and knowledge across generations. It preserves a tradition and possibly also develops and accumulates the skills and knowledge contained in the tradition. It educates a body of people to a shared understanding of the tradition and preserves the community. Consequently, some forms of higher education in arts contain elements of the guild model, where the close master-disciple structure supports learning and mastery that otherwise would be

impossible (think, for example, of the importance of what are called master classes in music and elsewhere).

At the same time, the guild mode lacks some important features that one would expect to characterize research. First, the model does not, as such, systematically promote criticality, progress or even change. The point of the model is the preservation and transmission of the tradition, not overcoming or transforming it. It might with good reason be questioned whether artistic research (or humanities or social sciences) should be seen as something that progresses in the (naïve) sense in which natural science is sometimes seen as progressing: new theories that are better replacing older theories. However, in all research one has, at the very least, to be critical toward received wisdom and tradition—nothing should be accepted solely because it is traditional—and present one's own results as subject to change.

Second, the model is closed. Not everyone can enter, and not everyone who enters can proceed. There are no transparent checks and balances on how decisions over the transmission of knowledge and skills are made. Moreover, the community is potentially hermetic and in no transparent way accountable to anything outside itself. As often as not, the point of the guild is to keep certain things secret—the very opposite of the ideal in research.

These two characteristics are directly linked to the issue of power. The modus operandi in a guild places all power explicitly with the masters, whose main interest is the preservation of the tradition. The only systematic way in which an individual can have an effect is to become a master, and even then the room for disruptive manoeuvre is small. Symbolic authority is concentrated in the appreciation of high-level and highly standardized skill. This internal structure is often reinforced by a privileged status granted to the guild in the wider society, with all the economic and political benefits and interests included.

It would not be completely wrong to say that the ideals of openness and criticality characterizing (modern) scientific research were in part designed as responses to the lack of these features in the guild model and, more prominently, in authoritarian models of scholarship under religious and secular tutelage. The ideals intend to tackle the problem of concentrated traditional power by giving the final say to empirical experiments and public argument. These ideals are further operationalized as methodological approaches and methods in research.

Like the guild model, natural science as an activity also promotes the transfer of skills (becoming a scientist) and knowledge (models, theories). It also forms a social community committed to promoting the task; a community

in which learning is not always in practice completely different from learning in the guild model.

However, in contrast to the guild model, the ideals of openness and criticality are embedded in the practices of the community. In principle, anyone can join the community. In principle—the methodological principle—the criteria for scientific arguments are public and transparent. From this point of view, the systematic work that a research methodology has to do is to make the research as transparent and open as possible. In other words, the method is there in order to make it easy to criticise the research, whether the research is produced by a "master" or by a "novice." This means that the evaluation of scientific skill and knowledge is, in principle, intersubjective (some would like to say "objective") and public.

Consequently, science has an internal process for "error correction" or change. The least one can say in favour of natural science is that the amount of erroneous beliefs in its accumulated knowledge base diminishes. The jury is still very much out on the question of whether that means that natural science makes progress.

In any case, one big difference inside sciences runs between the natural and social sciences: it can be characterized with the help of an observation made by Thomas S. Kuhn, of *The Structure of Scientific Revolutions* (1962) fame. Kuhn's points about the theory-ladenness of observations, of incommensurability between paradigms and of the nonlinear and noncumulative cuts produced in scientific revolutions have been taken to mean that there can be no objective measure of progress in science. (Kuhn himself prefers to say that the problem-solving capacity of theories increases, even though there is no clear cumulation of knowledge through time.) Furthermore, this conclusion has been taken to mean that there is no absolute divide between natural sciences and social sciences, as both undergo nonlinear revolutions and contain a measure of interpretation.

Be that as it may, Kuhn (2002) observed a salient difference. In natural sciences, it most often happens that scientists do agree about a paradigm and the basic concepts and methods in their discipline and then proceed to make science that—as long as the agreement lasts (called "normal science")—seems to progress and cumulate knowledge. In contrast, in the social sciences, most of the time scientists do not agree about the basic concepts or methods—they might not even agree about what their science is about (what is society, what is an individual and so on). Social scientists proceed on the basis of this discord, sometimes diminishing and sometimes increasing the level of disagreement. It might even be said that the point of social science is (also) to question received ideas and theories. In any case, the point is that this disagreement is not a fatal

flaw for social science. The ideals of criticality and openness can and have been upheld in ways that do not presuppose agreement for the whole social scientific community.

This difference, naturally, means also that the power structures in natural sciences and social sciences are different. Things are in a sense more clear-cut in natural sciences. Wider agreement is expected, and rules for adherence are stricter. At the same time, ideally, the power in the community lies in public argument, not in positions or roles: anyone can prove Einstein wrong, just by providing the proof. The authority of natural science is big in contemporary societies, some would say too big, even harmful. However, usually the harm is seen in the influence of the scientific world in itself (such as Heidegger's claims of the "technological understanding of Being" in science), not in the corrupt behaviour of individual natural scientists.

In social sciences, matters are, from the start, more complicated. Issues of interpretation, influence, schools of thought and style have an effect on what is thought to be valid and relevant. Even so, amidst all the disagreement, and even precisely because of the disagreement, social scientists find ways of systematically, that is, methodologically, accomplishing criticality and openness. Some of the ways tend more toward the model from the natural sciences; some are more independent and border on the arts, for instance, in some cases of sociological, ethnographic or anthropological literature, not to speak of theory in psychology and so on.

Further on, one encounters the humanities, in which it would be absurd or counterproductive to insist on wide-ranging or final agreement. The point of humanist research is to argue—as openly and accessibly and skilfully as possible—for a view, an interpretation, a way of seeing things, while at the same time basing one's argument on previous humanist research. Again, openness and criticality are expected, but they are not operationalized through empirical experiments or measurability. Openness is a matter of language and the structure of argument. Criticality, in turn, presupposes a familiarity with the existing tradition; it presupposes scholarship.

There are very seldom "knock-down" arguments in the humanities, even though some views and approaches can gain traction very fast. On the other hand, views long forgotten and supposedly repudiated can be returned to and vigorously defended, if one comes up with the proper and fruitful argument. Nothing definitely "dies." Matters of style enter the equation decisively. The presentation and the content are not separate, which means that methodological skill is, again, about craftsmanship.

If one takes Foucault's (2000, p. 341) definition of "governing" as "structur[ing] the possible field of action of others," we see that the

possibilities for government are wide in the humanities. Even though no topic or approach is forbidden as such—the powers that be are unlikely to say that you are not allowed to research a given topic—the field of study and its institutional organization is so structured that certain topics and approaches go while others are virtually impossible or unthought of.

On the other hand, the "masters" of the humanities are not as invulnerable as the masters of the guilds. One is allowed and even encouraged to challenge them, if only ever so subtly. Arguments and decisions happen in public and the reasoning behind them is presented. The discussions go on; sometimes disagreements are resolved, sometimes proliferated—and that is a part of the point.

By its topic and nature, artistic research is closest to the humanist model. Usually, the exact methods of the natural sciences do not apply or can, at most, be used as a part of a larger approach that overall is not exclusively naturally scientific. The methods of the social sciences lie closer to hand. However, the inclusion of the artistic aspect inevitably tilts the research toward the humanities (as a study of humans and their cultural artefacts).

Consequently, the methodological virtues and vices in artistic research are very close to those of the humanities. Scholarship—being well versed in the tradition and being able to situate one's research in context—is important, and so is skill in argument. In the humanities, this generally means skill in writing, but in artistic research there are more media available. Once again, this skill and its criteria are internal to the practice itself: what is good writing in a field of humanities cannot be mechanically defined, and likewise with artistic research. Good arguments can be recognized, not predefined.

Education in the arts often happens in circumstances that have a lot in common with the guild model. This is quite natural, as working close to a "master" or a set of masters is a good way of learning a skill that involves prolonged embodied practice. When the idea of research is joined together with the guild approach, bad things happen, because the ideals of the two models do not coincide. For one thing, the ideals of research are there in order to make the "masters" more accountable and the transmission of skills and knowledge more transparent. And, yes, this also means making the tradition more explicit, more "bookish," if you will.

From this perspective, artistic research is something like "guilds + humanities + something else": it has roots in the guild model, augmented by openness and criticality, proceeds much like research in the humanities, but can venture outside text in presentation and argument and can borrow methods from the social sciences, too.

Why and How Do You Care?

Leena Valkeapää's artistic research dissertation called *Luonnossa* ("In Nature," 2011) concerns a particular way of life, nomadic reindeer herding in Lapland, in the most northwestern parts of Finland, bordering on both Sweden and Norway (see also Chapter 12 in this volume). The goal of Valkeapää's research is to describe the reindeer herding life as a whole that includes livelihood (economy), ethnicity, culture, habits and so on, trying to get at the unique characteristics of what makes the life what it is. As a starting point, Valkeapää uses the poetry of Nils-Aslak Valkeapää, and the text messages she got from her husband, Oula Valkeapää, who is one of the very few practitioners of nomadic herding, and, as it happens, Nils-Aslak Valkeapää's nephew.

Valkeapää describes her own relation to the topic as an intensification of involvement. First, she encountered the area and the life there as a hiker, making tours in the northern "wilderness" around Kilpisjärvi on foot and on skis. Here the famous poetry of Nils-Aslak Valkeapää that was born in the area and has as its topic the herding lifestyle and its natural habitat, its worldview and so on, was an important companion to her. After first meeting Oula Valkeapää by accident, she starts following Oula's travels, which, in turn, are structured around the movements of the reindeer. Gradually, Leena Valkeapää is integrated into the reindeer-herding lifestyle, marrying Oula, and starting to co-live the reindeer herding life. From being a tourist, Valkeapää was gradually acculturated into being at home in the reindeer herding area.

In Valkeapää's description of her research, there is a parallel between what happens to her as an individual and what happens to her position as a researcher: there is a continuum from a more or less outsider observer position through making interventions to an involvement that engages the individual in all of her being. As an artist, Valkeapää had painted and created documentaries and environmental art in the northern environment. She writes about the change (2011): "My artistic work has shifted from visual art through environmental art and documentary into researching the essence of life in my new habitat" (p. 52). Finally, in the dissertation, these two processes come together: the topic of research and the way of life fuse into one; Valkeapää is researching the life that she is also living.

Valkeapää's gradual path into this situation perhaps highlights something that is quite common in artistic research. Often the topic of research is something in the artistic experience, work or approach of the researchers themselves. However, for an artist, this starting point can be so self-evident that it is hard to thematize it and take it under methodological consideration. Valkeapää's route into an initially alien life (nomadic reindeer herding) points

out that the life one lives, however committed and "natural," is at the same time something learned and artificial, even consciously "chosen."

From the opposite perspective, the immersion in the way of life that one has as a research object reveals a methodological possibility for artistic research. The position of the person living the life is quite different from the position of an outside observer, and this necessity should, as Nietzsche recommended, be made into a virtue.

The method of Valkeapää's research is autoethnography, but as she writes (2011), "autoethnography does not mean autobiography, since my life is not the object of research but rather a way of understanding the research object" (p. 21). This is a crucial methodological shift. Living a life is a potent way of understanding that way of life; that much is obvious. Now the trick lies in making that understanding as open as possible for others not living the life. There are obvious limits to such an undertaking. With good reason, it can be said that in any kind of life there are aspects that are understandable and accessible only by living that life. The point is, however, that after accepting these limits, it is still quite possible and likely that "living a life" can be used as a research method that has its unique possibilities.

Valkeapää describes her approach more precisely in terms of employing "artistic thinking" (see Varto 2008), a form of thinking characteristic of artistic practices, in which reliance on experience, the bodily and sensory human existence, the recognition of uniqueness, being immersed and enchanted by something, being vulnerable and being communicative are essential features. Varto has described the form of knowledge produced through artistic thinking inspective (in contrast to perspective and aspective knowledge): it is knowledge that arises from inside a world, in a situation from which there is no escape and which has an inescapable aspect of emergency.

The continuum in Valkeapää's research and life runs from being an interested outsider into being an immersed participant, who wholly stakes her life with the topic of her research. In general, a similar continuum can be observed with regard to positions that researchers can take through different research methods (see Figure 5.1).

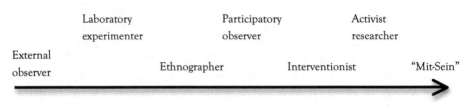

Figure 5.1. Researcher Position Continuum

On the extreme left we have minimal involvement with the research object. Indeed, the ideal of the outside observer may be that there is zero involvement and zero interference. The observer just coolly looks at the world and describes it, without adding or subtracting anything. Likewise, the point of constructing a laboratory for experiments is to keep the involvement to a minimum. In a laboratory, ideally all the external circumstances having an effect on the phenomenon to be studied are known and controlled. Then one can produce changes in one of the variables, observing consequent changes and thus revealing regularities. Conceptually, the idea is to have a minimal level of involvement: the researcher manipulates just one thing in the world, keeping everything else constant, and then measures the effects.

Moving to the right, the level of involvement increases. An ethnographer participates, lives in the community, but does not purposefully try to influence it. However, as is well-known from various methodological discussions, simply the presence of an ethnographer is bound to have some sort of effect on the community to be observed. This effect can be made intentional, for instance, in various forms of interventionist ethnography or in action research. Here the effect produced by the involvement is developed into a methodological tool. The researcher tries to change the world in order to understand it, and not only that: the point may be to change the world.

In methods of activist research, developed for instance with the popular movements in South America, research is not only intended to effect practical changes but also to be done directly by the people whose lives are in question. The research is not supposed to be carried out by "detached" or "expert" academic researchers. In activist research, the research agenda, the process of research and its results are all carried out by activists living the lives that are under research.

This is, in a sense, already the maximal point in the continuum on the right side of the figure: one lives, breathes and is the research object, while

being the subject doing the research as well. Here, in Valkeapää's words, the life itself is the research method, so that any change effected by the research (such as increased understanding) directly feeds into the life itself. Somewhat pompously, but in order to evoke the hermeneutic circle that this position involves, one may call it "*Mit-Sein,*" or "being-with," a term used by Heidegger to describe how a human being always is with (and by and through) others.

In the position of minimal involvement, the idea is that by coolly detaching oneself from the research object, one gains in both internal objectivity (so that the prejudices, hopes and fears of the researcher do not interfere with the results) and external noninterference (so that the researcher does not inadvertently contaminate the observations). Consequently, one is supposed to care about the facts and the scientific method itself, while keeping personal attachment at bay. There is, indeed, something to be said for this ethics of detachment and the resultant ideal of objectivity. However, at the same time, the position means that there is an instrumental divide between what is valuable in itself (the scientific ideal, objectivity, facts, improvement of humanity) and what is valuable as a means (the particular research project, the object of research). In Aristotelian language, the finality of the research is outside the research object.

At the other extreme, that of maximal involvement, the detachment is discarded in favour of a position of caring about the research object. There is no finality outside the research object. Again, on a naïve level, it is quite obvious that artist researchers care about their topics; otherwise investing so much time and effort in them would be utterly irrational. So the methodological question becomes not so much why do you care but how do you care about the research topic or object?

And here we might start to have some inkling of the methodological uniqueness of artistic research. If and when artistic research is able to devise open and critical ways of caring about something, ways that can be travelled by others willing to take the trouble, it indeed brings something new to the world of research.

The ethics of care is, of course, quite different from the ethics of responsibility that is typically utilized when discussing research ethics. Especially on the noninvolved end of the continuum, there is a clear tendency toward "obeying science": "I didn't do it; it was science!" As in Mary Shelley's tale *Frankenstein,* the problem is not so much that the medical student Frankenstein creates a monster to begin with, but rather in that he abandons the monster and accepts no responsibility for it.

Now, does this shift toward "being-with" and an ethics of care mean that— in contrast to Dr. Frankenstein—we should be content with the world as it is

and try to find a harmonious way of coexisting with all other beings? Who knows, maybe, but here we have to quote Slavoj Žižek (2007), who, while discussing Heidegger's call for letting be (*Gelassenheit*), of overcoming egotistic will and finding a nondomineering and nontechnological relation to nature, reminds us: "Beware of gentle openness!" (p. 37). What is Žižek's worry? Calls for "harmonious coexistence" can be misleading in at least two different ways. First, such a call may contain the hidden premise that such a harmonious situation, indeed, is possible for humanity. This is a quite controversial claim, given that in any society there are contradictory interests and groups and individuals at cross-purposes. Consequently, someone like Žižek can go as far as stating that society is always based on contradiction and struggle, so that a "harmonious society" is a contradiction in terms.

This leads directly to the second point. If a society contains contradiction and struggle, then any call for "harmonious coexistence" in that society tends to cover over those contradictions, tends to normalize the situation, thus perpetuating the prevailing ideology and power structures. Against this ever-present allure of normalization, we need a hermeneutics of suspicion: the traditional interpretation always has to be questioned, examined, and, at least in part, rejected.

In Heidegger's favour, it must be said that he was very aware of the danger that Žižek points out. Following Heraclitus, Heidegger insisted that the human world is always based on struggle (Heraclitus's *polemos*). If the struggle ceases, the world pulls away. Thus we might say that the ethics of care that the methodology of artistic research includes is not based on the self-assured and self-contained identification with the life that one lives (and the part of it that one does research on) but rather on the fact that all human lives are, in a deep sense, impossible and sustained by a commitment despite that impossibility.

Another methodological aspect of "maximal involvement" has been repeatedly noted by several activist researchers. Just to take one example, Gandhi insisted that lasting knowledge can be gained only in struggle, where opposing forces are present. The Norwegian philosopher Sigmund Kvaløy describes this Gandhian idea on the basis of his experiences with the environmental movement. The movement started by coming together for reading texts and analysing the situation, but, according to Kvaløy, didn't really have any grasp of what the problems were before first engaging in actual environmental struggles (against hydroelectric plants, as it happens). Only through those struggles could the environmentalists discover what forces drive destruction, what kind of arguments are needed, who one can count on for support and so on. The point is not a problem of applying (preexisting) theory to practice but rather that there is nothing that the (detached) theory applies

to: the only effective knowledge is possible from a situated perspective, a perspective that is a participant in the ongoing struggle and cares about the world it encounters.

Kvaløy (1993) described these "experiments with truth" in the following way:

> Gandhi tells us that the most important source of human knowledge is not to be found at some university or in meditation, but at the center of social and political conflict, the fight for Life and for Truth. But this "Life-Truth"—what is that? Above all, these are experiments; you yourself have to help the definition along, through your own fight. It's not laid out beforehand, on a map, not in the real world, which is a creative stream. (p. 144)

Further on, Kvaløy (1993) nicely sums up the doubly transformative nature of this kind of care for the truth:

> There is only one way to become courageous, and that is to be courageous. Step into the river instead of just looking at it, and be grabbed by the current [...]—you are changed and changing the world at the same time. (p. 150)

Indigenous Research and Artistic Research

Let us return to the question of a community of practice looking back on itself in research and the concomitant problem of parts of the wider and implied research community not being a part of the community of practice. Given the description in terms of the "continuum of involvement," discussed earlier, it is clear that an outsider position, a detached position not committed to the practice and not under the same problems and possibilities, cannot have the same structure of care, and, consequently, not the same kind of epistemological or methodological, not to speak of ethical, relationship to the topic. This is one possible root of problems: if the detached perspective prevails (for instance, because of its institutional power position) over the involved one in terms of research, it is not only ethically bad but also methodologically wrong.

There is a form of research in which a similar situation has been encountered. Historically and to a surprisingly large degree even today, in research on indigenous people one often finds a community of people living in a particular way, with its own material and spiritual conditions and goals, and a research community looking in on that community. According to an old joke, in some of the more interesting communities there is a resident anthropologist in every hut. The colonialist situation this creates is relatively well-known and widely discussed: the knowledge created for the relevant

scientific discipline is often far removed from the knowledge inherent in the
community and too often fails to benefit the community in any way, if it does
not outright threaten its material and spiritual life (when the expropriated
knowledge is used in assessing natural resources, in devising paths for
[religious] education, in producing cultural commodities, etc.).

Increasingly the researchers are also from the indigenous community,
which creates a new situation with new problems. Crudely put, the indigenous
person doing indigenous research occupies a hybrid position, inhabiting two
cultures of knowledge and two sets of values or lifestyles. The values of
"Western science" and of indigenous cultures are more often than not at odds
with each other. Typically, the value systems and metaphysical beliefs of
indigenous cultures are, to Western science, misguided and mistaken
("primitive"), while the indigenous culture sees Western science as flashy but
ultimately naïve. At the extreme, the two cultures do not even agree on what is
truth, or what is meaning, in general, so straddling that hybridity is a tall
order, indeed. The researcher is an insider and an outsider of both
communities.

It is relatively easy to spot similarities between indigenous research and
artistic research. This is because both have as a background a more or less
identifiable community: a territorial, linguistic, ethnic, cultural community in
the first and a community of practice and values in the second.

It may sound preposterous to compare the communality of artists with all
of its variety, virtuality and cosmopolitanism to the communality of an
indigenous group, but there is at least one important reason to do so. In terms
of their relationship with scientific knowledge, the indigenous community
faces, as Linda Tuhiwai Smith (2012) has extensively described, a wall of
articulation. This is because the way in which things make sense in the
indigenous life and in the scientifically oriented world are incommensurable.
Often this incommensurability is so deep that if the scientific view insists on
some sort of translatability, it only ends up producing a misrepresentation or
an outright colonialist attack on what it is supposedly translating. Things
articulated in science do not make sense (or are not important) in the
indigenous context and vice versa.

Likewise, with regard to the narrowly defined scientific world, the artistic
community also faces some sort of partial wall of articulation. The values and
phenomena self-evident in communities of the artists may not be self-evident
in communities of scientists. In a famous quip, Heidegger responded to the
long-standing claim that it is a scandal for philosophy that there still is no
watertight proof for the existence of other minds than my own. True to his
philosophical insight that minds are first social and only then individual, he

replied that the true scandal is that people feel a need for such proof. Crudely put, the wall of articulation between the communities of artists and the communities of scientists is based on a similar scandal. On one hand, the artistic community is under some pressure (from the scientific community if not the society at large) to prove that its endeavours and activities are important and worthwhile, while on the other hand, the community itself feels that the need for such proof is a scandal in itself.

Of course the wall of articulation is not impenetrable and may very well be more porous in the case of the artistic community than in the case of an indigenous community. The very existence of something like artistic research shows that there are important possibilities and initiatives for overcoming and dismantling the wall. Often an indigenous community is held together by a more or less shared worldview, involving a sense of the sacred that is absent from nonindigenous life. In contrast, the artistic communities are held together by shared skills, practices and values that may be less binding than a sense of the sacred—but, on the other hand, they may include that, too. In any case, the similarities in the communality entail similarities in terms of a wall of articulation and of having to engage a hybrid insider/outsider position when doing research.

The insider/outsider position further feeds into the hermeneutics of suspicion mentioned earlier. As if the impossibilities and anxieties of one way of life were not enough, the artistic researcher has the task of caring about both the world of research and the world of the particular practice. This means that any rosy dreams of "harmonious coexistence" without ideological tensions quickly go out the window.

What of the differences? These seem to be more of degree than of kind. Often, indigenous communities find themselves under a clear and present existential threat. This may be ecological, environmental, related to health, cultural survival and so on. Consequently, the communities typically have very pressing communal research needs. For example, pollution needs to be monitored, the effects of clear-cutting evaluated, possibilities for better health care explored, grounds for autonomy and self-government investigated and so on. With regard to communities of particular artistic practices, such existential threats and clear communal research objectives may or may not be present. Insofar as these factors are present, often the task of indigenous research is, at least partially and initially, preservative: the goal is to give the community more breathing space, both materially and spiritually. In terms of artistic research, this goal is accompanied with its transformative twin: the goal is to nudge the community toward self-critical and self-conscious change.

So what about avoiding the pitfalls of exploitation, of colonialist practices? The minimal conditions that Tuhiwai Smith (2012, pp. 122–125) listed in the case of indigenous research are quite commonsensical: before starting the research, there must be informed consent from the community for the research; the community must retain rights to its knowledge and practices; the community must be able to exercise ongoing supervision and gain at least equal benefits from the results; and the community must have the ability to deny access to its resources, knowledge, and practices.

More practically, Tuhiwai Smith (2012) offered a set of questions through which one can perhaps clear the thicket around the thorny question of "how do you care?":

- Who defined the research problem?
- For whom is the research relevant? According to whom?
- What knowledge will the community gain? According to whom?
- What knowledge will the researcher gain?
- Likely positive outcomes for the community
- Possible negative outcomes
- To whom is the researcher accountable? (p. 175)

If one has some ideas for answers to these questions, the insider/outsider position is greatly clarified: not necessarily made easier but much more explicit. Also, it is important to notice that these questions are not only ethical or social but epistemological and methodological. The phenomenon one is investigating as an immersed and committed insider exists only because of the immersion and commitment, the being-with. If one takes an outsider position, the phenomenon disappears. Therefore, the existence and appearance of the research object is dependent on the (ethical, social) quality of the commitment and on how one cares.

6. Different Roles of an Artistic Researcher, the Public and the Uses of Sociological Imagination

An artistic researcher never works in isolation, outside the worlds of arts and humanities. He or she is not living in a social vacuum but in various societal, social and cultural contexts with various publics and audiences. What, then, are the roles and positions of today's artistic researcher? And what could they be? Let us first briefly sketch a typology of the possible roles and positions of an artistic researcher, those of a professional, a policy adviser, a critic and a public intellectual, and then take a deeper look at C. W. Mills's ideas on the researcher as a public persona.

Artistic Researcher's Roles: A Typology

Artistic Researcher as Professional

In a professional role, an artistic researcher performs and acts in two different surroundings: on one hand in studios, galleries, museums, streets and other public spaces, and on the other hand, inside the corridors and lecture halls of academia. This split creates both methodological and theoretical problems, as well as problems of identity. "What are my roles, positions and purposes as a researcher?" "What is my research method?" "What is my methodology?" These are typical questions not only for an artistic researcher but also for many others, especially students in various branches of humanities. In addition to methodological and theoretical problems, an artistic researcher is often forced to tackle questions of research policy and funding ("Is my artistic research part of the humanities, social sciences, visual studies or what?"; "What is the role of multidisciplinarity in my artistic research work?"; "Where do I get the money to make a living?"). These questions are related to career choices and academic distinctions, that is, struggle for merits and a place in the academic sun.

Artistic Researcher as Policy Advisor

Whereas the professional act of artistic research takes place in the academic sandbox, the policy role consists of the researcher's acts in the public sphere, that is, in the different fields of policy making, be it cultural policy, educational policy or perhaps economics. An artistic researcher can be part of committees, commissions or boards, which gather information and prepare reports for the governmental or parliamentary decision making. In these roles, he or she is an adviser, sometimes resembling a legislator. This individual can also serve different nonprofit funders such as foundations, or private sponsors and collectors in the gallery business. In these roles, the individual often acts as a consultant, using his or her reputation, know-how and wit.

Artistic Researcher as Public Speaker

In his or her public role, an artistic researcher defends and allies with civil society. In the manner of a public sociologist, an artistic researcher "works in close connection with a visible, thick, active, local and often counterpublic" (Burawoy, 2005). These connections can range from anti-advertising and human rights organizations to "occupy" and DIY movements. In the public role, this individual aims at generating dialogues and understanding between artists and publics in various sites of civil society. Usually he or she joins forces with progressive or activist movements. "What can I do with art—mine or someone else's—to create critical consciousness of this or that issue?" "How can I participate to solve it?" "How can I help others to become part of the movement?" Thus, the individual's role would be that of curator, speaker, facilitator, advocate or mentor inside and especially outside academia.

Artistic Researcher as Critic

More than just participating and facilitating, an artistic researcher in his or her critical role is prepared to change the unequal and inhuman conditions. This individual is a "practical epistemologist" who critically engages "in real-world projects and action, doing 'participatory work'" (Street, 2001, p. 17). "The practical epistemologist engages with knowledge in use, not simply with propositional knowledge, and he or she works with partners in real-world contexts in the interest of equity and justice" (Street, 2001, p. 17). Perhaps an artistic researcher is also the person who grabs Walter Benjamin's emergency

brake trying to avoid the catastrophe of humanity in the bullet train of progress. In other words, this individual acknowledges the role of art and artistic research as parts of a hegemonic struggle in society, the fact that in good hands, they not only interpret but also change the world. Of course, at the same time as artistic research presents itself as a critic of ideology in the market-driven society, its critical position applies also to the methodology of artistic research itself.

C. Wright Mills and the Public

Whatever the role of an artistic researcher, he or she is always in relation to and with different publics, sometimes smaller, sometimes larger. Thus, this individual must build a point of view to such questions as what does "public" mean and what does it mean to act with a public?

The works and writings of sociologist C. W. Mills (1916-1962) are of particular interest in discussing these questions and the different roles of an artistic researcher. In addition to his books—*White Collar, Power Elite* and *The Sociological Imagination*—written for sociology and sociologists in the 1950s, Mills wanted to share his words with people who read and discuss and are interested in the state of the words, or in other terms, with the greater public beyond an academic audience. He thought this would be by far the best way of following his sociological vocation. The first book written for the wider audience discussed the Cold War, the threat of nuclear war and the necessity of peace: *The Causes of World War Three* (Mills, 1958).

Our nomadic sociologist also visited Cuba, where he listened to and recorded revolutionaries' speeches and wrote *Listen, Yankee!* (1960/2008a). For this book, he interviewed Fidel Castro, Ernesto "Che" Guevara, and other revolutionaries, along with journalists, soldiers, and officers. He wrote the book in just six weeks, planning to offer the American audience a perspective that was different from the official policies that disapproved of Cuba's revolution. While the American mainstream press kept quiet about the happenings of the small and distant island state, the book immediately became a bestseller. The style of the book was interesting: Mills wrote the interviews in the first person, referring directly to the voices of the Cuban revolutionaries (Mills, 2008a, pp. 243-254; see also, Kurlansky, 2008, p. 194).

Mills emphasizes his wish to understand the structure of society, the overtly individual meanings of the social and the relationship between individual experiences and social facts in a manner typical of sociologists (anomie, alienation, bureaucratization, mainstreaming, a wartime economy,

etc.). On the other hand, Mills introduces a sort of outline on how to change the world by emphasizing the responsibility and importance of the intellectual in "leading the change" (Burawoy, 2008). Perhaps that is why his books usually had two parts: an empirical part and a programmatic part aiming at furthering sociological and political imagination—in other words, a pedagogy that accents the educational values, sense and freedom.

The current debates about the tasks of the social sciences have also offered other values to replace sense and freedom. Sociologist Michael Burawoy (2008) wrote the following in his letter to Mills:

> What values does sociology represent? In *The Sociological Imagination* you are quite explicit that the ultimate values upon which both sociology and society rest are those of reason and freedom. Without doubt those values are important, but are they the values that distinguish sociology from other sciences? In referring to freedom and reason you perhaps reflected the threats to those values from fascism and communism. Today, I might suggest that the values that underpin sociology are justice and equality—very much the continuing legacy of the transformation of sociology in the 1960s and 1970s. (p. 374)

The differences highlighted by Burawoy show the German classic sociologist Max Weber's influence on Mills's thinking. In 1946, together with his teacher Hans Gert, Mills had already translated and edited a collection of Weber's texts in English. Weber emphasized the task of sociology as a professional vocation that practices "simple intellectual honesty" in order to clarify the relationship and perceive the connection between soul searching and the facts. Social sciences can provide information about the techniques of controlling the functions of society and the people and teach methods and tools of clear thinking that help determine the clarity of different perspectives and value problems and the mind of social action (Weber, 2009.)

In his book *Power Elite*, Mills (2000a) reflected on the features of a mass society and devoted attention to the question of public opinion in a democratic society. Mills pointed out two types of a society ("small models or diagrams," as he wrote): a discussing society (or public) and the mass society, which was also referred to later by Jürgen Habermas in his book, *Strukturwandel der Öffentlichkeit: Untersuchungen zu einer Kategorie der bürgerlichen Gesellschaft* (1962). Mills wrote the following:

> In a public, as we may understand the term, (1) virtually as many people express opinions as receive them. (2) Public communications are so organized that there is a chance immediately and effectively to answer back any opinion expressed in public. Opinion formed by such discussion (3) readily finds an outlet in effective action, even against—if necessary—the prevailing system of authority. And (4) authoritative institutions do not penetrate the public, which is thus more or less autonomous in its operations. When these conditions prevail, we have the working model of a

community of publics, and this model fits closely the several assumptions of classic democratic theory. (p. 303)

In a mass society, the aforementioned issues of expressing one's opinions, communications structures, control over communications and institutions of the authorities are the other way around:

At the opposite extreme, in a mass, (1) far fewer people express opinions than receive them; for the community of publics becomes an abstract collection of individuals who receive impressions from the mass media. (2) The communications that prevail are so organized that it is difficult or impossible for the individual to answer back immediately or with any effect. (3) The realization of opinion in action is controlled by authorities, who organize and control the channels of such action. (4) The mass has no autonomy from institutions; on the contrary, agents of authorized institutions penetrate this mass, reducing any autonomy it may have in the formation of opinion by discussion. (Mills, 2000a, p. 304)

According to Mills (2000a), communication models are also different in these societal models. While communications in the mass society make people passive receivers of messages and segments of media markets, in the public society, interaction between the people brings their messages to the common field of communication and has them confirmed then by the mass communication (p. 304).

A few years after the publication of *Power Elite* (Mills, 2000a), in his book, *The Causes of World War Three* (Mills, 1958), Mills listed several conditions for the public society or substantial democracy: "By democracy I mean a system of power in which those who are vitally affected by such decisions as are made—and as could be made but are not—have an effective voice in these decisions and defaults" (Mills, 1958, p. 118). According to Mills (1958), true democracy necessitates the following circumstances:

- Functional and real public or discussing publicity.
- Nationally responsible political views that discuss important issues straight and openly.
- A state administration that has information and sensitivity and that is comprised of skilful people who are independent of corporate interests.
- "An intelligentsia, inside as well as outside the universities, who carry on the big discourse of the Western world, and whose work is relevant to and influential among parties and movements and publics. It requires, in brief, truly independent minds which are directly relevant to powerful decisions."
- A genuinely communicative media through which the independent intelligentsia can turn people's private problems into public questions and

show the significance of public questions to private life and arrange the union of intelligence, power and the publics.

- "Free associations linking families and smaller communities and publics on the one hand with the state, the military establishment, the corporations on the other. Without such associations, there are no vehicles for reasoned opinion, no instruments for the rational exertion of public will." (pp. 118–119)

Mills regards mass education quite critically. In *Power Elite* (2000a), he reminds readers about the ideals within the educational system—the objective of increasing people's awareness so that they can think and ponder common issues. This was the political goal incorporated in education. "In time, the function of education shifted from the political to the economic: to train people for better-paying jobs and thus to get ahead" (Mills, 2000a, p. 317). Mills states his opinion clearly: "In large part education has become merely vocational; in so far as its political task is concerned, in many schools, that has been reduced to a routine training of nationalist loyalties" (Mills, 2000a, p. 318). With "pure professionalism," Mills refers to the routine-like education of joyful robots. Naturally, education has conflicting objectives, such as development of professional skills and societal awareness, but these are not contradictory.

Certainly, some skills are more important to self-education and societal awareness than others: "To train someone to operate a lathe or to read and write is pretty much education of skill; to evoke from people an understanding of what they really want out of their lives or to debate with them stoic, Christian and humanist ways of living, is pretty much a clear-cut education of values. But to assist in the birth among a group of people of those cultural and political and technical sensibilities which would make them genuine members of a genuinely liberal public, this is at once a training in skills and an education of values" (Mills, 2000a, p. 318).

Mills calls on educational institutions to try and produce these "dual qualifications" and practice skills so that individuals, as a part of their education, will have the opportunity to develop their self-awareness and intellectual analysis of common issues through debates and discussions. The possible result of these kinds of education and growth processes or "liberal education of sensibilities are not less than self-education or the self-educating, self-cultivating man or woman" (Mills, 2000a, p. 155). This notion leads Mills (2000a) again to the fundamental educational viewpoint that concerns the whole sociological thinking:

The knowledgeable man in the genuine public is able to turn his personal troubles into social issues, to see their relevance for his community and his community's relevance for them. He understands that what he thinks and feels as personal troubles are very often not only that but problems shared by others and indeed not subject to solution by any one individual but only by modifications of the structure of the groups in which he lives and sometimes the structure of the entire society. (p. 318)

The promotion of self-education is, according to Mills, especially important in mass societies where decision making is largely the action of the elite and the group of representative politics, and where consuming goods often occupies people's attention. In these circumstances, the task of liberal education is "to keep the public from being overwhelmed; to help produce the disciplined and informed mind that cannot be overwhelmed; to help develop the bold and sensible individual that cannot be sunk by the burdens of mass life" (Mills, 2000a, p. 319).

Mills returns to this theme again and again: he recoils from mass society and the joyful consumptive robot it demands and even becomes distressed by his own notions every now and then. He understands the opposing viewpoint in education that aims at fostering morale in people who have the guts to question the authority and professionalism that show off their power. This kind of human being is a brave and sensitive, self-educating and self-taught individual, who has what it takes to reconstruct the whole society when needed.

As the counterpoint to his radical educational view, Mills's overall evaluation of the institutionalized practices of education and upbringing is critical. Formal education in schooling institutions has not upheld its promise of helping people develop self-awareness, self-educative skills, social understanding and the ability to function. Education still does not improve people's ability to evaluate their prejudices or to analyse the structural reasons for their personal problems. Education does not serve intelligent citizenship, but instead the economy, and only personal professional and social advancement are valued. School institutions are afraid of renewal, and teachers are politically shy as they encourage "happy acceptance of mass ways of life rather than the struggle for individual and public transcendence" (Mills, 2000a, p. 319). Mills's (2000a) tone becomes more strident:

There is not much doubt that modern regressive educators have adapted their notions of educational content and practice to the idea of the mass. They do not effectively proclaim standards of cultural level and intellectual rigor; rather they often deal in the trivia of vocational tricks and "adjustment to life"—meaning the slack life of masses. "Democratic schools" often mean the furtherance of intellectual mediocrity, vocational training, nationalistic loyalties, and little else. (pp. 319–320)

In *Sociological Imagination*, Mills (2000b) deliberates the political meaning of work and what he calls liberating education. At the beginning of the chapter "On Politics," Mills introduces three basic values that, according to his understanding, guide the work of a thinking human being, and, for that matter, the tradition of social sciences at large.

The first of them is the value of truth but not in the abstract sense that results in methodological inhibitions. First and foremost, he regards it in a political and moral sense. "In a world of widely communicated nonsense, any statement of fact is of political and moral significance. All social scientists, by the fact of their existence, are involved in the struggle between enlightenment and obscurantism" (Mills, 2000b, p. 178). In the modern world such as ours, the action of social sciences is, in Mills's (2000b) opinion, "to practice the politics of truth" (p. 178). The second value is the use of the educated mind, referring to the reflection on the human significance of research findings within social settings and political contexts. "Whether they are, and how they are, is in itself the second value, which in brief, is the value of the role of reason in human affairs" (Mills, 2000b, p. 179).

The third value covers "human freedom," including the opportunity to act, discuss, study and form reasoned opinions on various issues and people's freedom to make their history (even if they do make it according to their own will, "they do not make it under circumstances chosen by them," as Marx wrote in *The Eighteenth Brumaire*). "What I want most to say here is that, having accepted the values of reason and freedom, it is a prime task of any social scientist to determine the limits of freedom and the limits of the role of reason in history" (Mills, 2000b, p. 184).

When analysing a social scientist's position, Mills does not want to see a social scientist as the omniscient king of sociology. He also does not want to curry favour with the authorities regarding adaptive sociology, but he defends the independence of intellectuals who create ideas in the loneliness of their thinking. Mills's ideal seems to be the intellectual who reaches through the history of his or her discipline and into the wealth of concepts and drops the pearls of his or her thoughts in his or her texts "for the people"; the intellectual acts for the people, not with the people. This kind of intellectual does not stray into being a servant of the power but shields sociology from the power. Burawoy (2008) had a critical remark:

> In the chapter on politics you distinguish the "independent intellectual"–your model for yourself–from the Philosopher King, the intellectual who rules in the name of superior knowledge, and the advisor to the King, the servant of power. You fear that the servants of power, the technicians, the experts, are taking over our discipline. They accept the terms of their clients, solve their problems and receive their paychecks. Your fears were exaggerated. Today the world of power, whether

corporations or states, is less enthusiastic about sociology—perhaps because you were so successful in giving it a radical color! And so, whether we like it or not, our political role concerns talking to publics and at kings. (p. 372)

Burawoy's criticism does not quite hit the nail on the head, because Mills specifically writes about how a social scientist must talk about a "third place" peculiar to him or her, and to the governing and the governed, and to kings and the public society formed by ordinary people. According to Mills, a social scientist cannot live as an autonomous individual outside society but must always be inside society. Being in society means, to some extent, the realization of one's own helplessness. A social scientist, as most other people, "does feel that he stands outside the major history-making decisions of this period." However, "No one is 'outside society'; the question is where each stands within it" (Mills, 2000b, p. 184).

Although social scientists are subordinate to societal, political and cultural powers, "it is his very task intellectually to transcend the milieux in which he happens to live" (Mills, 2000b, p. 184). The scientists' work is to address their words to those who have the power and know it (the power elite), and to those who have the power but do not necessarily realize their use of power and its consequences, and also to those who do not have the power and whose knowledge is limited to their everyday surroundings (Mills, 2000b, p. 185). A teacher's first audience is his or her pupils, but in addition to them, the teacher addresses others, the public. Being aware of the teacher's public task, Mills (2000b) wrote about liberating education:

In so far as he is concerned with liberal, that is to say liberating, education, his public role has two goals: What he ought to do for the individual is to turn personal troubles and concerns into social issues and problems open to reason—his aim is to help the individual become a self-educating man, who only then would be reasonable and free. What he ought to do for the society is to combat all those forces which are destroying genuine publics and creating a mass society—or put as a positive goal, his aim is to help build and to strengthen self-cultivating publics. Only then might society be reasonable and free. (p. 185)

In addition to skills and values, Mills points to sensibility and places it on a continuum with skills and values as the opposite extremes; sensibility is situated between them. It "includes them both, and more besides: it includes a sort of therapy in the ancient sense of clarifying one's knowledge of self. It includes the cultivation of all those skills of controversy with oneself that we call thinking, and which, when engaged in with others, we call debate" (Mills, 2000b, pp. 186–187).

An educator must begin with what interests the individual most deeply, even if it seems altogether trivial and cheap. He must proceed in such a way and with such

materials as to enable the student to gain increasingly rational insight into these concerns, and into others he will acquire in the process of his education. And the educator must try to develop men and women who can and who will by themselves continue what he has begun: the end product of any liberating education is simply the self-educating, self-cultivating man and woman; in short, the free and rational individual. (Mills, 2000b, p. 187)

This expresses quite clearly the same thought that has been under development in critical traditions of education from at least the late 19th century. It has been the inspiration by which many educational reformers still can live, work and love.

At the end of 1960, *New Left Review* published Mills's open letter, where he made known his alliance with people he called the "New Left." According to Mills's (1960/2008b) definition, the New Left was comprised mostly of university students and their teachers and representatives of cultural life familiar with societal questions. The old left stood for the working class that did not hold the key to societal change any longer, in Mills's opinion. It was stuck in Victorian Marxism and the metaphysics of the working class, with goals that lacked history and had become unrealistic (Mills, 2008b, p. 263). The text criticizes political opponents, those in ruling power, and their sociologist flunkies, and yet it is hopeful when it comes to young students' opportunities to change the world.

Mills strongly judges those in the right quarters who try to increase societal apathy by claiming that ideologies have ended and that the right-left juxtaposition is pointless. The end of ideologies is, according to Mills, just a craze that will come to nothing like other crazes, although it can—at least temporarily—mean the suspension of political awareness both in the capitalistic United States and in the socialist Soviet Union, based on vulgar Marxism.

According to Mills, the primary components of ideological criticism represented by the New Left include the awareness that political thinking is always ideological, despite what reactionaries try to convince us of. Methodologically, the end of ideologies represents empiricism without theory or idle research on trivial issues that does not promote societal change. In addition, it denies other, but abstract political and human ideals; when of another kind, they are seen as utopian.

As for ideological analysis, and the rhetoric with which to carry it out: I don't think any of us are nearly good enough, but that will come with further advance on the two fronts where we are the weakest: theories of society, history, human nature; and the major problem—ideas about the historical agencies of structural change. (Mills, 2008b, p. 260)

The latter question, related to the actors and historical action leading to societal change, Mills regards as the most important theme of all political thinking.

The right-left juxtaposition is not over, according to Mills, because the right emphasizes societal stability, society left as it is, while the left is the opposite—it accentuates structural criticism aimed at political demands and programs, reporting and societal theory.

> These criticisms, demands, theories, programmes are guided morally by the humanist and secular ideals of Western civilization—above all, reason and freedom and justice. To be "Left" means to connect up cultural with political criticism, and both with demands and programmes. And it means this inside every country of the world. (Mills, 2008b, p. 260)

Mills predicts that the end of ideologies will be compensated by theorists like him and the New Left, a true political philosophy that "helps people to act." He does not recognize this kind of political philosophy in the labour movement or its traditional combat repertoires, although he admits their value. Instead, political philosophy can be found in student movements and their direct, nonviolent action "that seems to be working, here and there" (Mills, 2000b, p. 265). This would be something that modern scientists should analyse: How did Mills's hopeful predictions turn out? Is there a living political philosophy that moves us to act, or have we sunk deeper into societal apathy? From this point of view, what is the meaning of an activity, such as, for example, Occupy Wall Street (see Blumenkranz, Kessen, Leonard, & Resnick, 2012)?

Consciously, Mills gives attention to ordinary people's possibilities of being in charge of their lives, participating in society and being heard on issues that concern themselves. He was constantly suspicious of the promises of the modern era and did not think they would involve much good—quite the opposite. He dreaded those mechanisms (including advertisements and most mass communication) that are used to keep people unaware and complacent. Instead, he tried to reconnect his thoughts with the great story harking back to antiquity, the rational purpose of educating people, inviting especially intellectual people and those working in the field of education to discuss and participate in action.

Sociological Imagination in the Hands of an Artistic Researcher

The author of *Sociological Imagination* (Mills, 2000b) found it important to develop thinking skills that help address the most topical problems of the era,

the uncontrollability of continuous growth and the consumption society, its alienating production methods, the power of money and the hidden techniques of political control. It was possible to combine singular perceptions with overall societal features and a singular human being's inner experience with the structure of social reality. This work meant "the capacity to range from the most impersonal and remote transformations to the most intimate features of the human self—and to see the relations between the two" (Mills, 2000b, p. 7).

The researcher's task is not limited just to neutral recognition of societal problems, because in reality, research cannot make the choice between "participatory" and "neutral" research (although sometimes these seem to be taught separately). Forming a research question is already a choice, and making the choice means noticing some issues and ignoring others based on some conscious or unconscious values and appreciations. Recognizing problems and revealing them can also result in opportunities for thinking and living otherwise that remain unspoken or that people forget to foreground for one reason or another.

In the long run, it may not be valuable for an artistic researcher to follow the cynical principle "publish or perish." By contrast, it can be valuable to take one's social, cultural and political role seriously just for once and participate in action and social transformation with others. Thus we have the prime principle: Act and create simultaneously; publish later. Be bold.

This principle has become familiar from the ongoing discussion on "flipped academics." In a nutshell, the flipped academic

- Informs and creates first and publishes later.
- Participates socially, culturally and politically and helps others to participate.
- Emphasizes the development of social and cultural practices.
- Understands funding as an input, not an output.
- Develops and designs learning materials and environments—digital, traditional and their combinations—which enhance transformative learning.
- Acts wherever is possible and needed (not necessarily inside academia; see Bruton, 2012).

To be involved and to participate in the individual and collective processes of reflection and critical consciousness precedes the publication of research findings. In fact, there should not be such a thing as "publishing results" without a good, solid and strong praxis in which real people meet each other

in tackling and solving real issues and also enjoying the company. The academic publishing industry should always and in every instance be subjected to such praxis that puts things in perspective. To paraphrase Peter McLaren (2012, p. 491), a poet laureate of critical pedagogy, in order to have an artistic research of any kind, there needs to be a philosophy of praxis, which requires that we recognize that artistic research is determined by its dialectical relationship to praxis.

In praxis-oriented artistic research, the researcher is genuinely determined to make an impact on society in the variety of its forms and practices—whether in the political, social, cultural or any other sector—and does not want to differentiate his or her philosophical/conceptual work from the practical/ participatory but understands them only as two sides of the same coin. With his or her example, the researcher encourages other co-participants, and with his or her methods and techniques, the researcher guides and mentors students and others involved in the transformative praxis. That being said, it is clear, however, that a researcher's most important contribution boils down to his or her capacity to see the larger contexts that surround the specific question in hand.

The meaning of research funding also changes. Nowadays, funding received is often seen in a quite perverse way as a result or an output, whereas in a praxis-oriented paradigm, it is seen as an input. In research work, the amount of money is not valuable as such: what is essential is the value of the research acts one can do with the money, that is, how one can use one's working time in solving pressing issues.

In praxis-oriented artistic research, every means to increase the publicity of research and teaching is a valuable part of creating equal social and cultural practices. Thus an artistic researcher welcomes new innovations in research and teaching (e.g., digital learning, Wikis and Massive Open Online Courses [MOOCs]) with joy; he or she is a keen participant of the ELP, the Educational Liberation Front (as yet a fictional organization).

In traditional, frontal teaching, the true agent of learning is not a student but a teacher. It is the teacher who prepares the lesson plan and selects the materials to be taught. In designing the school day and reviewing the materials, he or she also has an opportunity to gain new insights. In a reversed or flipped situation, the possibilities of learning are distributed to all, that is, they are more or less democratized. The flip then contributes to a communicative form of learning, too. At best, transmission turns into collaboration between participants, who in turn transform into teacher-students and student-teachers.

It can happen that transformative work to change the world is not possible in the university, or at least it is disturbingly difficult and frustrating. That is the reason why artistic research with praxis orientation must act wherever and whenever it is possible and needed. In a positive case, the university is among the other knots (free civic associations, grass-roots organizations, activist coalitions) of social, cultural and political movements.

This is often the situation in which an artistic researcher finds himself or herself. The individual realizes that there are few if any safe havens for his or her creative work. This being the case, the researcher anyway needs theoretical, methodological and practical guidance in his or her artistic/research work. C. Wright Mills was fully aware of the same sort of problems that confronted his sociology students in their thesis work, first at the University of Maryland and later at the University of Columbia in the 1950s. Thus, he wrote a short piece on intellectual craftsmanship. He had written it in the early 1950s and had distributed it in mimeographed form to his students prior to its publication as an appendix to *Sociological Imagination* (Mills, 2000b). In the appendix, he guides his readers in the use of their sociological imagination. Among the more pragmatic advice are the following six ways to boost one's imagination:

- Find your notes and files and rearrange and remix them. Re-sort your notes and papers. Try to do it in a relaxed manner. Be aware of the research questions at hand, but be also receptive "to unforeseen and unplanned linkages."
- Be playful; it loosens up the imagination. Play with the phrases and words: look up synonyms to learn all the possible connotations. This sharpens your pen and you will learn to write more precisely. In addition, such an interest in words gives you an opportunity to evaluate the level of generality of every key term. Given the need, you can either "break down a high-level statement into more concrete meanings" or "move up the level of generality: remove the specific qualifiers and examine the re-formed statement or inference more abstractly . . . So from above and from below, you will try to probe, in search of clarified meaning, into every aspect and implication of the idea."
- Search for types and typologies of the notions and make classifications, for "a new classification is the usual beginning of fruitful developments . . . Good types require that the criteria of classification be explicit and systematic. To make them so you must develop the habit of cross-classification. The technique of cross-classifying is not of course limited to quantitative materials; as a matter of fact, it is the best way to imagine and to get hold of new types as well as to criticize and clarify old ones . . . For a

working sociologist, cross-classification is what diagramming a sentence is for a diligent grammarian. In many ways, cross-classification is the very grammar of the sociological imagination."

- You should consciously concentrate on extremes. "If you think about despair, then also think about elation; if you study the miser, then also the spendthrift . . . If something seems very minute, imagine it to be simply enormous, and ask yourself: What difference might that make? And vice versa, for gigantic phenomena. What would pre-literate villages look like with populations of 30 millions [sic]?" The imaginative key is in variations. "You try to think in terms of a variety of viewpoints and in this way to let your mind become a moving prism catching light from as many angles as possible."

- Make historical comparisons and orient your reflection historically. A comparative grip on the materials gives you leads.

- Remember that "how you go about arranging materials for presentation always affects the content of your work." (Mills 2000b, pp. 212–217)

In summing up the roles of artistic research in the social, political and cultural realms, what is needed in the future is the combination of artistic research and liberating education—in the words of C. W. Mills (2000b):

> This role requires that individuals and publics be given confidence in their own capacities to reason, and by individual criticism, study, and practice, to enlarge its scope and improve its quality. It requires that they be encouraged, in George Orwell's phrase, to "get outside the whale" or in the wonderful American phrase, "to become their own men." To tell them that they can "really" know social reality only by depending upon a necessarily bureaucratic kind of research is to place a taboo, in the name of Science, upon their efforts to become independent men and substantive thinkers. It is to undermine the confidence of the individual craftsman in his own ability to know reality. It is, in effect, to encourage men to fix their social beliefs by reference to the authority of an alien apparatus, and it is, of course, in line with, and is reinforced by, the whole bureaucratization of reason in our time. The industrialization of academic life and the fragmentation of the problems of social science cannot result in a liberating educational role for social scientists. For what these schools of thought take apart they tend to keep apart, in very tiny pieces about which they claim to be very certain. But all they could thus be certain of are abstracted fragments, and it is precisely the job of liberal education, and the political role of social science, and its intellectual promise, to enable men to transcend such fragmented and abstracted milieux: to become aware of historical structures and of their own place within them. (p. 189)

7. What to Read, How and Why?

Intellectuals are people who read and who write, and then they discuss and debate. Are researchers intellectuals? Not necessarily, but research is a practice that certainly requires a certain amount of reading, and well, also writing. And, not to forget: arguing about and with, both with the past and the present articulation of the specific theme and field.

But what kind of reading and why?

The American philosopher Richard Rorty (1998, p. 12) caused a stir some years ago by claiming that it is novels rather than moral treaties that are the most useful vehicles of moral education. What we need is imagination, not moral obligation, if and when we are asked to live and if we have to live together and accept others in our dissonant plural realities.

What this might indicate and imply, for a practice of research, and what exactly is embodied within Rorty's idea, the anticipation and aspirations laid upon imagination and creativity, are addressed later in the chapter.

For now, let us start with another route and another kind of platform. It is an outline of the dual aspects of what to read and why to read. This outline is divided into the task of (a) contextualizing the field within which a research is taking place—this is the background and the histories of it, and (b) determining what, exactly, is possible and meaningful to expect from the acts of reading so that something out of it might turn out to be tools for thinking ahead in a creative and imaginative way.

We start with the notion of what one should know about one's own immediate surroundings. This includes what has been done, said, written and produced in that particular section and the areas relevantly next to it.

In the field of artistic research, there has been a sea change in volume between our previous collective effort in the year of 2005 and today. There is more activity and more publications, both more abstract texts on what it is and ought to be, methodologically and structural-politically, and especially texts by researchers themselves finishing their doctoral projects. What has changed in such a short period of time is that now we have something that most of us then were still anticipating and speculating about. Now there are numerous publications as a result of artistic research that are available and accessible. These are there within each specific field from music to fine arts, and they are there in each university and each nation-state. There is no longer any shortage of material that is contextually home grown.

Are these publications read? Are they well distributed? Are they any good?

We have no expertise on the second question, and the third one is out of the focus here, even it is a question that in each case and context should fully and vigorously be addressed, asking the following: what is the current state of the quality of writings within artistic research? But here, our intention is to ask this: are these publications read by their own closest contacts and peer groups, and if not, why, and what are the consequences of this failure?

There are, understandably, no hard facts and data on this, but the recent experiences through all the fields in various departments and universities tell a sorry tale: most of these publications get no attention at all, and it is soon forgotten than the actual publication is even out there—somewhere.

But why? Why is it that, especially in the no-longer-so-new field of artistic research, the attitude toward the intellectual products of artistic researchers is so low? And isn't it sad that now that there are publications on artistic research produced by artistic researchers, they get so little attention from their own kind? There are the common reasons, such as that people in general tend to read less, they tend to be very busy (or at least have learned to pretend to be), they tend to be wanting and they tend to be asked to get deep into their own very specific holes that cut off any other kind of knowledge. In short, the sign of the times and the necessities of specification of academia force all of us to know next to nothing about the publications produced in our own backyards and neighbourhoods.

Thus, we are lazy, and the grass, oh yes, is always greener somewhere else— and the beer cooler, too. It is so much nicer, so much finer and so much more creative to reach out somewhere where one can act as a proper tourist and not be bothered by the gravity that pulls when things sit too close to home.

Perhaps this is the answer, but not quite. There is evidently something in the structures of the doctoral programs that both allow and even support this almost total lack of interest and care for the publications that come out among us or next to us. This comes down to the need for a collective give-and-take research culture that both informs and orchestrates the processes. This research culture, at best, is a localized version of a think tank that has the pulling and pushing power; it gets people to join in and come back for more, and it attracts enough contradiction and exchange that views and visions are challenged and developed. This is nothing other than a set of rules that are nonnegotiable. Everyone attends, everyone reads and everyone opens their mouth—one by one, one meeting after another.

The not so overwhelmingly cheerful experience shows that, sure enough, all doctoral programs are very keen to organize a wide variety of events, both locally and internationally, but their common character misses the very point of trying to create and generate a continuous and local-based research

environment. The discussions are structured so that there is never time for a proper presentation, not to say a full-blooded intensive discussion. What's more, the seminars are too often pitched so that the participants might come for that certain event together, but they would soon enough disappear after it without much of a trace left behind.

Most strikingly, this dilemma is seen in the choices for advisers and opponents: they are gathered from all around and as often as possible from the higher parts of the assumed hierarchy of low attention-span economy, not from scholars and colleges actually working close to the research issues (both physically and discursively) and thus being available and also being participants in the same or similar place-bound and locally driven yet internationally open and interconnected discourse. Big names might make a big splash in the e-flux reality, but they have very little impact on the day-to-day practices of ongoing lived experience-based research.

Needless to say, achieving an organic research culture and a collective is not easy—and it has to be worked on and maintained constantly and coherently, for years. But structural misperception and inefficiency comprise one thing; the personal lack and shortcoming comprise yet another. Why do individual doctoral students so often act against their most urgent self-interest of knowing what is published within their own field, learning from it and using that material so that it makes one's own future product better?

The partial answer is that the neglect lies in the heart of the game. We do all remember that fearful moment—that moment when you are at the beginning of your studies and by some weird reason you find yourself confronting the end result of a doctoral project. You get a glimpse of how it will end, and what you see and what you feel is something you definitely do not like—that particular sad but true end product, the works connected to it, the lame boring blah blah discourse surrounding it. That is simply devastating and horrible, and it has nothing at all to do with you. Because if you have any sense, any self-respect at all, all of you, your mind, body and soul, will sing you this song: I will do better; I will make a difference, and I will sail happily past all the obvious and silly shortcomings of this one sorry character that I by chance had to witness.

Obviously enough, when one starts a process like a PhD, a certain amount of cockiness is required. In the end, we do realize that if we want to hit the target, we have got to aim higher. Following this metaphor, we also need to learn how to use the particular "gun" we want to make that remarkable effect with. And we do intend to make and create a difference. But how is it possible to make things better if one does not know the site, the content, its histories

and the struggles, dilemmas and saving graces, and when one's intuition claims that the less I know, the better I will be?

Deep down and dirty in the human psyche, we do not know why, but what we do know is this: it is simply impossible to label an act as serious and meaningful research if that act is not aware of and does not know what has been published and discussed in that particular field before. Because if you do not know your history, you are not anchored, not situated, not even, well, a researcher. You are doing a lot of other stuff, and perhaps plenty of it is even interesting, but no, it is not research.

It is the past, present and future of your particular field and the similar fields connected to it that you must be a master of, partly because of professional courtesy of caring for what others do and partly because of a common curiosity of how others solve the problems that you have to face; mainly, it is because it is in your most direct self-interest.

Let us be the stupid villains in this story and put a number on it: more than 10. If you are doing working on a doctoral dissertation or any other long project of artistic research, you have to read more than 10 dissertations in order to know what is going on. Of course, presenting a general demand in exact terms is a joke. But the number gives a rough estimate of how many cases of artistic research one has to go through before a certain saturation starts happening: you begin to notice common problems, common ways of dealing with the problems, common obstacles, common ways of avoiding the obstacles and so on. In other words, you begin to get a feel for the ground; you can expect what is going to happen next, what are the likely outcomes and ways of argument. Of course, there will always be something to surprise, something new and so on, but gaining some saturation gives self-confidence and helps also in identifying with the field of research.

The goal is simple: to know and be aware of the past and how it effects both the present and the future. Know it, but do not get caught by it. To know how to relate to and reflect with the past is the act of mapping the terrain. It is the part of "what." After that is accomplished, well, then the fun begins. Then it gets serious. Then you need to do something with the knowledge that you have gathered. Then begins the "how."

How do we read in order to be creative and have a great exploring and rigorous imagination?

Imagination is, well, a change of perspective. It is to think differently, to alter positions, to change points of view. It is to simulate and play with the position you are talking from—as in the coordinates of the lived experience. A point of view, going back to the heart of the matter of phenomenology, can only be achieved step-by-step, one after another, not simultaneously. Following Merleau-Ponty (2005), "things we perceive make sense only when perceived from a certain point of view" (p. 499). What this implies is that whatever we see and feel, it is by its character an act of temporality, bound to its specific time and space. An act that looks and is looked at, it has an effect and it itself is affected. "If the object is an invariable structure, it is not in spite of the changes of perspective, but in that change or through it" (Merleau-Ponty, 2005, p. 103).

Thus, it is not only where you look, or how you look, but also when and why. And, what you find depends on what you are looking for.

Is there anything more to imagination? Perhaps yes, and perhaps in a sense what is central with imagination is that it is nothing in itself. It is, to follow Foucault (1978, p. 93), a productive mode and moment. It is a site and a situation that can turn whichever way—pleasant and positive, brutal and sad. In itself, it is only a potentiality, not a solution, not an answer. There are no guarantees of its colours and consciousnesses.

This central element of its potentiality is also something that must be protected and savoured. It must not be lamented that imagination is neither an entity nor a dreamlike wishing well. The danger with imagination is never far away. It is so inviting to project on it all the things we would want to have and possess.

There are many examples of writers who claim to find, if not a downright solution, then at least a solid promise of a solution, in terms of ethics and politics, from creative acts of imagination. Out of numerous possible essayists, we can here, just as an example, highlight the Russian-born, emigrated writer Joseph Brodsky, who made an important distinction between experience and position, between having knowledge of classical literature and having a higher education. But reading classics has a further implication for Brodsky. He (1995/1997, p. 60) believed that it is much harder for a person who has read a lot of Dickens to shoot another person in the name of an idea, than for a person who has never read Dickens.

Sometimes imagination is seen as something very special and special to a particular field and act. Imagination is then labelled an art, an act of producing art. One of the most prolific of these writers is Richard Rorty,

mentioned earlier (e.g., 1991, 1998). In his now-famous and often-cited essay, "Heidegger, Kundera, and Dickens," Rorty (1991) outlined most efficiently his own thoughts on the comparison between what he calls theory and novel. It is a juxtaposition, the geography of which is very telling. Rorty, as a philosopher, is looking toward something else, something out there. He is gazing into what he feels and sees as the promise of novels—with the help of Kundera, Orwell and others who write about what it means to write novels.

For Rorty (1991, pp. 73–75), the positions and placements of theory and novel are charged and clear-cut. Theory is driven by the aspiration for truth-seeking, while the novel is guided by the spirit of humour. Where the former stands for contemplation, dialectic and destiny, the latter stands for adventure, narrative and chance. The first is essentialist, while the other is defined through tolerance and curiosity. The first, in caricature, is like a grumpy old man, and the other the free spirit of a heroic individualist. As the title of the essay promises, the theory part is played by Heidegger, and the novel's representative is Kundera, especially his writing on the novel as being synonymous with democratic utopia, an imaginary paradise of individuals. And yes, in this comparison, Heidegger is given the part of representing the pretechnological pastoral utopia.

There is no reason to dwell on the accuracy or credibility of Rorty's interpretation of either part of the game. What is of interest to us here is the role that Rorty projects on the act of imagination, coming together in the mode of a novel. Rorty's projection tells a symptomatic tale of his division of public and private matters, something of an enigma for his whole oeuvre of writings. This is a dilemma, if one takes Mills seriously, because the idea of a complete and clear-cut separation of private and public is not valid or in any sense and sensibility meaningful. On the contrary, the question is how these two sides are intertwined and why. It is about their connectedness and their interrelated imbalances and shifts of focus and shifts of power positions.

What is even more worrying, when changing, well, the perspective, is the scale of hopes and intentions an act of imagination is loaded with in Rorty's tale. The role of the novel in this game is so lop-sided with all the good and beautiful and wished for things that choice is not possible any more. When faced with the alternative between theory and novel, who would opt for theory when the novel promises so much more? The main problem is not in the promise in itself but in the presuppositions that are placed upon the ones doing the act of imagination. In fact, it is hard to think of any other more effective starting point for a very hard case of a writer's block than the need to change the world with one's words and wisdom.

Funnily enough, Rorty's examples of the wished for novel are historical, reaching back to the 19th century and beyond, through writers such as Cervantes and Dickens. No contemporary cases of novels are introduced and analysed. The other rather humorous aspect of the great divide is that in this line of thought, Rorty very practically forgets the writers of theory that he otherwise is very preoccupied with, writers who are not essentialist but process-based and very much admired by Rorty himself, such as Dewey and also Derrida.

But not surprisingly, Rorty is not alone. The wishing well kind of a projection of creativity, imagination and art is also found with Zygmunt Bauman (2008), reloading creativity and arts with too high hopes and dreams:

> Our lives, whether we know it or not and whether we relish the fact or bewail it, are works of art. To live our lives as the art of living demands, we must—just as artists must—set ourselves challenges that are difficult to confront up close, targets that are well beyond our reach, and standards of excellence that seem far above our ability to match. We need to attempt the impossible. (p. 17)

This act of living life as a work of art, in our current conditions of a fully individualized society, is lived in acute uncertainty and hesitation, the oscillation between security and freedom, balancing between oppositions of "joining and opting out, imitation and invention, routine and spontaneity" (Bauman, 2008, p. 18).

But do we have a choice? Should we even wish for a life as a work of art? From the viewpoint of a sociologist, Bauman described (2008) it as something positive and worthwhile to be striving for. What about the change of perspective to the view of an artist? Would an artist also want to extend the act of making art into the making of his or her life as a work of art, too?

Certainly, we can make a list of examples of narcissistic artists who happily and loudly claim that their main work of art is their life itself. But that is not the only type of game to be played or made. There are still a large number of artists in each and every field who are seriously committed to work on their production, that is, end results that are objects of sorts, books, records, plays, videos and so forth—and then, before and after that, and sometimes during, but always along with and among, they have and live a life. Why? Because otherwise, if you only do and focus on that one thing, that one thing will in the end be suffocated and static, taking itself much too seriously and self-importantly.

One central question to Rorty and Bauman is this: is it really a good idea to strive toward turning our lives into objects of desire and into products? Certainly, a work of art is and has to be more than just an object to be used, bought and placed, but it is nevertheless also an object. Obviously, both Rorty

and Bauman mean well; they are civilized and educated—but they still miss the point by confusing their private wishes with the internal logic of the practices of the professional group of people called artists.

The main problem with the wishing well of the philosophers here is not only that their view of the lives that artists live is highly romanticized and idealized. Although even this point is, in fact, a danger zone because it entertains the aim of "living and working like artists" as an image without a reality, serving to be posed as a model for what partially already is achieved and is going on in the whole society and its workforce. This is what the sociologist Andrew Ross (2003, p. 258) called the "No-Collar" workforce and, well, whether they are or are not aware of it, artists are used and instrumentalised as a model for this type of precarious work (more so-called freedom and less protection and common rules) to which it is assumed to be willing and able to be fully committed, to work totally flexible, and to sacrifice everything for the sake of the work and not be so interested in the financial outcome of it.

On the practical and day-to-day level, the central serious issue is something that can be dubbed a profile neurosis. The problem is that it fails to comprehend the conditions of situated and committed production of works of art—a production, as in day-to-day acts of making, that is famously lacking in its eloquence and elegance. It is hard work, filled with a lot of anxiety, dead ends and frustration. It is, well, a work like any other work that goes up and down but mostly is located in spirits and annoyances somewhere along the middle. There is nothing spectacular about it, except the fact that it is only in and through the daily working with the practice of what it means to be making art—negotiating a new perspective and strategy with every new project—that results are achieved. (For reflections by artists themselves on the lived experience of producing works, see, e.g., Bärtås, 2010; Donachie, 2008.)

Finally, the confusion of the roles and hopes is based on the hallucination that is projected on what it means to be creative, imaginative, and well, poetic. But creative, imaginative and poetic of what and how? Sure, these processes can be defined by attributes such as exploring, experimenting and challenging. But the life lived by the so-called creative class, the one pathologically determined to be overeducated and underpaid, is never so much about the high point of the glory but the tacky slowness and laziness of midweek afternoons. The other side of the now-silenced picture is then all the other not so glossy and great attributes, such as small-minded, boring, self-righteous, self-absorbed, and well, simply ruthlessly arrogant.

These are sides and side effects of the lives we live that are always there and always point toward this: not anything and everything we do, even if we

would call ourselves artists, is in itself great, magnificent and meaningful. Because, well, if it would be so, we could automatically and dramatically close off any chance for process and evolution. We would land there where the version of an almighty God has been parked, in the story by William Burroughs (1993), told in his uniquely annoying and vexing voice: if the almighty God is already everywhere, it no longer can go anywhere. It is stuck, gone.

Possibility of Reading (Change of Perspective)

If the glorified and in itself exoticised act of reading, such as advocated by Rorty and Bauman, is not the way to go, what then?

A first step toward a strategy is also addressed in Rorty's essay. He highlights the proposition made by the writer George Orwell. For Orwell, the attitude one should take with reading and any intellectual activity is called generous anger. This is then the notion of how to relate to a text, or whatever, an act guided by free-floating intelligence that is not about juxtaposing but opening up different views and their variations. But generous how and in anger with what?—remembering that in anything we do, it is important to choose which fight you pick up and on.

Let us add another step, through a second strategic observation on imagination, especially social imagination and its relation to the fights to pick. The anthropologist David Graeber (2011, p. 50) made the point by telling of a simple school task: boys are asked to imagine and write a short essay on the topic, "My day as a girl," and girls, you guessed it, must write a short essay on the topic, "My day as a boy." In a typical American high school, the girls write detailed and rich descriptions, while many of the boys flat out refuse the task. Graeber (2011) observed the following:

> generations of female novelists—Virginia Woolf comes immediately to mind—have also documented . . . the constant work women perform in managing, maintaining and adjusting the egos of apparently oblivious men—involving an endless work of imaginative identification and what I've called interpretive labor. (p. 50)

The difference reveals a more general imbalance in social imagination. Groups and individuals occupying positions of structural privilege and power tend to know less and imaginatively identify less with groups and individuals in subaltern positions than vice versa. Crudely put, the bosses don't know what the workers and servants think and feel, while the workers and servants spend inordinate amounts of time imagining the thoughts and feelings of their bosses, in order to ego-massage them and anticipate the effects of mood swings on their lives. The imbalance in interpretive labour and imagination is

reinforced by existing social structures and ultimately upheld by force and violence. As Graeber (2011) put it, "The subjective experience of living inside such lopsided structures of imagination is what we are referring to when we talk about 'alienation'" (p. 55).

If imagination in a hierarchical society is systematically lopsided in this way, the task of reading and imagining has to be approached in a particular way. We already know that reading is not supposed to arrive at "the right interpretation," and the lopsidedness of social imagination means that no imaginative act is innocent with regard to structures of power and privilege. Imagining is taking sides. In a nutshell, the interpretive labour and imagination that go into reading and writing have to be ideologico-critical if they want to do something other than reproduce the existing power structures. It is this ideologico-critical approach that is the engine of both generousness and anger in reading. And yes, the need for ideological criticism once again means that one is aware of the history and the present of one's immediate surroundings in some detail. One needs to recognize the situation for what it is, its internal contradictions, relations and interests, analyse and understand those, and then—act.

Writers who look for words and advice from books are not in short supply. There are many, some higher, some less poised, in their positions in the hierarchy, addressing the lives we live through readings and words and wisdoms derived from Proust to Winnie-the-Pooh—not to forget the style that used to be called pulp fiction. But what is there, for example, in any given canonical classic that we recognize and that we might recall with dread from high school—and that we might discover in a list of "what to read before dying" or turning 54 or so?

Why to read the classics is, of course, in itself a classical question—and already a sort of classic of its own, called *Why Read the Classics?* by Italo Calvino (2009), the Italian writer, also previously mentioned and reflected upon here. In the collection of his essays, Calvino underlines how classics help us do the double job of being both conscious of the current situation and aware of the past in the present. Therefore, for Calvino, reading classics is neither a formula nor a neutral matter: it is about positions from and toward something. "In order to read the classics, you have to establish where exactly you are reading them 'from,' otherwise both the reader and the text tend to drift in a timeless haze" (Calvino, 2009, p. 8).

Thus, how much are we expected to known before we can get it? And whose classics and from what sort of *Weltanschauung*? It reminds one of the anecdote about Ricoeur, about how he tried to confront the protesting students at the end of the 1960s, when they asked him with not so generous

anger why the youth should listen to the weary establishment. The so very uncool professor—Ricoeur's outburst of innocence and confusion is telling: "because I have read so many more books than you." But is that enough—the quantity? What about quality? What about pleasure and enlightenment?

Thus, let us take an example that is definitely worth our attention—both in terms of content and its symbolic value in human affairs. Let us take a closer look at Leo Tolstoy and his *War and Peace* (originally published in 1869). As a book, it is a product that is, well, almost everywhere in social imaginations and exists in many forms and formats. It is also a product that has been extensively interpreted, especially in terms of how to write history and what is knowledge of history (see, e.g., Berlin 1991). The product itself focused on here is the recent English version, translated from Russian by Richard Pevear and Larissa Volokhonsky, published in 2008.

If imagination is about change of perspective, what does it mean here, with *War and Peace*?

Contrary to a rather commonly held perspective and hope, it is not so much about what you can learn and understand about humanity and being a human *an sich*, or about comprehending the reality in Russia in the second decade of the 19th century, or, for that matter, when the book was written in the 1860s, or how it has been read and interpreted through the years, and various views and eyes, in different spaces and places, circumstances and selections. Certainly, we get drawn—lured and caressed—into the narratives, into times and days that are very far away for us and somewhat incomprehensible in their inner cohesion and contradiction. The conditions of conditions of everyday life, its expectations and norms, anticipations and hopes, are, in fact, alien to us. So many prime notions of who we are, how we perceive ourselves, in what kind of world and within what kind of structures our lives are orchestrated are simply incompatible with our world today.

Instead of understanding Russia, or the Russian soul, or the generic universal human soul, or the internal struggles of an honourable man and woman, we have a chance to get closer to something else—something that is not beyond our grasp. It is how the reading affects you—how you feel about who you are, where you are and how. You read about that something else, out there, but in and through the act of reading, sinking into the story, and through that sinking, and the alteration of perspective that takes place, something has happened. It is not a spectacular sensation, not a celebration, but something smaller scale, something very close to yourself and your immediate surroundings. You read, and you are affected, pushed around and caressed—and you think, not automatically but semiconsciously. You think about yourself, where you are and how you relate to your environment. You

read within a site and a situation, which are never given but shaped partially in that very moment. It is particular, not general.

The principal effect of relating to and with is this:

1. Me—me
2. Me—my surroundings
3. Me—others

It is not in itself so much about learning about others or having knowledge of something out there. First of all, the act of reading bounces back and hits home—if it makes the hit at all. It is the me-me relationship and a lived experience. It has its specific inherent proximity, but it is not with the surrounding environment or anything to be seen and called as the others. It takes place within the struggles and negotiations of the plural interests and fears existing inside, in a person. The face-to-face experience here turns inward, not outward.

Thus, if we take notice of the necessity of proximity for both knowledge and lived experience, in and through the vast lands of *War and Peace*, it is doubtful how much we can actually understand about anything. But what we get closer to—because of that passing by moment and through the experience we gain and carry along—is something else. It is the realization, an actualization of our being in the world. It is richness, sure, but not a noble activity. It is guided and lighted by our own wants, wishes and fears, which bring together not some pretty picture but a reading that is anchored to the everyday acts of what have you. In the first round, a novel like this brings comfort. If we have the required stamina, it becomes a sort of friend, for a short period, but a friend that you do not need to care about so much afterward. The second round takes a longer timeline and route. You slowly start to think about how you act and how your acts might be seen and felt through your friends and family members. And finally, the third round is the slowest one, the one that you almost unconsciously bring along.

You are asked to read, and to jump out and go along, but then you need to land—in your own circumstances. And yes, hopefully you land both on your feet and with your feet running.

But the point being is it lands you here, not there. And it lands us, in the claim about reading Tolstoy in its connection to Mills—the connection conducted through the central elements of a crime of passion, so to speak, of what it means to be a human being in a particular society, the interrelations and connections between a person and the society. It is not the same content

as in the times of Tolstoy or in the times of Mills, or right now, but the structural interdependency and embodiment are the same.

It is time, oh yes, for a quote, from Tolstoy (2008):

> Man lives consciously for himself, but serves as an unconscious instrument for the achievement of historical, universally human goals. An action once committed is irrevocable, and its effect, coinciding in time with millions of actions of other people, acquires historical significance. The higher a man stands on the social ladder, the greater the number of people he is connected with, the more power he has over other people, the more obvious is the predestination and inevitability of his every action.
>
> "The hearts of kings are in the hands of the God" (see Proverbs 21:1).
>
> Kings are slaves of history.
>
> History, that is, the unconscious, swarmlike life of mankind, uses every moment of a king's life as an instrument for its purposes. (p. 605)

When transformed and translated into the times of C. Wright Mills (2000b), the same matter and the same comprehension of the interconnectedness of the personal and social level, the necessity to bring together the biographical and the historical spheres of an analysis, are stated as a guideline: "Try to understand men and women as historical and social actors, and the ways in which the variety of men and women are intricately selected and intricately formed by the variety of human societies" (p. 225).

In the case of Tolstoy, writing in the 1860s and relating to the events of 1805–1812, the quote focuses on the destinies of kings, but the novel, in and through its over 1,200 pages, goes through the changes and chances of many individuals on various levels of society, albeit typically persons inhabiting the higher layers of the establishment. Through the whole, its coherent proposition underlines the inherent connection of freedom and necessity and the never-ceasing interplay between these forces.

> Freedom, not limited by anything, is the essence of life in the consciousness of man. Necessity without content is man's reason with its three forms. Freedom is that which is examined. Necessity is what which examines. Freedom is content. Necessity is form Only by their union do we get a clear picture of the life of man. (Tolstoy, 2008, p. 1210)

Then again, moving through the years and landing at the post-World War II period, it is Mills (2000b) who is there to remind us, with another hint and another piece of advice that desperately needs to be quoted: "Know that many personal troubles cannot be solved merely as troubles, but must be understood in terms of public issues—and in terms of the problems of history-making" (p. 226). We translate as this: to be understood ideologico-critically, in the above

sense, as aware of the structural effects on our imaginations and interpretations.

What Tolstoy was interested in, among other things, was how history is understood and how it is told. For this, he certainly used a lot of historical writings and materials, which he then brought together into a novel through working on it for five years. In comparison, Mills had a less grand aim: he was interested in how to work better, and to do that with the help of what he labelled as sociological imagination, and to understand both who we are and where, and also how we could potentially make a difference in our sites and situations.

What brings both projects and both specific time periods together is their deliberate and willed anchoring in a both-and comprehension of how we are effected by, and how we also can have an effect on, ourselves and our surroundings. It is the push-and-pull, the give-and-take, of a situated self that Gadamer conceptualized as historically effected consciousness (2006, p. 299). We recognize ourselves as situated actors within a historical realm, an understanding that allows us to confront the necessary prejudices that we carry along with us to any and all circumstances and themes, and that we are not standing outside, but within these situations and prejudices.

> The historical movement of human life consists in the fact that it is never absolutely bound to any one standpoint, and hence can never have a truly closed horizon. The horizon is, rather, something into which we move and that moves with us. (Mills, 2000b, p. 303)

What this all comes down to is nothing other than this: to relate to one's surroundings, to interpret the information and experiences that you are confronted with, is not a given or a static formula; it is a process, in itself an event taking place in a certain time and space—searching for its articulation of a content of a concept, image, symbol, event or act. This is the process of trying to become a place that is singular and particular, a temporary actualization interconnected to its own past, present and future.

In short, imagination.

Personal Takes on Reading—Coincidentally and Randomly Chosen

Case I (by Mika)

Bernard MacLaverty: Cal *(1983/1998)*

How do Tolstoy, Mills and Gadamer fare with the act of reading? Here, a closer look is taken at and with a cultural product called *Cal*. It is a book that deals with the events of Northern Ireland that have been dubbed there as the "troubles." It is a book that is many things: a love story, a tragedy of violent death and a tentative story of a microcosmos of how the ongoing animosity across the confessional divide effects the daily lives of anyone and everyone.

If one would start, and hold up through each and every page all along these guides, the process of reading would end very soon, not later. To have Tolstoy in front of you when reading *Cal* would be the most effective way of stopping the flow. The same goes with anyone, from Mills to Gadamer. What you have is the novel that should be allowed to talk to your self in the vernacular, rhythm and thematic it has decided to argue for. Thus, the principles of hermeneutical dialogue are to be followed. First we listen and listen well and carefully. After that, we relate and reflect, critically yet constructively, asking what it says to us and why.

With *Cal*, what do we hear? We hear a laconic, reduced and detailed story that moves along the events with significant and dramatic flashbacks to previous times. We have Cal, just barely out of his teens, who is involved and now tries to get away from the increasing violence—both to and from. Cal falls in love, first with a name and the destiny it has spelled for himself through his own acts and choices and then later on with a person, whose name is Marcella. Her husband, a policeman, has been recently executed by the Catholic ultras. Cal was, indeed, part of it, not as the one who pulled the trigger but as the person who drove the getaway car. It was this that Cal heard sitting in the car: the injured man screaming in agony for his wife.

But it is first of all a love story, a love in times of unfairness and very limited choices. The structures of everyday life close up and demolish the hope and the chance. Cal ends up beaten up and in disgrace, in prison. Love that was is no longer. Before the end, things get serious. Cal's home is firebombed, and his father loses his will to work and live. And Cal? He is duly playing with cards and options that lead from bad to worse. Hiding from his old friends and their illegal activities, and doing this hiding in the old cottage of the family of the killed policeman while working for them in the fields as a hired hand, he is wearing the old clothes of the man whose murder stands in-

between the newly found love between two lost characters in a rough and raw place.

But how do we read and understand this story? Do you need to be well-rehearsed in the histories of the troubles in Northern Ireland? Is it required that you have visited the place and that you have friends living there? Do you need to have an authentic momentum with the issues?

No. What you need to have is an openness for the story, for the narrative. In short, it is about this: curiosity and the ability to listen, to pay attention, and also the willingness to be taken somewhere. It is not the lure of the real, or the facts, but the lure of the narrative: a comprehension of the cleverness of the structures of the story and how it evolves and comes about. It is a narrative that connects the points between expectation and experience, anticipation and limitations. There is, in the end, not that much in *Cal* to understand. It is a case study, a horrible and traumatic case of lost and lonely individuals feeling slightly less alone and lonely while clearly living on borrowed time.

You read with and feel with—and think of what this says to you about your life here and now—and then, then you keep on keeping on: thinking with and being with. Not with Cal, not with Northern Ireland, nothing that is far away and detached from yourself, but with everything that is close, important and annoying in your own lives and tales. We are talking about stories that go far but remain close—with the chance of getting closer to the magnificent moment of here, not there. Because if and when you feel sympathy, it is not with the abstract notion of love or tragedy; it is by its character local, always situated and embedded into lived experiences, anticipations and dreams, and also fears.

Case II (by Mika)

Will Self: Umbrella (2012)

Here is another accidental case of the act of reading.

It is a novel that I bought, and wanted to read, but failed. I did not understand it, literally. I did not get into it—physically and mentally. I bought it because I had previously read two novels by Will Self and I knew his style, the hyper-textualized and hyper-connotative writing that constantly goes all over the place. I also bought it because of the cover blurb, written by John Banville, another writer whose books I have read, most of them if not exactly all of them, and whom I admire and enjoy very much.

In the cover blurb it says the following: "In these culturally strained times few writers would have the artistic effrontery to offer us a novel as daring, exuberant and richly dense as *Umbrella*. Will Self has carried the Modernist challenge into the twenty-first century, and worked a wonder."

I bought the book because, well, I misunderstood what Banville was referring to with the notion of Modernist challenge. It was my fault and my mistake. I thought the book would deal with the Modern challenge of the last 100 years, of what is consciousness, how it might function and also not function in the spheres of social imagination. But the Modernist challenge Banville refers to is the challenge, not of the Modern project of social structures and biographical decisions, but the challenge of the content and form of what is a novel and how it is written.

Certainly, *Umbrella* is a Modernist challenge. It has, in fact, no clear structure, no chapters, very few breaks, and no chronological order, but a huge and for some I assume entertaining mess of almost 400 pages. I did not get what Self was saying or what he wanted to convey. I got lost, not in any pleasant and productive way but simply in a way that is stuck on incomprehensibility. This is partly because of the flow, the constant cacophony of the writing, and partly, because, well, I guess the richness of the language. I do not understand either the denotative meaning or the wished-for connotative meaning of many words, rarely used words that Self is sporting and playing with, which is to say, good for Self and not that good for me. Or, I got caught; I bought the book, but I could not read it. Not now, but—perhaps later.

But even now, what an effective play and case of a change of perspective.

Case III (by Tere)

Alexandre Dumas, père: The Three Musketeers (published in 1844)

A contemporary lead toward Alexandre Dumas senior, the prolific author most famous for the *Three Musketeers* and *The Count of Monte Cristo*, among literally hundreds of other popular and successful books of adventure and intrigue, comes from another enthusiast of drama and tight-paced narrative, Quentin Tarantino, and his film *Django Unchained* (2012). Here the wealthy Southern slave owner Calvin Candie displays his library to Dr. Schulz, who is distinctly abolitionist. In a discussion on how Candie let his dogs tear apart a runaway slave, appropriately named D'Artagnan, Schulz lets the unsuspecting

Candie know that Candie's favourite author, Alexandre Dumas, was in fact black. Further drama ensues.

This vignette shows one feature of reading that applies generally but in an especially delightful way to Dumas. Books do not relate only to books and other texts but to the writers, their lives and times, and the afterlives that the writers and their books have. Tolstoy is another good example. The "hermit of Yasnaya Polyana" became famous because of his books, but it was his life and example in trying to find a mode of existence that would not contradict his Christian anarchism that constituted the basis of the Tolstoyan movement. That later Tolstoy saw literary work as unsuited for a true seeker of truth only augments the impression of human breadth imparted by the novels.

Dumas was the son of General Thomas-Alexandre Dumas, himself the out-of-wedlock son of a French aristocrat and an Afro-Caribbean slave, who took his mother's name after having been disowned by the father. Thomas-Alexandre rose to prominence during the French Revolutionary Wars, until falling out of favour with Napoleon, allegedly after having angry words with the Emperor himself. Alexandre's family history sounds like background research for his plays and novels with their high-octane emotional twists, secrets and subterfuge, rapid social ascendancy and equally sudden turnabouts. His own life carried the ancestral banner with panache. Quickly rising to literary fame on the basis of his romantic plays, Dumas was the unrivalled master of the roman feuilleton, the adventure novel serialized in newspapers. He would have been rich if he had not squandered his income in aiding friends, starting theatres and especially republican newspapers. In 1851, he fled to Belgium because of a mutual dislike between himself and the reactionary Louis-Napoleon Bonaparte. After spending time in Russia, he took part in the unification of independent Italy, again establishing a revolutionary newspaper, *Indipendente*. These and other adventure-filled travels resulted in an avalanche of newspaper articles and travel books. In modern parlance, Dumas could be labelled a public intellectual.

Thus, despite the fact that Dumas's novels, like *The Three Musketeers*, are overly romantic, crafted to push the buttons of popular sentiment, it cannot be said that they are altogether removed from reality, at least as experienced by an ebullient and restless person like Dumas himself. The age-old and tired juxtaposition of popular and high culture cannot be evaded in the case of Dumas. All the known accusations have been laid on his door: he wrote too much, used too many adjectives, did not know what he was writing about, sold too much and did not even write everything published in his name. All of these claims can be easily answered with retorts familiar from the discussions around popular art during the 20th century: Dumas wasn't writing nonfiction,

artists regularly employ staff to help them produce the works, the novels treat the noble and the royal as humans like any other, thus spreading an egalitarian message where the qualities of the heart matter more than anything else and so on. However, all of this misses the crucial point. The accusations may be true, as such, but that takes little away from the stories themselves. The novels and plays are children of their times, to be sure, but there is no cogent argument to the effect that what Dumas wrote would be systematically detrimental to the self-identity or worldview of its readers. With good reason it can be claimed that a certain type of romantic literature, for instance, the soft porn of the *Fifty Shades of Grey* kind, promotes a patriarchal view of the world. Likewise, some forms of war and spy literature certainly feed a one-sided and aggressive self-identity. The celebration of adventure, friendship, loyalty, purity of heart and noble causes in Dumas may not be suited to our refined tastes, but it is hard to argue that they are something universally detrimental.

Maybe one of the things that helps save Dumas's romantic prose from being hopelessly naïve is its tragic undercurrent. Despite their valiance, his heroes and heroines often have to pay a price, and the happy ending is tinged with the sadness of things lost. In the sequels to *The Three Musketeers*, especially in *Le Vicomte de Bragelonne*, this tragedy is pushed further to the fore. Porthos's fabulous strength finally fails him, and he dies after overstraining himself. Athos finds no peace, and D'Artagnan keeps on doing his duty to royalty even though he finds it harder and harder to see why. The world loses a lot of its lustre, and the musketeers find that they respect and understand their old enemies, the henchmen of the deceased cardinal Richelieu, much better than their current nominal allies. In this way, the world and old age tone down the binary views of the young heroes, and a weary if determined wisdom seems to be forming. Like Tolkien in *The Lord of the Rings*, Dumas seems to be suggesting that the history of the world and the life of an individual run a trajectory where both good gets less good and evil gets less evil, as time runs by. The banality of good and evil is revealed, but this does not lead to a wholesale resignation.

The other unavoidable elephant in the room with regard to Dumas's books is pleasure. The books are fun to read. People have been keeping them on best-seller lists for well over a century now. Maybe there is a more general lesson here, too. Sometimes it may be necessary to force oneself to read something that goes against the grain or to keep reading because one really needs to know. Otherwise, the rules are perplexingly simple: music is good if it sounds good; books are good if they are good to read. "Fun" is only a part of "good" and not a necessary part. Still, the accomplished art of storytelling is something both the reader and the writer should delight in. Terrence Rafferty

(2006) noted the following in his review of a new translation of *The Three Musketeers*:

> In a sense, though, *The Three Musketeers* is nothing but digressions. That's the beauty of it—and the reason Dumas was able to continue the musketeers' saga for another several hundred thousand words . . . No novelist since Dumas has been more irreverent of the conventions of well-made fiction or any more determined to tell stories without identifiable centers . . . His historical novels always wind up saying that everything that matters—love, courage, pleasure and, especially, all-for-one-and-one-for-all friendship—exists most vividly not in the supposed centers of power, but elsewhere: in the margins of history . . .

. . . And Change of Self

> . . . the novel has always been about the way in which different languages, values and narratives quarrel, and about the shifting relations between them, which are relations of power. (Rushdie, 1992, p. 420)

Salman Rushdie is not what is dubbed a writers' writer, a professional who has great credibility among the other professionals in the same field but who somehow lacks a larger public recognition. As is well-known, and for some still a fresh memory, in the early 1990s Rushdie certainly got as much recognition as anyone could have hoped for—and just a little bit more. We now know this as the *Satanic Verses* controversy that, well, completely changed his life. A *fatwa* and a price were set on his head, and a life in the underground, protected by his Majesty's forces, was ahead.

But just before all hell broke loose, Rushdie published a collection of his essays and criticism. These texts desperately need to be reread and reactualized. The collection has a telling name, *Imaginary Homelands* (Rushdie, 1992), and it contains texts from 1981 to 1991. Not so surprisingly, his second collection of nonfiction writing has a very different colour and tone to it—making it a harsh but remarkable sign of the times through an extreme case of personal tragedy and the inevitable dealings with it. Here too (2002), its title is telling: *Step Across This Line*. It is more about what the world does to us rather than what is in the books that we read.

But the first collection of essays sets Rushdie as an essayist in the heart of the debates and discussions of that particular period. It is Rushdie as the voice, a critical yet compassionate voice for the stories of plural realities, hybrid identities and fabulous, not so realistic but very entertaining tales. In the collection, next to still very acute and accurate analyses of what it means to

be a writer—"I am a writer. I do not accept my condition. I will strive to change it; but I inhabit it, I am trying to learn from it" (Rushdie, 2002, p. 414)—he performs a selection of vivid readings of his fellow professionals. They are not at all just people writing from the same or a similar background, from the positions labelled (not without irony) as the empire writes back, but they are writers from all around the globe: Americans, Europeans and Russians.

With Rushdie, we not only get a closer look at what it is to be a writer, but we get a magnificent example of what it means to be an active, curious, never-ceasing and untiring reader. In the background, there is Rushdie's conviction that a novel is a political means because any serious description is a political act. There is also another building block for his acts: we should not allow others to describe ourselves.

But when it comes to reading, and reading a lot and doing those acts of reading well, Rushdie puts the finger where it belongs. This does not hurt, but it does wake us up, not with a sense of relief but with a certain type of a feeling of hope. Reading as an act of thinking with is not an escapade; it is not a flight from one's own realities that always bite. Reading as a situated and committed act is enrichment. Here, you sense a passion, a burning desire. You become more, you gain something, you are adding up even if it never ever stays the same. But you are living a life a little bit richer, nuanced and versatile—and most likely also just a little bit less lonely, too.

At the end of an essay written in the year of 1982 and sharing the same title as the whole book, Rushdie is turning toward Saul Bellow and his book called *The Dean's December*. From this book he takes a motto (Rushdie, 2002) that is worthwhile both to remember and to take with us—letting it carry us along when thinking about what to read, how to do it and how to activate our imagination in any field or situation of lived experience: "For God's sake, open the universe a little more" (p. 21).

PART III

CASE STUDIES OF ARTISTIC
RESEARCH PRACTICES

8. Per Magnus Johansson: What Do You Do When You Do What You Do?

Per Magnus Johansson is a psychoanalyst and clinical psychologist in private practice; his training took place in Paris. In 2009, he published the fourth volume in his series *Freuds Psykoanalys; Inblickar i Psykiatrins och den Psykodynamiska Terapins Historia i Göteborg 1945–2009* [*Freud's Psychoanalysis; Insight into the History of Psychiatry and the History of Psychodynamic Therapy in Gothenburg 1945–2009*]. Johansson is an associate professor and a senior lecturer in the Department of History of Ideas and Theory of Science at the University of Gothenburg. He is founder and editor in chief of the cultural journal *Arche*. In 2006, he received the decoration Officier dans l'Ordre des Palmes Académiques from the French Department of Education and Sciences.

Mika Hannula: As a practicing psychoanalyst, you have been in analysis yourself. With whom?

Per Magnus Johansson: I started my analysis with Pierre Legendre; it was in Paris, in 1979. He was a didactic analyst at École freudienne de Paris, an institution founded by Jacques Lacan in 1964 and dissolved by him in 1980, close to his own death. I was in analysis with Pierre Legendre, who was a professor of History of Religion. He started out as a lawyer and his training was consequently academic. He wasn't a psychologist, nor was he a psychiatrist. He was an analyst, trained at École freudienne de Paris.

So, I met him in December 1979 and we have been working together in different ways up to now. I have translated him, and his texts have been published in the journal that I started in 2002 and of which I am also the editor in chief. It is called *Arche* today, before it was *Psykoanalytiskt tid/skrift*. He was my supervisor and my analyst. We still keep in touch, even if less regularly now.

MH: This characteristic, the analyst being in analysis, is central for psychoanalysis, for the process of studying it and also for the process of continuing with it. As in your case, you have continued your analysis with your supervisor.

PMJ: Yes, the background for training to be an analyst, both today and historically, was Freud's discovery that the analyst is a person who, in a way, is

just like anybody else. It means that he has an unconscious, that he has conflicts and that he is suffering. This was also the reason why there was a necessity for the analyst to submit to an analysis of his own. This became a very natural part of the training to be an analyst. When I started psychoanalytical training after studying at the university, that is, after finishing my degree in psychology, it was an opportunity. It was a possibility. I wanted to talk about myself, I wanted to talk about my history; I wanted to talk about my current situation. There was no doubt in my mind about it, no hesitation. I did not question it.

Even today, a psychologist who wants to become a psychotherapist or a clinical psychologist still needs to be in something that is called personal therapy for a minimum of 50 sessions for each student. Today, there is a discussion questioning this practice at the university in Sweden but up until now, psychology students have been obligated to do it. I think what Freud invented and created, the knowledge that a person in this trade has to gain a certain measure of understanding of himself, is natural and important for people in the clinical field, even to people outside of the psychoanalytic field proper.

MH: What kind of an analyst one becomes is therefore strongly connected to the person one studies with?

PMJ: That is clearly so. And here is one important notion. What is hard to understand is the fact that your path and your way of being an analyst is also decided by who you will meet and what kind of a relationship it will be possible for you to establish with that person, and also what kind of a relationship that person, your analyst and supervisor, will be able to establish with you. This exchange is fundamentally unique.

In many ways, this relationship is comparable with the situation of writing a doctoral thesis. It is a relationship where some things are possible and some are not, depending on the background and particular needs of each person, etc., but also on the way in which the process of writing a thesis is closely connected to what kind of a relationship you can have with the key person in that process and in your life during those couple of years.

People stay in analysis for a long time. If you take, for example, Jacques Lacan—who was of course an exceptionally brilliant person, with great social skills and wisdom, a very creative person—many stayed with him for 20 to 40 years, because he meant so much to them and because they found it really meaningful to work with him. These people became very influenced by Lacan, and by what he—as a specific person—was able to give in that specific relationship.

I have studied the history of psychoanalysis in Sweden and published four books on the subject [Volume 1. *Freud's Psychoanalysis. Points of Departure* (1999); Volume 2. *Freud's Psychoanalysis. Inheritors in Sweden.* Part 1 (1999); Volume 3. *Freud's Psychoanalysis. Inheritors in Sweden.* Part 3 (2003); Volume 4. *Freud's Psychoanalysis. Insights into the History of Psychiatry and Psychodynamic Therapy in Gothenburg 1945–2009. Inheritors in Sweden.* Part 3 (2009)]. The existence of this phenomenon just mentioned is true also in Sweden. There were a couple of persons who made a profound impact within this limited environment, persons training people who wanted to become analysts. They were all marked by this experience, the experience where this one person becomes the centre of your world for a period of time. The way that person acts and speaks is extremely important.

In analysis, it is called transference, which is Freud's own term for it. They say that if you analyse your transference—which is what analysts try to do—you do it to understand to what extent the transference is a kind of repetition. You repeat something that is related to your parents, normally, and now you have another opportunity to understand this transference, to understand how you relate to other persons. By analysing this transference, you become a free person; that is the theory. It happens, of course, but even if you try to analyse the transference it may happen that the person in analysis decides that he/she wants to stay with the analyst, wants to continue to be inspired by him or by her. Others choose a different path, they may stay for say four years, which would be the more classical length of an analysis, being analysed four times a week. During that time they get an understanding of the transference, they analyse it and then they leave the analyst, never to see him or her again. They continue their life, taking that experience with them, but there is no more contact.

MH: Staying with your case, and taking up that fruitful and good comparison between the process of psychoanalysis and the process of supervising a PhD student, nevertheless, and taking all similarities into account, there seems to be a clear difference: that of the level of involvement and intensity, also a difference in intention.

But let me ask you first about the language of analysis. You studied first in Sweden, in Swedish, and then in France, in French—or?

PMJ: My first psychoanalytic training in Sweden was in fact in English, with people from South America and North America. I was in analysis with Sylvia Avenborg from Buenos Aires and then I went into analysis with Enrique Torres. He was also from Buenos Aires, a member of the International Psychoanalytical Association (IPA) and a medical doctor. It lasted for five years, and it was in English. I never spoke Swedish in the

process of that part of my psychoanalytical training. At the university though, teaching was in Swedish, sure. In France, in the beginning of my analyses I spoke English for a while but then I went on to speaking French. After having started 30 years ago, I have since kept to speaking French when in Paris. I am married to a French woman, our first child was born over there and I have been working with French intellectuals all along. So, I spoke French when in analysis in France.

MH: A question of memory and language. It is interesting that you have done your analysis in two languages, neither of which is your native language. I am not claiming that languages are closed up in themselves or that they are parallel worlds, but in recognition of the fact that each language has its own rhythm and its own internal logic, how has this affected your practice, I mean the fact that it is multi-lingual, or at least not monolingual?

PMJ: I can't fully answer this but I can try to relate to it. Yesterday, I was reading a text by Hannah Arendt. She said she was so influenced by the German language that she was grateful to be able to write in English. She wrote in English after immigrating to the USA. For her, there was a distance induced by her use of the English language that made it possible to write in a different way. She was influenced by the German language, by German poetry she knew by heart, for her it was a kind of freedom to write in English.

For me, I don't know exactly how it is. I know that when I came to Paris, in the very early days, I wanted to use English in my analysis, since I was in analysis in English before. So, I wanted to continue with that. But somehow, unconsciously, I understood that if I really wanted to achieve something in Paris, I had to speak French. They had another relationship to the English language than is common in other places and countries, like in Sweden or Germany and Holland. The French language was so important to the French. The culture is so specifically French, and I was interested in the French culture. There was a story on my mother's side that we were connected with the Walloons.

When I was very young, I read Baudelaire and Rimbaud. They were important to me. At that time, early on in Paris, I read an article [Schneiderman, S. (1978). On a case of bulimia. *Contemporary Psychoanalysis*, 14, 273–278] by an American analyst, Stuart Schneiderman, trained in Paris. It was published at that time. He emphasized that if you really want to understand the theory of Jacques Lacan and the theory of French psychoanalysis, you have to do it in French.

This article became very important for me. Thus, I decided to learn French, and I did it in quite a brutal way. I really wanted to come closer to French culture. It was something that became more and more important to

me. I think that my Swedish is in fact influenced by this close connection to the French language. I have had French persons in analysis, I have translated for example, Michel Foucault and French analysts, I have been working together with Elisabeth Roudinesco, who is a historian, I have done conferences in Paris, etc. It has been a work-in-process through the years. French language is both familiar and unfamiliar to me. I feel like in-between two languages. But, I am of course also marked by the English experience, at the beginning reading Freud in English, even if I did it while also reading a German edition. I have always also had English-speaking persons in analysis.

I want it like that. I like to work in several languages, it was important to me. Also, it is true of psychoanalysis that it was always a profession in exile. This being so is related to the fact that it was founded by Jewish people. Psychoanalysis has a Jewish history. In the beginning, most analysts were Jewish. Freud was preoccupied with the question that it should not only be a profession for Jewish people. That is one reason why Carl Gustav Jung became so important to him. But the question of exile and different languages is central for psychoanalysis.

MH: Just adding a small detail to this. So, Schneiderman interprets that it is only within the French language and culture that you can understand Lacan properly. But did Lacan state that himself? Here, I would like to link all this with something that Heidegger stated in no uncertain terms: he said you can only do serious philosophy in Greek and in German.

PMJ: Lacan was so very French and so very close to the French language, and he was—so to speak—*parisien* to such a degree, that for him it was Paris, nothing but Paris. I think what Schneiderman says has to do with the training he got in Paris before returning to New York. He was strongly inspired by the way Lacan taught. The way he transmitted or transformed psychoanalysis and the importance of psychoanalysis, how to understand it—also how to understand the effect of the transference—all of this was deeply intertwined with the French language and culture.

MH: Yes, this brings us to the topic of dealing with the original sources, not the authentic ones, but it clearly is something completely different. Let's talk straight; it's a completely different game if you are doing it from the inside-in or from the outside-in. Like with Arendt, sometimes this fact of entering into a language from the outside, the resultant distortion, this can be very helpful. The distance can make it a bit easier to retain a critical perspective and not take that original point as something impenetrable and authentic but rather as the result of a process of interpretation. It is easier to ridicule with the distance, whether the distance is forced upon you or chosen

by you. You do lose and you do win some, but it is simply a different game that is played.

PMJ: I agree. You lose and you gain, it's a bit of both! There is a basic knowledge which is necessary in order to be able to work with a language. The process of learning and then knowing something is also fascinating. I think psychoanalysis is closely linked to language, as Freud already showed, and I am grateful for these multiple language experiences that I have had.

MH: Let's change track, and let's return to the beginning. This sentence, this rather annoying question "what do you do when you do what you do," comes from John Dewey and was articulated early in the 20th century. This sentence is the central question when studying any practice, and it is not a tautology. It might sound like a bad disco-title but its legacy goes all the way back to Aristotle.

But, about your practice and practices. One of them is the practice of being a psychoanalyst. It is a practice in which you are in a situation where you are trying to speak about things that one can't speak about, things that are difficult to talk about. But that moment of listening, that situation, let us try to focus on it and leave the common old cliché of an old dusty couch aside. That situation however is definitely not an authentic one, it is a made-up one, it is a constructed situation. You meet at a certain time, in a special space; there is a continuity to it, etc. Clearly, there are also the various demands and dangers on both sides. But what I wanted to investigate more closely is the structure of the *how* you are trying to construct and create that situation of listening. And this through the experience of over 25 years of doing it yourself, not in a general or common way but through your personal perspective and in the light of your own experiences. How do you facilitate talking about things that we find difficult to put into words?

PMJ: It is a very big question, and difficult to answer, but something can be said. I think that a psychoanalyst can only work if there are persons willing to put him or her into a position of being an analyst. This means that there are people who trust and who believe in him. This believing is of course hard to define, why do we believe in someone and not in someone else. But I trust patients or analysands to be sensible persons. They hear what you say, they hear when you are silent, they hear how you are listening, even if you don't say anything, and when you do say something, they hear whether what you say makes sense or not, and they realize when it makes sense in a deep sense. And then, when that happens, you become, in a way, an object of hopes and dreams. You feel this: I know that I can speak to him or her, even if you may question this "knowing" at times. But there are other people, other analysts

that you may try to work with, with whom you feel that their way of being present and listening does not make sense.

This point is of course very interesting in my profession. Psychoanalysis is a practice. I am, however, not convinced one form of training is much better than the other. This means that you have to have a gift for this work from the beginning, you have to be sensitive as well as judicious; I just read Leonard Cohen's biography—*Leonard Cohen* by Anthony Reynolds (2010)—and, like it is said there, you also need some luck. You have to meet the right persons; you have to be at the right place at the right time.

Then we also have to remember another important thing: the success of a treatment is not only related to what is happening in the treatment per se, it is also related to events taking place outside of the treatment. If you have a patient in analysis, and that person, while his or her analysis is in progress, gets an important employment, or meets someone who becomes an object of love, then there are things going in the right direction. There are external circumstances that you cannot control, things that can be favourable or negative to the analysis. It is very complicated. Some analysts find that there are many persons with whom they cannot work, and some are able to work with a lot of different people. You don't exactly know why you as an analyst feel sympathy and respect for one patient, and why there are other patients that you have a hard time to understand and to love—in the broader sense of the word. And that makes the treatment very difficult.

Then today, there are patients whose expectations are unrealistic with regard to what your psychoanalytic training has prepared you for. Today, there are children who have had no parents in the sense of the older meaning, people who are marked by a sometimes dismal upbringing, having been forced to try to survive under really difficult circumstances; to use a medical metaphor: there are illnesses that you cannot cure. This is true also within the field of psychoanalysis.

MH: You emphasize the word "today," this being the case today. Now, would you be able to reflect historically on this issue, since it seems evident that there would be a huge difference in the experiences and also the expectations of people living in the early 20th century as opposed to in the early 21st century. What is behind the situation that we have today? Earlier, there were all these wars and dramatic events, and then later on there were all those years of peace and prosperity; how come there are more unrealistic expectations today?

PMJ: It is an important question to which there are several answers. First of all, simply put: psychoanalysis in the times of Freud was for a small minority. These people were basically all married, they worked, they had no

economic problems; their sufferings were psychological. They developed symptoms and these symptoms could be analysed, were possible to try to understand. In this sense, many of the analysts were in a really privileged position.

Today, psychotherapy is basically for everybody. There are hundreds of thousands of people who are in psychotherapy throughout the world. And analysts, dynamically oriented psychotherapists, now and then or pretty frequently, take patients who, in Freud's time, would never have been accepted as analysands.

About a week ago I spoke with Georg Klein, author and professor emeritus of Tumour Biology at the Department of Microbiology, Tumour and Cell Biology at Karolinska Institutet in Stockholm, about religion, something I am really interested in, not because I would consider myself as a religious person, but there is something there that begs various questions, like: what happens to people when they declare that they no longer believe in God? What, in that case, do they believe in? I don't know. Perhaps they believe in money, a new bathroom or a new kitchen. They might believe in going some place where the climate is warmer and sunnier, that this would make them happy. However, I for one think neither the bathroom, nor the kitchen, nor the sun will make them happy.

I don't know what all these people believe in, but I do know many believe in psychoanalysis, or psychotherapy, and many believe in drugs. We live in a period when we are trying, I think, to cope with the fact that religion has lost its former privileged position. Intellectuals believe in writing and reading, that is clear, it is meaningful to us. But there are very few intellectuals. Most people are not intellectuals. Psychologists, for example, are absolutely not intellectuals. They do not believe in reading, they do not believe in writing. They go through their university training and that is the end of it as far as they are concerned.

The fact that so many people are searching for and wanting something they can believe in, is one reason why psychologists and therapists accept patients that were never ever considered as possible patients before. I would not criticize it as such, but you need to critically assess who you can and who you cannot treat and what you can promise a prospective patient, consciously or unconsciously. It is a question of ethics.

Freud, of course, was a very privileged person. He was, especially at the end of his career, from the year 1914 until his death in 1939, an analyst whose patients were mostly people who themselves wanted to become analysts. Freud was a didactic analyst. His patients or analysands were motivated: they believed in psychoanalysis, they wanted to understand something about themselves.

Freud had a very clear-cut definition of who can profit from an analysis. He made a distinction between a patient presenting what he called a transference neurosis and a patient whose problems resided in a basically narcissistic structure. Freud maintained that a narcissistic person cannot profit from an analysis because he or she does not have the required ability to work within the frame of an analysis.

Today, this limitation principally no longer exists. Everybody who wants to engage in an analysis is accepted as a patient. This being so, I however think we need to use critical thinking, albeit without being repressive and denying that fact that we may be facing a person who really wants or needs to talk to somebody. There may however be other and more suitable contexts, contexts that will function better for a certain patient than would a psychoanalysis.

MH: Yes, the aim of this question is to try to get an overall view of the conditions of an analysis, or the conditions within which an analysis can take place. Obviously, this leads us to the recognition of there having been major differences through the years. These hundred years in between are clearly different, but it concerns also the way in which we relate to and see the past; do we think of it instrumentally? Do we try to solve its issues and take care of them and then move on, or do we recognize the past as an open-ended, on-going process that we need to confront and deal with continuously, as something never-ending, a process of continuous coming-to-terms-with?

Another key issue is this: how deep is the understanding of tragedy in one's individual sphere or in a collective sense, thinking of the relation to death, etc. And thinking of how in contemporary times there is a strong tendency to use a great deal of money and energy denying that one day we will all die. It is definitely an uphill battle. I mean, during the first decades of post-World War II, it was impossible to deny the presence of death in daily life, since it was there, before your eyes and visible. Of course, people tried to deny it and look away but it was not possible. But today, we have all these various techniques that make this indeed effective and possible. Now it is possible to deny it, now you can spend a lot of money to wipe death away.

But let us be very specific. How long does it take for you—and I am not asking generally, I am asking about your personal experience—how long do you need to form an opinion of whether you will be able to establish the required connection with a particular patient?

PMJ: It used to be said that the analyst needed 10 sessions to understand this. One session is approximately 45 minutes. Ideally, 10 sessions should suffice; in that amount of time you should be able to do it in an effective and meaningful way.

But let me try to articulate another thing that this brings to mind. Psychoanalysis has a relationship with the uncertainty of human life. This means that for a person who has no interest in what has been written of the human predicament that results from this uncertainty—everything from the Greek culture up contemporary times, say Kafka, Joyce or Proust, Ibsen, or Strindberg—i.e., a person who acts as if he believes only in the superficial aspects of the world—for such a person I am not convinced that psychoanalysis would be of any help. For psychoanalysis to be effective, you also have to be a specific kind of human being. You need to be introvert, interested in the tragedies of human life, wondering what you are going to do with your life during that relatively short period that you are around.

Of course there are central questions, like what has your father meant to you, or your mother, in what ways are you or were you protected, what action, if any, are you taking in order to try to do something with your life and your situation. Like asking: how is your way of assuming your position as a father connected with your own father? These are basic questions related to what it means to be a human being. These questions are the questions par excellence for psychoanalysis. And you can say that a human being who has a close and natural relationship to these questions and wants to understand something about them, this person is also suffering, one way or the other, and this kind of a person, no doubt about it, is also suitable for psychoanalysis.

I really believe, like Freud wrote, psychoanalysis is for some people, not for everybody. This is not a problem, not at all a problem for psychoanalysis. This should be accepted without guilt.

MH: Yes, this is closely connected, not only to what it means to understand human tragedy, but to the vulgar version of an egalitarian society where the idea would be that everyone should be able to do the same as everybody else—and to be able to do that all the time, and everywhere. The things we do and the places we come from are not universal, they are particular, there is no same formula for everyone.

But let me get back to the practicalities of the 10 sessions. Within those ten sessions you meet, can you say something about this initial setting and its terms? Not like how to do it, but what are the main pitfalls to avoid in order that a session would be functioning like it should? What makes it better, and what makes it worse?

PMJ: There is no fixed or absolute answer to this. It is fundamentally individual. There are, however, some useful criteria. These are: does the person really want to talk to you? Does he or she listen to what you say? Does he or she bring up material that can be considered as psychologically relevant? Are you able to detect a willingness on the part of the potential patient to

continue to work on this? Is the patient capable of working—i.e., is he able to work towards an interpretation of a psychological question? The question is whether there is an open attitude, an understanding of the fact that a statement can be understood on more than one level and interpreted in more than one way, in fact that there is indeed always the question of interpretation, that there is not one, but several psychological readings and understandings of what was said, different versions; what was said is not the final word. The interpretive process is forever present.

In a way you can claim to establish a relationship that has on the one hand a democratic quality; its foundation is the dialogue and exchange between two people. On the other hand, the patient will—if there is to be an analysis—place you in the particular position that is the analyst's. The analysand needs to have some kind of expectation that you will be able understand more about him than he himself is able to do. That there is a some kind of connection between you and him, that the analyst's presence makes itself felt and makes you believe that together you will be able to understand more about your situation than was possible before, feel that there is actually a real question that, together, you will attempt to answer. I often say, when lecturing, that there is a similarity between psychoanalysis and research.

Both disciplines harbour genuine questions, and in both disciplines there will be a genuine and serious attempt to find answers to those real questions. Within an academic setting you ask someone to be your supervisor because you know he or she knows more about your chosen topic and will be able to help you. I believe you can help me in this and will do so in order for me to make progress and I think we can do this together. We have different positions but we are working together. Psychoanalysts often stress this: it is a question of working. You work, and then you work some more.

There is another, related problem. Or rather, the problem can be turned around: mostly, psychiatric treatment—like taking pills, putting your trust in pharmaceuticals—requires no effort or work. In contrast with psychoanalysis, it allows you to be ignorant. You can sleep through it. You can think about nothing, and then it is over. The treatment consists of swallowing the pill.

MH: Yes, this is a clear-cut case of one-dimensional instrumentalisation: on the one hand, there is the problem, on the other hand there is the direct solution. Instead of living with the problem and dealing with it while trying to work through it, you get it fixed for you.

PMJ: No medical doctor will ask you to keep on working on the problem. Once you have been given your medicine, it is over. Nothing more is required. More than: you should not smoke, not drink alcohol and you should try to be

physically active. Psychoanalysis on the other hand is about working, working together with that particular person who is your analyst, being required to make an effort, having to think about what you have said, having to reflect on that and on what your analyst may have told you. There is a clear parallel with the relation a doctoral candidate has with his supervisor while in the process of writing a doctoral thesis. The student may choose to disregard and refuse the supervisor's comments and recommendations, but then it is over. In this case there is no collaboration. The thing is, not everyone is able to collaborate.

MH: Work. In fact, this can be said to be the starting point, really, with the connotations this word has in many languages; there is the whole range of different meanings of the word, from manual work—just think of Charlie Chaplin—to this completely different version of work that relies on its internal development and quality and meaningfulness to keep it progressing instead of condemning it to endless closed-off repetition. This discussion also has, and now we are back to Arendt, a connotation to the often heard and used claim of not being responsible: I am not responsible; I was just doing my job, and so on and so forth. Really, it all comes back to this concept of working, of working through.

But let's try to get back to this again. Obviously, there can't be any definite criteria, it is a human situation that you can't determine beforehand, and you need to accept that. But there is always something in these processes, something that is called, for example, tacit knowledge, or internal values of a practice, some quality or element that, if present, makes a practice better or, when not there, makes it less worthwhile.

What if you turn it the other way around? What are the things you should absolutely try not to do or force in your practice? What are the criteria for a catastrophe?

PMJ: This is a question that also depends on the way that a particular person is structured. Today, you often encounter patients who suffer from the inability to choose. I am supervising therapists in training at the university. It happens that a prospective patient will tell his therapist-to-be that he has been in treatment and that this went really well, but that now he is thinking of trying something else. In this case I would be having serious doubts about the meaningfulness of the process.

Motivation is really important. It is also very important that a patient will be able to choose to commit, which means that the patient can say "I am prepared to do it with you and nobody else." People might try Buddhist meditation, drug treatment, various group therapies. This effort to try everything and anything soon becomes too much of nothing. In fact, by trying to choose everything, you choose nothing instead of choosing something.

Obviously, it is quite possible to have a patient who, at a particular moment, needs medical treatment and this, of course, is something you have to accept. However, what you cannot accept is a patient trying to have several psychological treatments simultaneously.

MH: Ok, another analogue, a naïve one. The similarity between psychoanalysis and research is clear, but there is also a similar element in a serious and committed conversation that could compare with what goes on in a psychoanalysis, and by that I mean a conversation like the one we are having right now, the exchange that is going on between me and you, the kind that requires a give and take to be meaningful. I am talking of a genuine conversation.

Now, what are the criteria for a good, genuine, conversation? The ABC rules are very clear. Both parties need to bring a kind of good will to the situation. To be able to have that kind conversation, you and I must both be motivated to take the time needed. The two of us have to be looking in the same direction to be able to argue about what we see and what way best to look at whatever we are focusing on. We need to agree on the name of the game we are playing; there is no sense in one of us playing basketball and the other playing handball. So far it is quite simple. Then, of course, you also need a certain amount of luck. But, returning to the before mentioned elements of "presence" and "making things possible"—what are the ways of making it possible for a conversation to happen, not blocking it or standing in the way of it?

This is a subject that lends itself to the writing of extensive texts and long books by people who use qualitative research methods, but the basics can in fact be fitted into one A4—in fact that you always, always need to deal with a particular situation. There is no way out of that—it comes down to a particular situation, this situation rather than that one. Facing it, living it and then saying something about it.

PMJ: I agree, completely. As a scholar and as a psychoanalyst, I believe in reality in the very concrete sense of the word; I believe in empirical reality. I have made hundreds of interviews—hundreds of them for my books—and you can never know in advance what will happen when you sit down together with someone. Something will happen, and I think that a psychoanalyst who effectively functions as one is capable of this presence, this difficult-to-capture act or quality of being present in the moment. What it means is that he is there, with that particular person, because that person interests him sufficiently for him to be willing to be there and also sufficiently for him to be able to be there.

But—and this is something very important—there are times when he will fail to be there. There is something that, until now, we have not yet spoken much about and that is the unconscious. Because even though you may want to be together with somebody, now and then it happens that you can't. You may well want to love somebody but may find that you can't. There is another possible scenario; you may at first find yourself lacking the motivation to listen to a certain patient, then, suddenly, you hear something. All of a sudden there is something to capture your attention and your interest is awakened. This is a difficult moment to define and it is very hard to pinpoint or to understand why, exactly, something does or does not work at a precise moment.

What I believe is this, and this is a radical view, which of course can be criticized. But what I believe is that some people have a particular sensitivity or susceptibility from the very beginning—and others have not. They either have it or they don't. Why? I have no good explanation. But this is how it is. And those who lack this susceptibility, even if they train for decades studying psychology, it does not help. Some people love to work with patients, they love to listen, they love to hear what the others have to say. They are simply interested in those questions, and this inclination is authentic. It doesn't result from a particular attitude, nor does it stem from something they have been taught, either to be or to do; it's just there.

MH: When did you first realize that you had this sensibility?

PMJ: I would answer this in two ways. Firstly, my parents owned restaurants and hotels. I happened to be passing through a restaurant, in Gothenburg; I was 17 years old. There was this Swedish singer, famous at the time, Monica Zetterlund. She is dead now, but she was there then, together with someone, she was known for her performance of this song (translated from English in 1961), called "Sakta vi går genom stan." It is about Stockholm. Anyway, I saw her there in the restaurant, and she was crying and she spoke to some guy there; they were drinking wine. They were there, together, talking. In a way, this memory of two people talking to each other in the night, telling the truth or trying to, suffering; I still remember it, that moment. I knew that something was happening between them, something meaningful, for them, and to me. I never spoke to them. I just saw what happened between them. I somehow realized that what I saw was really meaningful, it was not just anything.

MH: And secondly?

PMJ: Secondly, I would give the following answer: I noticed that people who came to me realised that I was interested in them. I also noticed that they wanted me to listen to them. Some supervisors also told me that this was the case. I was working with Montague Ullman—he was a professor of psychiatry at

the university—he wrote and recommended me to a couple of people. I guess you can say that I was supported by some of the teachers. I noticed that patients wanted to see me and I was motivated to work with them. So from a young age I started to work, and work hard; this became my reality from the very beginning when I started my training in 1974. Ever since, these issues have kept me hard at work.

MH: I think this here is a central notion. This feedback you just mentioned and its importance for the things we do and the way in which we do them. The internal values of a practice may be such that something in the act of performing it feeds into that very performance of the thing. And it will result in the choice of one particular direction rather than the other.

PMJ: Yes, if I had not gotten the feedback, I would have been obligated to do something else. That is clear.

MH: Yes. As we go forward we have yet to mention desire—although it has somehow been addressed all along anyhow . . .

PMJ: Yes, I mean, another way to say it is this: what, in fact, I have been talking of is desire, the desire of the analyst and the desire of the patient. Psychoanalysis is a game where desire is present. Let me also say that I noticed how the practice of psychoanalysis became a passion for me.

Then, what happened was that I needed some kind of a distance in relation to that passion, and I managed to obtain that distance when I started to work at the university again, writing and publishing. What I had was a real passion and a real desire to understand how to understand the other, to listen and to make those things work, make them function. For this I had to have some kind of a distance; it was absolutely necessary. Without it I wouldn't have been able to go on.

MH: But let us return to another dramatic issue that you brought up. Even if you have the training, even if you have that sensibility and you know what you should do, there is always that one word—the ever-present unconscious—that will keep us company along the way, that phenomenon that will open up stuff or close it down, stuff that you can't really control, things that may go wrong in an even worse way if you are determined to control them in spite of everything. So, in your experience, what happens then? Let's say, you try to be present but you fail. Then what? I am not talking about patients here; I'm talking about you, as a psychoanalyst. I realize that it's a big issue, but the cruel reality of it is that it happens.

PMJ: Yes, it does happen. I can tell you something in connection to this, something kind of funny. I met a friend of mine, Johan Cullberg—he is a well-respected psychiatrist and psychoanalyst—at an occasion where he gave a talk about August Strindberg. Anyway, we met and talked. He came to our house

and when it was time to go home, he said to me: when you have a patient who is not very creative and not very co-operative, don't you wish that you could just finish the treatment? (laughter) I was surprised to hear this really well-educated and well-known person all of sudden putting it like that.

But to put it differently, you may say that if you are absent for too long periods of time and too frequently with a patient, the treatment will stop.

MH: You are saying that, in such a case, the treatment would stop, kind of organically?

PMJ: Yes, and if it continues nonetheless, if the patient insists that it should go on, this is really bad. It is very destructive; not good for the patient. It is not at all productive or healthy for the patient.

What can complicate the situation is when this happens within a long process of treatment, and keeps happening too often, maybe after years of working together. Then, I think, from an ethical point of view, the analyst should be obliged to seek supervision; the analyst then needs to understand something about what is going on with him. Because your absence amounts to a form of aggressiveness directed towards the patient. It means that you are no longer taking the responsibility that you should towards your patient, and this is not acceptable. It is a difficult situation, and you are dealing with serious matters. If you indeed take the life of another human being seriously, you must never forget that, when such a situation arises, what is at stake is really that person's life.

MH: When was the last time this happened to you?

PMJ: I am still in supervision today, continuously. I go to Paris, for many reasons: Paris is home to my family, and when there I see to it that I meet with Legendre. Nowadays I do it approximately five times a year. If there is something that I feel I need to talk about: if I am confused or disturbed by something in my own life or in my dealing with patients, I talk to him.

MH: So, you gain and generate this needed distance through constant reading and writing, and also with the continuous contact with your supervisor. That has been a relationship going on now for over 30 years, a certain kind of luxury in a very positive sense, since this continuity obviously also feeds the tree, so to speak.

PMJ: Absolutely.

MH: Five times a year. Now, how should I phrase the question? Are you like two old colleagues, then, who meet over dinner, or how is your meeting structured?

PMJ: It depends, I can raise personal questions or professional ones, and well, there is of course a very close relationship between us. He knows who I am and what I do, but it is also a professional meeting. Our meetings are not

about us being friends; they are about us doing analytical work—and I am there in order to continue to make progress in my work and to be able to take the patients I am working with seriously.

MH: Now, this is a really nasty question, but I can't help but to ask it: what will happen when he is no longer around?

PMJ: He is now exactly 82, being born in 1930, and I was born in 1950. And when he dies, yes, he is as close as family . . . it will be sad, very very sad. And that is life.

MH: Reversing the question, what about you? He is supervising you, but how many people are you supervising—kind of giving back what he gave to you?

PMJ: Many, many people. On a continuous basis, the more intensive and long-term kind of supervision, around 30 people.

MH: That is a big number and a huge responsibility?

PMJ: Yes, of course. I know it's a big number. It happened gradually and unintentionally.

MH: The volume is amazing—is it possible to manage? Clearly, even if there are different intensities and even though, on a long-term basis the intensity varies from one case to another . . . still, it's a big number. Like in a PhD situation, I think it's very difficult if the number exceeds 12 or so. But then again, these are of course different things.

But is there a collective way of addressing these issues in psychoanalysis?

PMJ: No. Collective things are things like the journal I produce and edit, from a clinical point of view there is no collective.

MH: There are of course conferences and so forth, but no groups.

PMJ: Yes. Another difference is how often you work with patients. In Freud's time it was about five times a week, but I see my patients once or twice a week, and this is how I have been working all along. Of course, I want them to do their best in accordance to their capacities and am motivated by these things, so, as long as I am healthy, I try to take this responsibility.

MH: This long-term aspect is really interesting, because no matter how unfortunate, our current conditions of life are such that so many things counteract this idea of a long-term commitment, in all areas of society. There is a certain hysterical need to get results faster and faster instead of letting things develop slowly and organically.

PMJ: We can address the issue of the so-called crises of psychoanalysis, and the difficulties that face psychoanalysts in our times, but for my part, I can say that I have never been touched by the crises of psychoanalysis, not for one single moment. I have never had as much to do as I have at this moment—the need is indeed increasing.

MH: What do you say to people making a business out of saying that psychoanalysis is in a crisis?

PMJ: I don't know. Actually, I believe that there is a strong need to meet somebody who is capable of relating to another person, deeply and profoundly and seriously. Someone capable of saying something to another person, of listening to him or her, someone willing to remain accessible for as long as it is needed.

MH: Then again, we know that in the countries where we live and operate, the social and political structures do their best to eliminate the chances of a long-term commitment.

PMJ: Of course.

MH: So the chilling truth is that, on an individual level, the need is increasing, but on the structural level, that need is suppressed and strangled.

PMJ: I believe in continuity. I have been studying and working at the university, at the Department of History of Ideas, where I met Sven-Eric Liedman, professor in that field. He supervised my PhD—*Freud's Psychoanalysis. Points of Departure/Freud's Psychoanalysis, Inheritors in Sweden*—and we are still, to this day, working together.

MH: OK, let me ask one last question, connecting the theme of desire with the experience of listening to you and seeing you talking about these things in public. Having just watched you talk and perform, and noticed your physical presence, a funny comment comes to mind, a comment that a friend of mine, a female artist, made. Having watched you and listened to you, she said: Oh my, I really don't want to be left alone in a room with this guy. What do you say to her?

PMJ: I think it is probably the right decision. For her and for me.

9. Wolfgang Krause: A Place for Imagination—Three Projects, One Discussion, Four Annexes

Wolfgang Krause, born in 1957, studied at the Dresden Academy of Fine Arts and worked as a teacher at the Weissensee Art Academy in Berlin, Germany. He has focused on interventions in public space, especially in the area of Prenzlauer Berg, since the fall of the Berlin Wall (see http://www.wolfgang-krause-projekte.de). He has participated in various international projects in public space. He was also part of *Good Life–Physical Narratives and Spatial Imaginations*, Belgrade October Salon, 2012.

Mika Hannula: We will intentionally begin in a naïve way. You are sitting on a train, it's boring. At some point, the person sitting next to you asks: What is your profession? How do you answer?

Wolfgang Krause: I make art projects.

MH: All right, but then he asks: What are art projects?

WK: They are projects in a public space or in exhibition spaces with other artists. They are inscenations—inscenations of installations. It is a form of directing.

MH: Do you see yourself as a curator or an artist—or both?

WK: The inscenations I create are works of art. It's always art in communication with others, in an open form.

Nachtbogen [night arc]

MH: Chronologically, the first of the two selected projects from the early 1990s (*nachtbogen* & *Knochengeld* [fake money]) we'll focus on, is *nachtbogen*. In hindsight, what was most important about *nachtbogen*?

WK: Before that, I have to say something else. Namely, the fact that I grew up in the DDR, in East Germany, in the Soviet occupation zone. I studied in Dresden. But what we learned there was not at all required by the cultural policies. The school was an island but there was no demand for those contents in the outside cultural life. After my studies, I went to Berlin, but all the galleries in East Berlin were taken by the Comrades.

At the Dresden Academy for Fine Arts I realized large-scale inscenations during a four-year period (1980–1984), with many participants. In the process, the entire Academy was remodeled several times. However, there was no possibility in Berlin to continue this form of work, especially in larger scale. I didn't want to realize my work in a church. It still represented a shelter for me, but not an option. It was too religious for me. There was no possibility in the country for me to work in larger scales in public space. Only after the 1989 change did it become possible for me to work in the public space and to act as a citizen. Also, it needs to be said that I grew up in a country without a sense of social belonging. There were no social problems that were openly discussed. However, the precondition for projects such as *nachtbogen* is always a free country, not a dictatorship. After the change, one could apply for funding and work publicly again.

MH: Let's discuss a biographical detail for a moment. The years between the end of your studies and the fall of the Berlin Wall. Did you consider leaving your own country?

WK: Unequivocally, yes. To go away. But the problem was my family. I have three sisters, one was at the university and the other two worked in the field of pedagogy, so if I had gone away, my sisters could not have worked any more. The question is how to solve the problem in the family. In my case, two sisters clearly wanted to leave. However, my parents would have stayed home without children or grandchildren. Going away implied that one would have to cross the border first and get to the West. However, the second issue was that one could never return to the city one grew up in. Eventually, the entire family would have to go away and such responsibility was difficult. It happened, though, that the 1989 change clarified everything. All of us wanted to go to the West, the whole family. My documents, half of my works, everything I needed, was already there. That is why I spent years living out of suitcases. After my studies I knew that I have to leave this country but I didn't want to get shot and I didn't want my sisters or my parents to end up in prison.

How do you resolve that? Between 1984 and 1989 my friends and I always lived out of suitcases, we were not really living any more. We sold everything we could.

MH: What does that mean?

WK: You didn't have a home any more, you didn't rebuild anything because it was clear that in many respects there was no future. As far as leaving was concerned, it was clear that one could not take anything along and that one could also not start human relationships that were impossible to maintain later. Close friends always knew that.

MH: Ok. *Nachtbogen*, version one, fall of 1991. Where did the idea come from for this project?

WK: Immediately after the change I founded the "im Dreieck" [in a triangle] gallery at 6 Oderberger St. with my friend Matthias Körner. The triangle was comprised of Matthias and myself, and the artists.

Developing and implementing ideas in context, together with the artists: space-oriented, site-specific, unique temporary works. I selected Oderberger St. because I knew this street very well. *Nachtbogen* took place in the city and the architectural space of the street—houses, façades, passageways, footways, partially the cellars, ... all possibilities were to be used in order to create an impression of a free ambience. The individual works were exactly thought-out for the street space and they were supposed to be easy to experience for the visitor. An open experience rather than a gallery space. The whole street was a cross-media inscenation—without the visitor's fear when setting foot on the island of art. Here we have to go back again. I come from a small country. DDR had a population of 17 million, a little bit more than the Netherlands. The country was "walled up" from the outside, people were only leaving. Interesting people never came. We were always alone. After the change I could work publicly but the city also opened up and we were host to all of Berlin. Look at our district, look at our houses—all the houses were open and one could come inside and simultaneously feel art and context. Everything happened concurrently.

MH: Back to *nachtbogen*: What was most important about the whole project?

WK: The most important was the fact that we succeeded—this triumph— that something was *possible* in the public space, that one was a responsible citizen of a city and of a country. In the past the police controlled everything, now the police is tasked to support my projects. It was a lot of work and a lot of organization, which was also cumbersome at times. Getting permits from the environmental agency, civil engineering office, everything that goes along with it, installing electricity, traffic signs, roadblocks, making it work, and that the artists in the city don't work hidden somewhere in factories, but that they're "here" and belong to the society.

MH: What happened between then and now? A brutal question, of course, but still. The district where you live and where you have worked for more than 20 years is almost beyond comparison: between 1991 and 2011 approximately 80% of the former inhabitants moved away. Where is the hope now?

WK: That time is over. The renovation is still ongoing. But it also needs to be said that until the late 1980s Prenzlauer Berg was a destroyed district.

You could still see the bullet holes from the war, ruins, burnt houses, missing houses on corners...

But there was always room for imagination in the ruinous city. Today the view doesn't go further than 20 meters, to the next block. Back then, the view went beyond: above spaces between buildings, above garage roofs and further. Those are always places for imagination: "there could...," "there could have..." What used to excite, inspire and drive me in this place does not exist anymore. It was a unique period of a radical social change and I decided to work in that time and with those spaces. I don't want to surf—I want to work with spaces I know.

MH: When was the point reached when nothing here could be moved further any more?

WK: It is relatively clear to recognize: with the completion of the renovation and the rising rents. On the other hand: imagination never ends. There are other districts, there are other cities—and inspiration.

Knochengeld

MH: How did it start back in 1993?

WK: The idea came from Bert Papenfuß, the poet. I invited him. He proposed the project. It was logistically an entirely new dimension, in all respects. We were a group of four people who realized everything.

Our group was named Ioë Bsaffot. It's a made up name, an alter ego. The name also came from Papenfuß. It does not stem from the German language but from a special language called Rotwelsch which was particularly used by robbers. It means: "counterfeit papers." This name worked for us as protection from the law. Also, it is strictly prohibited to produce money and to install monetary cycles. We asked more than 50 artists to produce a new banknote. Each banknote was printed in 100 copies. During a seven-week period, businesses, cafes and stores accepted our fake money as money and a means of payment. The gallery became a bank. Once a week it was an exchange office: Deutschmarks and fake money were exchanged at a 1:1 rate; one could shop and pay in Prenzlauer Berg and in Mitte and when necessary, Deutschmarks were received as change. The principle was the devaluation of money. The money was supposed to be devaluated. If you didn't use your money for a week, it was worth less the following week... Money should not be "hoarded." It was clear: the monetary system of the Federal Republic of Germany was not functioning. High interest rates and income without performance for the rich, large assets became larger...

At the time, we first had the East German mark, then the Deutschmark, etc. The great thing about it was the motto: artists make money. That is the dream of an artist: you can make your own money and pay with it. It worked. I lived seven weeks with that money.

MH: Twenty years later: what was most important about the *Knochengeld* project?

WK: It was a piece of art and a piece of robbery. We were the first alternative money project in Germany since 1900 that was not halted by the judicial authorities or the police. All the economic philosophers and experts in monetary theory who speak about alternative money, who studied it and taught about it, had no courage to start something like that themselves. Later they came to us and partially held their classes here.

We were the first to practically implement those ideas without thinking too much about it. A pirate piece and a fortunate one, too. We were also fortunate to have the press help us. From the first day we had very good, knowledgeable articles in the *TAZ* about alternative monetary ideas in England, Canada, etc. On the second day, the *Bild* daily got involved. And after that, a day later, it was on all news stands: Prenzlauer Berg is printing its own money. It resulted in more than 100 newspaper articles about the project, a full page in the *ZEIT* weekly, various TV programs.

By the way, about the monetary union: Everything was going so fast, you could exchange only 1,000 or 2,000 East German marks at a 1:1 rate, then it was all over. As a consequence—and that was noticeable here in Oderberger St., as well—none of the people from the East had money to invest in houses. Only the Westerners could do that. That was not convincing.

MH: Well, it was convincing, in their colonial principle...

WK: I want to add something about *Knochengeld.* The practical part of it was interesting: we had to keep incredibly intensive communication with the businesses. We were all completely at the end of our strength. Each day we had visitors who supported the idea and wanted to exchange money. The new money was running out.

It was a communication project. A new dimension of my work. Back then, even the universities moved their classes to the gallery where *Knochengeld* took place. In regard to my practice, I can say that I have paid with fake money and was able to survive doing so. We wanted to incorporate the different city scenes—Tacheles, Tödliche Doris, Endart, young and established artists. A. R. Penck was best known and Strawalde [Jürgen Böttcher, filmmaker and painter] was on board, as well. Penck was aware of giving great support to the project with his involvement. He was also familiar with the laws and he said: you'll all land in jail, only I will get away with a fine.

MH: This incredible amount and intensity of communication. What else can you say about it—what was important?

WK: It is interesting to communicate with so many different partners and having to adjust differently to each new partner. Each conversation is led on its own basis. In fact, you need a promoter or other help in order to be able to stick to your idea. On the other hand, it is very enriching to network with so many participants. It reflects the diversity of our complex lives.

MH: Is the alternative in reducing and focusing everything a little bit?

WK: No, but when you have money, you can delegate. You can get good people when you've got cash. The mediated and sponsored positions represent too much of an energy loss.

Schulschluss [school closure]

MH: Project number 3 in our conversation.

WK: Yes, that was fine.

MH: How?

WK: Two or three things came together. The first was that Inge Mahn [then a professor for sculpture at the Kunstakademie, Weissensee] had offered me a teaching commission, in terms of doing projects. At the same time the school at Kastanienallee was to be closed down and moved, the buildings moved—in any case no artists were supposed to occupy it.

For me the situation was ideal. I was working for an academy and had the backing of that institution, and I had young students who could also help me.

The school was to be closed in three months.

But there was also something else in this project. Namely: we have all been in school, for 10-12 years, we know the classes, the bells, the tables and all, the photos. And in these moments all the memories come back. I didn't want an art project in the ruins. I wanted to focus on this particular school—on this feeling that someone was here yesterday with the school bag, that someone had forgotten a pen there, precisely this moment of arriving one hour after. What kind of pictures does it awaken?

The school was not closed, the move was postponed 17 times. In the end, we spent two and a half years at the school. And for me the school was also a very important point with regard to the whole district and its social life. A school is always a meeting point—not only when the parents come to the school but also for sporting events and for different hobby clubs.

We did two bigger and two smaller projects. And then for the real closure in February 2005 ... *die Leere* [the Empty]. With artists and students from Dresden, Halle, Düsseldorf, Wien & Helsinki.

MH: *Die Leere*, 2005.

WK: The important thing was to discuss these issues with the invited artists and students. Peter Müller built an archive, working with a whole class, the school kids themselves describing memories, dreams, future plans. Or with Bettina Hohorst, packaging sculpture, her own packaging for the sending of the buildings. And many other projects.

At the same time the issue was municipal politics and the opening of this space for the consciousness of the residents. The school was to be sold, no discussion. With these art projects we managed to make that into an issue, to question what does such a school mean for the whole city district. It was Art Project Plus. To open up and show what was happening, make everyone aware of what is going on—who is selling the school. The project certainly caused that the school buildings were not sold but rather leased out.

I am in general against the selling of municipal property. One should not sell our water or air.

MH: What was most difficult?

WK: The whole logistics. All the needed authorizations, the communication, 40 artists, 30 other partners. In the end the headmaster of the school was also against the project, but did not tell it to us. The problem with the headmaster and the chief janitor was really bad, we even considered giving up, but decided to go on.

We could continue because I had booked the Senator, and the mayor of Pernzlauerberg-Pankow to speak at the opening. Also the rector from Weissensee, mobile services and property management were positive. And so we could go ahead.

MH: Conclusion?

WK: Of the entire period?

MH: Yes.

WK: It was a luxury. It was always self-realization; I do not regret one moment. I have accomplished everything, almost everything I wanted.

MH: What about hope? Where is hope?

WK: Hope is inside me.

Annex I–IV (Wolfgang Krause)

Annex I–Art in City Space, Art in Public Space

The precondition is a free, democratic society in which a responsible citizen can become involved in the public debate/public life, in a self-conscious, free and creative manner, as a way of communicating with different fellow citizens, thus being able to articulate and participate. In that context, I particularly like the formulation by Albrecht Göschel about urban space "as a civic encounter with the unknown." I want this encounter with the unknown to happen in the public space, not alone at home, in front of the TV.

Annex II–Project Practice I

> ". . . to modestly participate in the production of a new reality."
>
> —Carl Einstein, *Fabrication of Fictions* (1973)

Parts of the project/construction site:
—a control centre for direct communication—a bulletin board with up to date information for everyone—description of the project with a team list, dates, etc.—outlines of the new site/city plan—framework conditions—relevant permits—open door for the team—keys—clear responsibilities and contracts outside and within the team—timetable with clear dates for individual construction stages—emergency plans, night duties, personal safety, phone lists, etc. My responsibility: work backpack—toolbox—black folder with all relevant materials and contracts—hardback workbook—pencils—sturdy footwear—robust clothing (also cold-resistant)—drinking bottle—G 1000 trousers, with a "pocket office"—ingredients, vitamins of all kinds for endurance—personal corners, with a chair—cash

Annex III–Project Practice II

The planning and inventing of projects is a beautiful thing because it opens inexhaustible spaces to imagination. When the "thought-out" project becomes concrete and begins in earnest, that's even more beautiful. The practical part is always a good change: most notably because the project then creates its own existence and many things become practical.

A sensual time begins in new spaces and structures, a time in a new reality, friction with others and the exposing of ideas in reality. At the same time, one is active in reality, a part of the concrete context; one becomes a protagonist, an acting person. The opening of the construction site marks the beginning of a temporary state of emergency for everyone involved. Life begins in a new creative situation: pleasure, curiosity and the sparkling of ideas, as well as opening for new contacts. All the doors for the unfolding of endogenous drugs such as euphoria, adrenalin, etc., are wide open... The construction site is indeed a space of invention. The construction later transforms into presentation and communication containing hope of a previously unknown future.

Annex IV–Nausea

Only three domains worked in the DDR:

- sports
- border protection
- state security

Ever since school, we were treated as though we were not the country's children but guests of the DDR. Many people I have held in high regards and worked with had already given up when it came to this and only wanted to leave this country. The dullness of the "Comrades" was unbearable. Besides, we lived with the awareness of 1968 [Prague], the expatriation of Wolf Biermann (1976) and the democratic movement in Poland (1979). From 1980 onwards I spent four years organizing and designing large-scale inscenations rich in tradition at the Dresden Academy for Fine Arts. During our studies, too, we were treated as guests of the DDR and its party. At some point in the compulsory classes (Marxism/Leninism) I realized "that I don't have a DDR visa, that I'm not a visitor in this country, that I live here and that this is my city."

That clarity helped me very much in realizing where I stand and that my own life is not the socialist cemetery of the DDR. That the omnipotence of the system is not all there is. And also that I do not want to postpone my own life and my precious time for later, when we all finally get to the West... Since nothing of social relevance was ever carried out, I grew up without "a feeling of social belonging."

10. Esa Kirkkopelto: "It Is a Matter of Collective Self-Education, Re-Education through Cooperation"

Esa Kirkkopelto works as a professor of artistic research in the Theatre Academy of the University of Arts, Helsinki, Finland. He initiated the performing arts collective Other Spaces. Founded in 2004, the group consists of artists from several fields: "Other Spaces invents and develops collective physical exercises through which people can enter in contact with modes of experience and being other than human. The aim of the group is to change together" (see http://www.toisissatiloissa.net/).

Tere Vadén: Let's start from the practical. How do the sessions of the Other Spaces collective happen?

Esa Kirkkopelto: We meet once a week, for circa 3 hours, from 6 pm to 9 pm. Each session is started by going over practical matters, if any, tuning in for the session, doing a warming up exercise and planning what to do, discussing ideas for which exercises to choose from the repertoire. We create a list over the exercises for the day, not so many, maybe four or five, and conclude each exercise with a discussion. The exercise must be enjoyable in itself, so that participants get something out of it. The sessions take place in an old gas workstation in Suvilahti, Helsinki.

TV: You have been doing this continuously since 2004, it's amazing!

EK: Now when I look at it from the outside, it seems remarkable, but it hasn't felt that way. Maybe because the whole thing has been all the time going forward. A feeling of progress has meant that continuing has felt good, so we have continued. Another factor contributing to the longevity is that I chose the Other Spaces as my main outlet for artistic expression. I bring a certain ambition to it. All the art that I have time to engage in, in addition to my other activities, takes place through Other Spaces. So I keep taking new ideas to the group, which also propels it forward. We have these weekly free exercises and separate projects, often with remuneration and professional production. Previously the exercises were intended to support the projects, but now they have been separated. And the solution has worked well.

TV: You are the principal organizer?

EK: Yes, I am the person who calls the collective together. But there are also other active members, I don't have to be present in all sessions.

TV: How much of this habit of exercising once a week for several years comes from the tradition of theatre, how much from other traditions of exercise and training?

EK: The ethics of exercise comes from theatre. However, the results are not those of the theatre. Well, that depends on the point of view. We don't call it theatre, but rather performing art. If we would name it performance, people doing performance would not like it, if we would call it theatre, people doing theatre would not like that. So it is a political decision to call it performing art.

TV: How about other traditions of exercise, such as shamanism or Eastern bodily traditions, do you think about those?

EK: Yes, we reflect over all traditions of exercise, including mysticism and sports. We have projects that concentrate on the athletic aspects. We try to be in dialogue with different traditions of exercise and we want to focus on the collective' and open nature of the exercise. It is for all. In principle, it is possible for everyone to participate, to engage in the exercises. The exercises are not virtuosic. The techniques can be shared. It can be taught to all. Unlike many other exercise-based forms of performance—like, for instance, buto, that we often come close to—we aim for a collective and modernist political agenda.

TV: What does it mean that it is collective and open? Should the form of exercise become more common, should it start spreading, to be adopted elsewhere?

EK: Yes, that dimension is included. The exercises we do offer themselves as a possible pedagogy. Also our performances are like pedagogical demonstrations. The idea that these exercises could be adopted in schools and that everyone could benefit from them is implied.

TV: In aiki-do or karate-do there are certain techniques, crystallized in katas, and different masters may have their own schools . . .

EK: The difference is that in our exercises there is no aspect of virtuosity. Anyone can learn and do them. Developing them is not dependent on a technical skill. There is no project of virtuosity in the sense that if you do these exercises you will proceed on a ladder towards higher proficiency. You get different experiences when you have practised a little compared to when you have practised a lot, and often the experiences in the early days are the deepest, because then the contrast to everything experienced before is greatest. The ethical change or change in world-view is not a direct consequence of the exercises.

TV: But there certainly must happen some sort of increase in skill when you do the exercises for a long time.

EK: Of course. And the exercises also develop the individual's ability to be a performer. In that sense they can be seen as a form of performance training. However, they are done because of their own value. They give pleasure and learning. How much they have an effect on your world-view and your way of experiencing the world depends on each individual. Also, of course, what you experience is fundamentally dependent on yourself. So there is a very important element of something being secret. We also share the impossibility of sharing. We mutually recognize the impossibility of sharing and recognize the pleasure each of us is having, watch each other enjoying; there are many aspects like this that are ethically, pedagogically and politically interesting.

TV: Are all the exercises embodied, you do something with the body, and the possible spiritual aspects follow from that?

EK: Yes, there is always a psychophysical feedback. Bodily action. Movement, posture and the relations between bodies create a particular kind of experience and the experience, in turn, creates a kind of movement and so on.

TV: Very concretely, you have to have comfortable clothing, shoes off . . .

EK: Yes. The practicalities are decisive; if we are outside we might use shoes, but inside and if we have to go near each other then, of course, you don't want someone with shoes stepping on someone without shoes and so on.

TV: And some exercises make you break into a sweat and some do not?

EK: Yes. Sometimes you are out of breath and sometimes not. Some are very intensive, some are very extensive.

TV: You said that you have taken these exercises as a vehicle for your own artistic process. How much do you use texts?

EK: When working with the Other Spaces group, I work almost without texts at all. I might do some small notes, a word here and there, so that we won't forget an exercise. And I sometimes write up comments from participants. But that is all. I hope that, from now on, I could also write about these exercises. But it is very demanding, in precisely the way that artistic research is demanding. This is, for me, an attempt to do artistic research in a way that is conditioned by the practice itself. I have done related research here in the Theatre Academy connected to a pedagogical development project and written in connection to that, but that happened in the framework of existing institutions and traditions so that I had guidelines on which to lean on. In contrast, when I try to write and do theory on the Other Spaces, on something that has been invented from the ground up, guidelines are sparse if non-

existent. You have to create the connections between different actors, traditions, fields of knowledge yourself. So in that sense it is a situation characteristic of artistic research.

TV: So do you feel that Other Spaces is so far mostly a non-verbal field, a wordless accumulation of material?

EK: In terms of discursivity and theory, yes. What it is, is still a riddle. Also historically it is still a mystery: why it exists, why it feels important, why people commit to it? These are all concrete questions that are at the same time social, political questions.

TV: Has the practice changed through the years? Have there been some breaks or turns of direction?

EK: Yes, it has changed. It is not just that I keep feeding things to the process, but the practice itself seems more and more relevant in terms of society and politics all the time. Also the performing arts seem to be developing in a direction towards which we have been working. So in that sense reality is coming to meet us. A good example is the Performance Center at Suvilahti. We started as a group without a fixed space, and the space, so to speak, came to us. We have been able to continue there without compromising our principles.

TV: How about the focus content-wise, has it all the time been on the borderline between the human and non-human?

EK: Yes, that has been there from the beginning. We started doing metamorphoses. But when the exercises get developed, you also start having meta-exercises, exercises that investigate the other exercises and their commonalities. The structure of experience starts revealing itself. So we have accumulated exercises like that also during the years, and they feel important. They are also important for me, research-wise. In that sense all the exercises are not on the same line, some of them are more prominent than others.

TV: So as a practical example we might take the exercise you demonstrated in a session that I saw during the spring. The participants created, through certain types of movement, a sort of protective cover or "space suit" for themselves, so that they could then go to places where an unprotected human could not go, but the exercise did not lead to the participants becoming other than human. This was a meta-exercise, right?

EK: Yes, it has to do with defence. To create an experiential way of protecting yourself so that you can go to places that are not hospitable for humans.

TV: So the "meta" here has to do with the fact that this kind of protective cover or suit can then be used in other situations, in other exercises?

EK: Yes, it is something that is always possible, always present, and in that exercise we emphasised the protective aspect of the cover. In a way, from that exercise you can deduce that the structure of experience is such that it at the same time covers you up and gives you access to something, and that you cannot get one without the other. Something of the ecology or economy of experience is revealed through the exercise.

TV: You mentioned change in the modes of experience earlier, and that how these are taken into different fields of life is dependent on individual participants. Often the descriptions of experiential ways of, for instance, overcoming a technological understanding of Being in the Heideggerian sense, emphasise that the crucial transformative experiences are rare, exceptional, peak-like, something separate from the everyday. This creates the problem that these peak-experiences, then, start having a new alienating effect, even though that alienation might be different from the alienation against which they were intended. So how do the experiences gained in Other Spaces relate to this axis from peak-experiences to the everyday? How is their special nature able to influence the everyday?

EK: Maybe I'm a Hegelian here. Alienation in our society appears not only in the classic sense as the unease experienced by the masses, but also in the fact that some individuals seek and are lost in peak experiences. The description of alienation should contain also this aspect: that some are afforded peak experiences—through what money can buy, for example: if you have money, you can go to space nowadays. In a Marxist way, misery does not mean only that some have very little money but also that some have massively too much money. Our work is intended to dismantle precisely this dialectic. It is like mysticism betrayed. All the most basic things, the investigation of which has previously been delegated to poets and exceptional individuals, are in a sense democratised. For example, death. In many exercises, we work with the theme of death. Death should be made into a shared and common thing, which it, in my eyes, is not in our contemporary society. Again, death seems to be either an ecstasy or the medicalised reality of a ward for memory patients. That is the full-body picture of our alienation.

TV: What about the experiential intensity? Do the exercises give experiences that are more intense than the everyday?

EK: In fact, part of the joy of the exercises is that they are so easy. It is delightful to notice how close the experiential modes are, always potentially present. Energy for the everyday.

TV: How have you, yourself, changed through these exercises?

EK: I have been partly able to initiate the exercises and participate in them as an artist, with the role of an artist. In that sense, they do not necessitate a

change. Maybe I have always had these naive expectations that things like theatre can change people. But one performance does not change anyone into anything. Change is always a matter of repetition, of exercise and being experienced. Further experience brings with it things that are more than just doing the exercises. Changes in my life that I have felt as important have happened on another level. Changes in way of life, relationships, and so on. However, on the other hand, keeping up with the exercises makes them into a kind of lighthouse that guides, maybe in a more unconscious way.

TV: The exercises take a lot of commitment, guts, tenacity. It can't always be fun, can it?

EK: Well, in fact the exercises themselves are always fun. But other related things, like productions, are always not, and during the years there have been painful moments when the group has teetered on the verge of extinction because of difficulties in productions, the connected problems with money, and whatnot. Now we are doing fine, but we had quite testing times, we had to reorganize ourselves as a non-profit and so on, but that is all in the past now.

Concretely, the exercises have changed me as an artist, my thinking about what it means to be an artist, how to be an artist, what is important in being an artist and so on. This way of working fulfills me as an artist pretty much completely. It is very restricted, almost craftsmanship-like, but I am very happy. Especially compared to when I previously was an auteur/director, realizing big visions on large stages. Now I do something well-bounded. Instead of monuments, I do small clay animals. And I feel that I can keep on doing this as long as I live. I am committed.

TV: Over the years, the exercises cumulate in a big amount of hours spent.

EK: Yes, but that must be compared to the total amount of hours in your life. That is precisely the point, that it is a part of life, not a string of separate projects, as often is the case in doing art. I'm very critical of the role of a director, especially because I tasted that life quite intensively for a few years, but left it behind. That is also connected to the pedagogy here in the academy, it includes a certain critique towards the director-centric view, and on the other hand an investigation of collective ways of working, self-organisation on all levels.

TV: Why do you want to deal with the non-human, strive towards non-anthropocentrism? There are some theoretical issues involved, I presume.

EK: Well, the theoretical underpinnings can be found in the manifestos I have written. It is a matter of collective self-education, re-education through co-operation. Together we seek and negotiate a new place and role for humans in the whole of that which exists.

TV: You mentioned that the exercises are easy and fun, and that the experiences are in a sense near. That means that the experiences are, in principle, accessible here and now.

EK: Of course that puts into the question the role of society. In a sense it makes visible the society that is missing from around the exercises. In that sense you could see it as a classic avant-garde strategy, art producing a better world.

TV: So if we would have another kind of society, other kinds of social structures, those experiences would be easier to realize here and now?

EK: It would be a part of our culture, our everyday existence. In any case, things are changing. In the last instance, we are engaged in a politics of phenomenology. But that is an unwritten book. I think that phenomenology has always shied away from its own basic insights. If you really trust in the power of appearing, of coming-forth, if you stick to it, it should result in something else than academic jargon. Phenomenology has been trapped by its own bourgeois presuppositions.

TV: In the manifestos, you describe how the experiences are socially structured, how they relate to certain ways of life, certain historical developments. So that brings up the question of whether the experiences are new or old. Also connected to the shamanistic aspects, mentioned before: maybe the experiences can be compared with something that has existed before, but the manifestos emphasise the particularity and uniqueness of the contemporary situation.

EK: For me, it feels very strongly that we are bringing out possibilities that have been there in modernism from the beginning. But it is very hard to prove anything like this, and that is a matter for research. In any case, now we have the opportunity for doing it, to do collective movement for its own sake, without subsuming it under something else, without making it a tool for a big goal or a leader. For instance, the goal is not to improve the health of the participants so that they can work longer and so on. And it is not a parade. People do it collectively out of their own volition, it is a value in itself. In the history of the workers' movement, there have been ways of manifesting oneself to others and to oneself through collective physical movement, through collective physical culture. Maybe some early words on the topic can be found from Rousseau or from Schiller. So in that sense there are many traditional strands. But on the other hand, there has never been a possibility of playing the game so openly and freely, as now. Because nobody is interested in this, and that makes it possible. There are no interests, nobody wants to capture it. Nobody can capture it. That is, on the other hand, a problem with regard to

the productions, because we get no hype. It cannot be connected to festival machineries. Well, maybe slowly it can, as things develop.

TV: Maybe it could be branded and sold as Method Kirkkopelto. That was why I was interested in the possible routes of dissemination for the exercises, since everything is open and democratic.

EK: We have already, in the spirit of open source, taught the exercises to quite a few people. Several generations have gone through the exercises as a part of their training, because they have felt that they gain something; what they gain is up to them. But there are already many people who know and do the exercises. So as an embodied skill, as a practice, it is already getting out there. And that is best.

TV: How does research as something intersubjective and critical fit together with an experiential practice? How can the experiential practice be opened, made intersubjective, for instance, through text?

EK: I connect that theme to a bigger whole concerning understanding, in which the central elements are appearance, mimesis, language, body. The understanding that has slowly been gathering through Other Spaces is, as I see it, on one hand, in contradiction with some prominent ways of doing theory, such as phenomenology, pragmatism and cognitive science, and on the other hand, connected to the theoretical self-understanding of the pedagogy of a performing body. When I read the theoreticians of the past century who have talked about the performing body—often they are directors or choreographers— I feel very strongly that the texts are contradictory in that the theoretical language used is far behind the practical and technical knowledge. They cannot be blamed for this, because the theories are insufficient. They are insufficient with regard to a just and truthful account of the phenomena. So my research aims at bringing these things together through re-evaluating certain basic premises. I would say that the evidence coming from the field of the performing arts forces us to re-examine these premises, regardless of what the theories might say. So, we should see what the evidence means to the theories, what it means to artistic practice and pedagogy.

In performing arts, the contradiction is clearest between the pedagogy of performing arts and the modernist and postmodernist demands for reforms. I think that the connection between these is not very well understood. Pedagogy and schooling are tied to a certain set of ideals, and on the field of art the ideals are, in fact, quite different. This means that the ideals of the field of art are compromised, amputated, because they are not implemented thoroughly enough. They get shrunk into value propositions or opinions or genres, instead of being seen as something that challenges our—especially the spectators—experience and our body.

TV: Do you feel that the discursive, textual dimension is important for the artistic research in Other Spaces? On one hand, it seems that you have not been in a hurry to formulate a theoretical position, or at least you have had time to ponder about it, and on the other hand it feels that when you talk about the evidence pointing towards a need for revision, there is a sense of urgency.

EK: It is simply because the matters are so hard. Maybe if I could have concentrated completely on Other Spaces I would be further along, but I have had projects in the Academy at the same time, projects that, on the other hand, have also been able to connect what I do to the big traditions of art pedagogy. So it has been a wide field of operations. And things have not been clear to me. If you read the first manifesto, you see why some people have seen it as Deleuzian. And yes, I recognize the connections, but that raises a new set of questions, namely, what is the relation between Deleuze and the tradition I know better, the German idealistic-phenomenological-deconstructivistic one. So there are these internal tensions. I mentioned earlier some of the roots of our practice, as I see them, but the whole story could also be told completely in a Deleuzian language. So that results in quite a philosophical debate, in which it is hard to build arguments, piece by piece. Slowly, I'm getting to a point where I can say at least something on the topic. In reading the texts of the past century, I have found nothing on which I could lean on, nothing that could support my argumentation. The only way has been to think oneself, and the questions are big. The relationship between Deleuze and the idealist-phenomenological tradition would be a life's work for a scholar, but I have to go through it as a side-issue. However, I cannot deny or pass it by, since the influence of Deleuze is immense. Besides phenomenology, Deleuzian thinking offers itself as a prominent theoretical framework for performing arts. Politically, it is a quite problematic or contradictory way of thinking.

TV: Art and artistic research are at least partly directed toward different audiences. Other Spaces seems like a peer group in itself, it is a channel of feedback and self-reflection.

EK: We are our own guinea pigs.

TV: And in the university setting you have a different audience.

EK: Then we are dealing with established discourses, with established audiences and communities. They bring their own comforts, but cause political problems. Differences between schools of thought, disciplines, territorial wars, and so on. In order to get things forward here, I'm trying to establish an international network for discussions.

TV: You mentioned the hardness of the questions: where do you get mentorship for your work with Other Spaces? Do you have a master that you can go to in case of a really tricky situation?

EK: I have had several masters in my life, and I have sought them out, but nowadays I'm on my own. I do meditate. It is important for me. But that too is a way of investigating things. I do not adhere to any particular school or system. However, it gives a certain certitude. Or, it gives a kind of evidence too. Things fall into place, insights are formed.

TV: Psychoanalysts have mentors, karatekas have senseis, but it seems that people doing artistic research depend mostly on the practice they themselves are engaged in, without outside supervision.

EK: In this case, yes. Therefore also the academic communities are very important for artistic research. In that sense there are peers, people in the same situation. The political utopia upheld through Other Spaces is also connected to this, the idea of sharing experiences without gods or masters, but together. What we share is some form of otherness, radical otherness. This is how I see it. In a Heideggerian way one could say that it is *physis*. But how these encounters are possible, that is the key question.

TV: In the second manifesto you seem to be taking back the concept of mimesis.

EK: That, in my mind, is a part of the evidence given by the performing arts. You can call it what you want, for instance, kineasthetic empathy, but the phenomenon does not change. I have been astounded how stale the philosophical thought on mimesis has been, it has been too easy to dismiss the whole phenomenon. Philosophy does not look at mimesis in its whole variety, the mimesis of plants and animals, and the continuum from there. If mimesis is not reduced to something else, then it is something we have to deal with. And it puts into question the phenomenological position more radically than has been articulated in the philosophy of deconstruction.

TV: Deconstruction proceeds quite a bit through the syntactic route, through systems of signs.

EK: And that leads to the phenomenon of language with which I'm quite engaged. In the performing arts, there is a lot of talk about a somatic turn, based largely on phenomenology and enactivism. In that discussion, I want to defend language and certain structuralistic elements. They are also inescapable. So what to do with them? This is very characteristic for theatre, since there the body is always talking. It does not just move and act, but also talks. Also with the Other Spaces group, we have felt that our work is linguistic, and we work with language, too. Being silent does not mean that

the linguistic sphere is not involved. The presence of language in a situation that seems completely non-linguistic is one interesting topic for study.

TV: If one wants to learn to know what Other Spaces is about, one has to take part in what you are doing. Also, in order to criticise, one needs to participate.

EK: Yes, but that is not very hard. It is easy to experience.

TV: So in that sense it is open, not closed towards criticism.

EK: If you want to dispute the theory of mirror neurons, you need a laboratory. I met some French researchers who were very critical towards the theory on mirror neurons. They said it has been tested only on apes, not on humans. Human brains are much more complex. But in order to test their hypotheses, they have to be very lucky: a particular kind of accident has to happen to someone in the US, so that a particular type of operation is performed on the victim, the skull opened in a specific way so that the tests they want to do can be performed. That is why cognitive science is so imperative, it pulls back behind the fortresses built out of laboratories.

TV: It is also epistemologically quite brittle, dependent on long chains of hypotheses and auxiliary theories, and therefore quite susceptible to change.

EK: And when they find out how a certain chemical affects your brain, then also institutions based on that knowledge are built, which in turn affects culture and experience. Medicalization is a lot of things besides chemistry.

TK: To sum up, the practice of artistic research that happens in the framework of Other Spaces, is essentially focused on the exercises, the meetings where the exercises are done. And it may result in writing, in texts. On the basis of the exercises, you have done productions, performances. And through your pedagogical practice it is a part of the work at Theatre Academy.

EK: The exercises are the starting point, that is true. There are, in addition, already, meta-exercises. And the exercises can be compared and analysed, and certain functional principles can be shown, and hopefully we can develop exercises that really focus on some particular aspect. And these aspects can, in turn, be connected to discourses. For example, the question of appearance, the basic question of phenomenology: I claim that these exercises can give you the experience of how appearing happens.

TK: *Phainesthai*, to appear.

EK: Precisely. And if we can reach that, what are the consequences? The phenomenological basic principle is that appearance is primary, and we experience our own body, from the ground up, in connection with appearance; we can not experience or think of our own body without the experience of it appearing; appearing also to others, to other bodies, and these need not be human bodies and so on; and that we are always already under

the influence of other bodies before any possibility of control, possibly under the influence of any body outside of ourselves. In this sense, our practice seems to quite radically re-write the phenomenological discourse from the inside. This re-writing cannot be reduced to the Merleau-Pontian phenomenology of the body, because it brings in the questions of mimesis and language, and power.

TV: That sounds like heavy stuff, something close to Buddhism, meditation, and so on.

EK: Like I said, it is a form of betrayed mysticism. Often we talk in the group that it would be nice to become a Buddhist and to start taking care of one's enlightenment, but then you always encounter the question of responsibility. And every time you go through that whole round of questions, you end up with the realization that you live in a particular historical situation in a particular culture, which has inbuilt a kind of, if not program, at least a wish, a tendency, a drive with which we are very deeply enmeshed. In this sense, retreating to the mountains would be a neglect or evasion of this responsibility. The last option. In any case, if you have a lot of money or otherwise, of course it is possible to retreat, but it is not a political solution. So the question is how to combine politics and mysticism. At the very least, ascetic mysticism is not something for the great majority of people, so if you choose that, you have turned your back towards them. The alienation of the masses is an inescapable fact. The deep injustice of our times is connected to the way in which we are isolated from each other and, at the same time, enclosed in the same globus. We are installed as the guardians of the globus: each and everyone is alone responsible for the whole globe and that crushes us, burns us out. It is a holistic economy and dialectics that is not easy to break out of. But it is possible to develop other ways of acting inside of it. Most of all, it is possible to seek contact with those who experience and feel the same way and to do things together with them.

TV: I get a strong feeling that you, in Other Spaces, have discovered something. Independently of the meta-exercises and the type of evidence you mentioned, you seem to have hit on something.

EK: We like to believe that. But we don't know what it is. And that is what we ask from ourselves and from our audiences, and I ask it more explicitly in my artistic research.

TV: In virtue ethics there is the idea that the good life has to be attained through exercises and practice; the good and the bad are not abstractions, but something happening in life, and something that you need training in, in order to be able to act right. Virtue ethics sees that it is possible to change through becoming more experienced, also by consciously training, educating

oneself. I see here a parallel to what you are doing in Other Spaces. I guess you are gaining insight into—not only the meta-exercises—but also into things that support or hinder the practice you want to keep up.

EK: I have said that each individual is free to take the experiences as she or he chooses and to let them influence her or his life in the way she or he sees fit. That is true. But on the other hand, if someone keeps doing the exercises for years, keeps participating, it is clear that it places demands on her or his lifestyle. For instance, in my case, it has meant meditation which has become an important part of my life. There is an aspect of devotion, also in the religious sense, that infuses life. And it is important that it can be done together. I also see what we are doing as one articulation of a much larger tendency, especially in the field of performing arts. People who want to do performance often have a tendency toward those kinds of aspects, and it is a good question why this dimension is now alive in the performing arts, if it previously has been alive through some completely different forms and institutional contexts.

TV: You said that you have changed as an artist. When you work with Other Spaces, do you use your professional knowledge as a director, as an artist, or as something else? Is it a thing of its own?

EK: It creates a knowledge of its own. Through trial and error. For instance, how to work with an audience. We notice that we have progressed there through experience. In the beginning we were very clumsy with audiences and received a lot of negative feedback. So the practice creates its own skills. It can especially be seen in that the more the practice has developed, the easier it is to introduce new people into it. It happens almost by itself. There is a cumulation. The participants have come and gone, in addition to me there is maybe one who has been there from the beginning. There is a cloud or a swarm of people around the practice that contains, creates and cumulates knowledge.

TV: An oral and bodily memory.

EK: It was a surprise to me how often the feedback we got was focused on how we are, how we exist during a performance as a group; how we act, how we communicate in the group, how we relate to the audience. It changed the perspective: this is what art is about today. Since that we have taken the pedagogical aspect more consciously. Again, that is something you see in the performing arts more generally: there are a lot of people focusing on the pedagogical and the ethical.

11. Mikko Kanninen: Seer/Doer

Mikko Kanninen is an actor, director and artistic researcher who teaches at the University of Tampere in Finland and is artistic director of the Tampere Theatre Festival. His doctoral dissertation, "Theatre as a Project of a Body" (mikkokanninen.com/new/en/), was examined in 2012. He plays in the KONEV band (konevband.com/).

Juha Suoranta: What do you do when you do what you do as an artistic researcher?

Mikko Kanninen: I usually discover that there is something in the (surrounding) observed reality that puzzles me. So it's quite simple: I come up with the research question and then I start to work within its "environment" (usually that is a performance or a framework for it). Research questions in my case (which usually is practice-led research in performing arts) are mostly artistic "hunches" or observations that something quite important is missing from my work. Research work itself involves work with theories (reading and writing), laboratory work (performance rehearsals and workshops) and critical evaluation (performances, discussions and seminars). I am quite concerned about the "third party" in my research. During research (artistic theatre work), these works (or the "information gained in them") go through such processes where the existing information has to be interpreted outside the actual performance practices of the works—outside the direct performer/audience interaction. The information existing of art thus must be translated in a way that the practical perceptions made by the performer and audience can also be understood by the "third party"—the research audience, without the actual artistic experience.

JS: Can you further explicate your idea of a third party?

MK: Simply stated: In the theatrical event (performance) there are usually two parties involved: (1) There is a person or a group of people who are assigned to status (by collective agreement) which has been prescribed as a "situation of performativity." They perform performative actions—they could be actors. (2) There is also a second person or a group of people who are assigned to a status (by collective agreement) which has been prescribed as a "situation of an audience." Usually the phenomenon of theatre occurs between these two statuses (parties).

If we take the question of "research" seriously in performing arts, one of the main questions is: How to "translate" or document the new knowledge

gained during the performance research to the future generations (or the "third party," which is neither performer nor spectator of the theatrical event)? It is somebody who doesn't know anything about the practice of your art and research. How to deal with the realities of "performance and theatre research"—the inescapable ephemerality in them? How to translate it (the practice) to lasting and reviewable forms of knowledge?

JS: Let's go to one of your latest productions. The Finnish Civil War in 1918 and its aftermath; the 20th century's bloodiest civil war in Europe. These events set a stage for a theatre-pedagogical project at the University of Tampere by six theatre students and you as their mentor/director. In the project you read and interpreted the Finnish author Hannu Salama's (born 1936) contradictory novel *Siinä näkijä missä tekijä* (1973) (in English something like *Where's the Seer, There's the Doer*). The title of the novel comes from a folksy saying meaning "nothing is left unnoticed." The novel is a chronicle of a somehow vaguely communist family and failed communist resistance during the Second World War in the Tampere City region. Why Salama, why now?

MK: Pedagogy is the keyword here. I was kind of researching the proper ways to "teach" or "co-learn" the rehearsal methods of the modern (leftist) theatre. As we all know, "The Left" is experiencing one of its all time lows right now (the ongoing forward march of the modern capitalism, the new rise of nationalism in Europe . . .) so I was experimenting with the question "What (kind) would the left-side of the theatre be now and how could it be co-learned with acting students." Local (leftist) history was kind of an obvious topic to work with. Salama's book is also a piece of very good literature—there is enough material to work and experiment with.

JS: This is indeed interesting and the emphasis on rehearsal methods is also nicely seen in the "end product." To me one of the most important tasks of theatre (and perhaps arts in general) is to be on the side of underdogs. And to me the left has always been an underdog in Finland, perhaps elsewhere, too. Even in the '70s, when, as it is nowadays told, Marxist Leninism raged, this far-left was only a small fraction of a leftist movement and mood; as if a tiny red spot in the white large canvas. Any comment?

MK: "The Left" is quite a problematic concept, especially in modern/advanced capitalism. In the arts, defining "the left" is not any easier task to complete. The problem with "the underdog" definition is that it doesn't represent the nature of class struggles or any other necessary "wrongs" in the world nowadays. Modern advanced capitalist society has demolished all of the old models, forms and stories of the classical "Class War." The battle lines between the proletariat and the bourgeois have diminished, and their ways of life, hobbies and interests have started to resemble each other more and more.

The fact is that in modern capitalism the exploited population is much larger than the "proletariat"/poor and it contains a large part of what were formerly known as "the middle classes"—almost everybody that is Since political art has therefore no real "place among the people" for critical aesthetics, it will be forced to create a second place (aesthetic, arts, theatre), and this is a process which may require that art stands against "the people"/underdogs. This process may even prevent it from speaking their language. In this sense, "elitism" today may have a radical consciousness. Revolutionary art may, curiously, become "The Enemy of the People," especially since during the last few years "The People" seems to be defined in Europe by the "Far Right" (True Finns, Sverige Demokraterna etc.).

JS: Could you clarify your logic of reasoning, the idea about the process of second place, and the claim that art may stand against "the people," and refuse to speak their language. Thus: Radical consciousness as elitism. What do you mean by it?

MK: This is the core of the whole idea, or philosophy of Art, stolen from Marcuse, that the relationship between "social reality" and "art" is always highly flammable—there is a tension between them. There has to be this "tension" between them or otherwise it is not Art, or at least not that kind of Art that is considered "radical" or political (left). When old "class war" boundaries fall, certain tensions and dichotomies between these "classes" fall too and this happens in the arts and aesthetics too. For example, what used to be working class music is now "middle class" entertainment. Old tensions disappear and become just . . . well, not art. When this tension, this real *place* among "the people" (the underdogs) disappears, it has to be created again so that "radical thoughts can develop and flourish" in bad times as well. In certain times this, or these created aesthetic products, can be considered "elitistic" or "unreachable" Art by "the people" or "underdogs." It all depends on the historical moment: in certain times minimalistic paintings can be considered radical or conservative—everything depends on the tensions in the overall class-structure on the current capitalistic society.

JS: Okay. Let's get back to your production with the students. What, then, were your methods in rehearsing the play? From the leaflet I can read that there were several phases in it. I was involved in one of those phases, but, really, what were they? And what was the prime purpose to do as you did?

MK: We conducted research. We began with defining the problems: What were the "white spots" in our map? We visited museums together, developed web-tools to continue working in private (Dropbox, Facebook, YouTube) and read books with a special question in mind. As our knowledge expanded we invited experts and academic authorities (like you) to visit and challenge our

findings and concepts. So we formed theories and problems: What actually is the history of local "Left," thus the historical concept of Hannu Salama's novel? What are/is the problem of political theatre and action nowadays? We gathered the information and made some practical exercises and aesthetic models out of it. Then we challenged our work with experts outside of the workgroup. So our method followed some of the quite familiar traditions of "self-learning" and practical research.

JS: One further question must be asked related to your research methods, group work and autodidactic learning processes. As I was involved in providing a private asylum to an undocumented and underage migrant, a youngster from Pakistan (of Afghan) origin, I had to "learn a mountain," that is, to learn a lot of new practical things and information. At some point after the events I realized (actually I was rather shocked) that regardless of (or, perhaps, due to) my (too many) years long academic studies and relatively smooth career path, I knew almost nothing besides the basics of critical theory and lots of sociological concepts. Now my question to you: Is there something the institution (university) and its learning opportunities gave to you in terms of your research topic, the above-mentioned questions, your methods and learning?

MK: Sure. I think it made me more aware about the process of things—that the performance we are preparing is actually research. That means more responsibility in terms of openness, criticism and the historical context of the research process. Doing artistic work at an open and independent university has enabled and secured the research aspects in my work within the modern cultural atmosphere, which, at least in theatre, is commercial and artistically quite narrow.

JS: As part of their artistic research project the student group wanted to ask, what does political resistance mean today? What did they and you find out in your research?

MK: Political resistance can have quite various forms nowadays. In the spirit of critical theory I would say that one has to define the battle before the fight. What are the good fights? What are the fights that can be won? If you blow up a few cars, nothing happens to the car industry but you'll get thrown into jail—battle lost. So we need to define the battles in every historical situation over and over again. Art (theatre) could be such a tool. Art could also deliver "information" to the audience, about the "wrongs" in the world. But if politics are understood only as criticism, or a solution to problems at hand, art is in the danger of losing something essential of its characteristics and deep, multi-layered political possibilities. As critical philosopher Herbert Marcuse puts it in *The Aesthetic Dimension–Toward a Critique of Marxist Aesthetics*:

We are experiencing, not the destruction of every whole, every unity or all meaning, but rather the rule and dominion of the whole, the superimposed and administered unification . . . Not disintegration but reproduction and integration of the disastrous. In this kind of a situation art can, by the power of its autonomous aesthetic dimension, revolt against this cultural fascism and forced integration. Practice of Art has the possibility to maintaining the multidimensional point of view in a 'One-Dimensional society.' Art cannot directly change the world, but in this way it can contribute to changing the consciousness and the drives of men and women who then might yet change the world. (1978, 51–53)

JS: If we take your and Marcuse's view that forms of art can be vehicles of critical ideas and changing the world, then, what in your opinion are the long-lasting elements and always timely themes of Salama's novel?

MK: The very essence of Hannu Salama's novel is that truth (art?) is never nice, neat, comfortable, easy or simple. Truth will always come out—as the novel's title *Where's the Seer, There's the Doer* suggests. The author takes out the glory and shows us the fall from hubris in the Finnish left revolution. At the same time the novel never underestimates the very need for radical change in social conditions in the reality the characters live in. These are eternal themes: Social change or revolution? Truth will always come out. (Violent) revolution will always eat its own children.

JS: In conclusion, let us reflect the practices pertaining to your artwork with the students. I have understood that you had several stages, or acts, in your practice with the students. First you, of course, read the novel and analyzed it together. Then you organized a series of workshops to which you invited several debaters, philosophers and political activists alike. Parts of their conversations are actually included in the play. Act three was a museum tour to the "Tampere 1918" exhibition displaying the civil war between the Red and the White Guards—a bloody and sorrowful period of Finnish history. Act four was a dramatization of the novel. You did it as a pair work, which is remarkable. Every pair dramatized a third of the text. And finally you wrapped it up with social and political outputs, namely, the students paid visits to several places outside the stage so to speak. One pair went to a homeless shelter to see and hear the homeless. Another duo visited a Thai massage parlour, which turned out to be a brothel. A third couple donated blood (which is voluntary in Finland, and donors are not remunerated). These visits, or mini-interventions, were partly reported both in social media and in the play. Thus, there were various mutual learning processes simultaneously in operation among the students and, of course, with you.

MK: Yes, my ultimate goal was to research different possibilities how theatrical performance could reach out and take place outside its usual limits. If our mission was to develop new (Leftist?) theatre, then the questions are as

follows: How could it (theatre) take direct action to the local wrongs it has discovered? How to contact "underdogs" hiding near our own neighbour-hoods? What kind of "battles" can be won with this theatre piece? What are the right questions to ask in this matter? Do we want to change ourselves, or society? In practice, this last question was a difficult one, hard to answer and a tough task to fill: Many "real" underdogs in our society (illegal immigrants, criminals, narcs, unemployed, homeless people...) don't care too much about art or publicity.

My students were in their final year of their acting studies. Thus they were in the middle of their MA-studies in this project. I did my best to provoke them to the use of new possibilities in electronic media to develop both form and content of their MA thesis, which usually consist of written text in which they evaluate their learning processes or personal art philosophy. This form may not satisfy the need of developing artistic knowledge that matters in the future. When we were researching our material and using our knowledge for the coming performance, we were actually, at the same time, researching new forms of presenting the artistic MA thesis. In our case the thesis could be a synthesis of many different forms of internet-based media (html-texts, YouTube, Facebook, Flickr, SoundCloud, Vimeo, Wikitext and so forth).

This involves a "secret" plan: We should start to "headhunt" and educate the future artistic researchers as early as possible, in the middle of their MA studies. This is a serious proposal for a new form (or species?) of the performance artist. A researching artist is thus a new possible job description for artists. Therefore, artistic research is not only a "development forum in the field" but, through examples, it can challenge the entire prevailing artistic image, working methods and goals to be subject to discussion. Research studies and practices also force artists themselves to challenge and question their working methods and ideologies over and over again.

12. Leena Valkeapää: "Recognize the Unique and Stick with It"

Leena Valkeapää is an artist, teacher and researcher who lives in Kilpisjärvi, Finland, about 400 kilometers north of the arctic circle, in a small house by a lake three kilometers from the nearest road. Her husband, Oula A. Valkeapää, is a reindeer herder of Sami origin, spending most of his time out in open air, where Leena often joins him. Leena Valkeapää's dissertation, *Luonnossa. Vuoropuhelua Nils-Aslak Valkeapään tuotannon kanssa,* (In Nature. Dialogues With Nils-Aslak Valkeapää's *oeuvre*) describes the experience of the reindeer herding way of life, using as starting points the poetry of Nils-Aslak Valkeapää, the texts of Johan Turi and SMS messages from Oula Valkeapää.

Tere Vadén: I want to discuss your artistic research dissertation on nomadic reindeer herding later, but first I want to ask what are you doing now that the dissertation is done? Are you still doing artistic research, are you an artist, a teacher? I know you teach and do art, but how do you see your practice these days?

Leena Valkeapää: I just gave a lecture in the University of Helsinki in a course on the roots of European civilization, and I think that the lecture was a work of art. For instance, the visualization was of a different kind than that typically used by scientists, and likewise I approached the rhythm of the presentation in a different way. Through its visual aspect and its dramaturgy, the performance aspect in terms of using one's voice and being present, I think the lecture was a kind of work of art. So like in my dissertation, all the means available were harnessed and used in order to bring forth the content.

TV: Does that mean that the transition from being an environmental artist into being an artistic researcher that you describe in your dissertation is still in effect, so that you continuously approach your work as an artistic researcher?

LV: Yes; artistic expression is a part of my work, even though the form of work may be lecturing. Just as an art work can be structured out of many different types of materials, you can structure a lecture like an art work—like painting in a studio, taking care that the different elements are in good relationships with each other, have a certain rhythm and so on.

TV: What about the topic, do you continue with the same questions?

LV: Yes, there are so many themes that have opened through the dissertation, themes I want to get deeper into.

TV: Very crudely and concretely, what are your days like? Do you have separate days for research and for the everyday, or are they mixed? Or are they sometimes separate and sometimes mixed?

LV: It cannot be planned or decided beforehand. There are certain times of the year that you know are going to be more peaceful, and on the other hand times like corralling the reindeer [*poroerotus*], which you know to be hectic, and the goal is just to survive through them. These periods are not precise, their place changes a little from year to year. But the situations change very fast, even during one day. It might be that I'm expecting a peaceful day and am in the middle of writing something, and then something happens with what Oula is doing, and I have to start acting right away. So the expectation is that everything can change at any moment. I don't have a researcher's corner into which I could go and close the door behind me and expect to be left alone. I have to seize the moment whenever there is time.

TV: Because your topic is the life you live, you cannot shut it out or leave it into a laboratory. In a situation like this, how do you create the distance needed, the minimum of detachment, that makes it possible to do research?

LV: One routine for the distance taking is collecting the post from the box by the road. It takes roughly half an hour to get there, depending on the weather, and another to get back. So it is one hour of movement, by walking, or skiing or rowing a boat. That is one element that creates a pause, even though I'm still in the same environment. On a bigger scale, it is very important to come to Helsinki from time to time, and to discuss with people here; otherwise, as a researcher, I'm quite lonely up there.

TV: In terms of the criteria for succeeding or failing in doing research, who are the people or which are the groups from which you expect or wish to get feedback?

LV: There is a certain rather mixed circle of friends, including colleagues and other people, who are eager to hear about my thinking and my world, and not all of them are at all professionally engaged in art or artistic research. The knowledge that someone is reading what I write is very important.

In my case and for my topic, the discussions with Oula are decisive. Without those shared deliberations I wouldn't have any content. In a certain way, I work as a secretary, but at the same time I have to understand what is being told to me, and I conceptualize it, and give it expression. All the time I'm discussing what I'm doing with Oula, asking him questions, trying to pin things down. He reads my texts and makes drastic corrections. It is a constant collaboration. Without this collaboration with Oula, I couldn't do my

research, I would lack access to the questions. It does not happen so that
nature would directly talk to me, this or that rock speaking . . . It is hard to
define what Oula's role is, it is so essential.

TV: More important than books and other literary material?

LV: With only the texts, I could not reach the levels that are needed. The
way of living in nature, experiencing it—for instance, a fire—in a way I can
experience it, being close to it, maybe having built it and set it alight, but the
way Oula relates to a fire is so much richer, has so much more content. In a
sense I'm still a tourist. Even when it comes to the texts, the essential thing is
Oula's way of approaching the texts, opening them; my tourist's gaze would
still not be able to extract as much from them.

TV: Is there an analogue here between your position with regard to Oula
and the reader's position toward your texts; you try to understand and convey
as much as possible from Oula's world, and we try to understand as much as
we can from your texts, and in both transfers some of the meanings get
watered down?

LV: That is one possible way of seeing it. But when I try to see it from
Oula's perspective—he is quite creative but the lifestyle does not afford him
time or possibility to be an artist or something like that—so it is actually quite
practical for him that he can think and bring forth these things, sometimes
crystallizing them in SMS messages or explaining things in depth until I can
write them down. So it's not only my quest to understand but also Oula's
need for expression that is at work here.

TV: Ok, so it's not just mediating something existing but also creating
something new.

LV: Yes, creating, and it is our mutual interest in the essence of these
things that creates the possibility for them to appear, so we are not so much
documenting as creating, even though there is always a very practical
background.

TV: The subject doing the research is not an individual, but a dyad or
something, created by the two of you.

LV: It's a dialogue. In many forms of art there is also often a dialogue with
something, not necessarily with a concrete human being, like in this case.

TV: That sounds like a very unique and demanding situation. It takes a lot
of luck for a relationship like that to succeed.

LV: Precisely that is something that cannot be planned ahead or
organized: "I'm going to be in a dialogical relationship with a person like such
and such." There is an element of destiny. But at the same time, it is also a
part of the skill of an artist to recognize a situation, and to seize it, and to work

on that ground. So it is a part of the talent of any artist or researcher to find in their life-world the uniqueness into which they have access.

TV: That is certainly one condition, the ability to recognize a situation for dialogue. But there seems to be another, more mundane condition. I'm thinking of the fact that you and Oula have been together for a long time now, and you have finished the dissertation, and also done other things during the time. It seems that such a prolonged relationship needs keeping up, some kind of maintenance, some kind of practices for keeping up the dialogue.

LV: Our whole relationship is based on this shared interest. The very first time we talked together we were looking out of the window in the Kilpisjärvi hiking center. Oula remarked that it is so cramped here, and I was looking at the scenery, and there is nothing there, it is completely empty. At that point we of course had no idea that we were going to live together or anything, but right from the start when I started asking about what that "crampedness" means and Oula was inspired by my questions, this mutual interest laid the foundation for our relationship. It didn't begin with my interest for doing a dissertation, but the other way around: the dissertation was born out of the possibility that the relationship gave. Our common creative and conceptual way of thinking was born first, not for my research. So in that way too the "autoethnographic" attitude is very deeply ingrained, it is not something assumed for the purpose of research.

TV: To succeed as a researcher and to succeed as a reindeer herder seem like two very different things. And a third thing is the autoethnographic and curiosity-driven attitude as an artistic researcher, as you just described. What would you say are the criteria for success for that? Or the other way around, when would you feel that it has failed so badly that it cannot be continued any more? It seems that you are bound to have either formal or informal agreements about continuing with the shared exploration. Typically, in research there are different times, sometimes you feel like you are making progress and sometimes nothing seems to happen. So how do you evaluate how you are doing?

LV: The practical life that is at issue in a way itself sometimes gives thrust to the research, it gives you pause. There are times when it feels like nothing is happening, no new thoughts. In the end the spark for new things comes from nature, for instance, from a particular encounter that Oula has, maybe with a flower or with a reindeer, and that he tells me about, and then I suggest that in that situation he thought in such-and-such a way, and he gets interested and maybe a few days later he is out again and thinks about the question, and sends me an SMS and so on. The life-world in its uniqueness sustains the research.

TV: That means that it is necessary to spend a lot of time with the environment.

LV: Life must constantly take place there, in that environment, because the events arise from it, from nature. Nature is also surprising, sometimes it seems very bland and sometimes it captures you. But the condition is that—like for Oula—your life is deeply engaged with nature. It doesn't happen for a tourist looking for inspiration. The engaged life makes it possible to be captured and amazed. That's what sustains the process. If we were to move away from that environment, the dialogue could not continue. We wouldn't have the sustenance for it.

TV: So what you can do intentionally is to commit yourself to the situation, make sure you spend enough time in the environment, and stay open and sensitive towards it.

LV: To be in a dialogue and to be flexible. It takes a tremendous amount of flexibility and endurance to face the circumstances as they come, to accept that there are times when nothing happens, to stay prepared for the times when something happens. It takes also self-confidence, committing yourself to the idea that this is something worth clinging to. Then you start testing the ideas, by writing or something, trying out whether there is something there. Some of the attempts do not succeed, some stand out, get combined, and move forward.

TV: What about the nature of your shared co-autoethnographical practice, has it changed through time?

LV: Yes, already during the dissertation process. In the final stages of writing it, I needed Oula all the time, I would call him while he was out with the reindeer and ask him to come back because I was not able to proceed without discussing with him. So Oula was also used to this intensive work, thinking together with me, and was used to the idea that I always expected input from him. In a sense, that was an easy time for him, since I was doing the writing, putting things in context and forming bigger wholes. After I had put together the wholes, he might see that there were mistakes, but I did the work of formulating the ideas and he could stay on a more abstract level. So after that we are still in a situation where Oula expects me to write an essay or something if he gets an insight, and it doesn't work like that any more. And I think that Oula was also surprised by his own expressivity, seeing his SMS messages in the book, like you sometimes get the feeling "Did I write this?" At the same time he is also somewhat ashamed of his openness.

TV: Do you feel that something new is needed for the practice of how you two work together?

LV: No, rather it should just continue, there should be no pauses. Oula expects that I write more, move on. And I feel that way, too. I'm currently writing two articles. In one of them I will try to open and deepen further Johan Turi's saying "Reindeer are like birds in flight" that I already quoted in the dissertation but didn't really work further with. I think that I will be able to give much more content to the idea now, because in the dissertation there was not enough time and space. And Oula is pouring new ideas on the theme of reindeer. So absolutely there is a lot more content and enthusiasm for work, but in the end my role in trying to find funding and so on is very stressful, worrying about whether possibilities and funding will be available, and trying to find a peace of mind for work amidst all that.

But on a more general level, the way of working is that I always reflect my text against something. I reflect it against Oula's comments, and both Oula and also myself reflect it against the life-world and nature. There is a constant back-and-forth, a constant dialogue, the thinking is being tested through different dimensions. If I have gained an insight, that insight is returned back and tested. Oula reads what I have written, and thinks about it, also in its context, so if I have written about the wind, for instance, after reading he thinks about it in the wind. I think this relates more generally to the idea that in artistic research the researcher is inside the topic. Likewise the constant testing, reflecting the research back to the practice and life-world. That way the written does not become fictive, but rather always returns to what it arose from. And that is a very inspiring feature of doing research. As an artist you can create worlds of your own. But I have been inspired in research by the fact that the richness and the expanse are there in the world. It needs no fiction in order to be interesting or to contain enough tension. There are already so many dimensions. So reflecting one's research back to the world gives the research a certain framework but also at the same time a tremendous depth.

TV: Does that mean that your artistic expressivity is now more in the use of formulating research?

LV: Yes, and it also manifests as a capacity to move between the different dimensions, and as a sensitivity towards them.

TV: Is that what you call artistic thinking, after Juha Varto?

LV: Yes, that as a whole. Like in artistic expression, in artistic thinking all means are available, all aspects of understanding are used. Typically, in research you shut out aspects like being enchanted. In reality, the spectrum of different ways of being that humans can in some sense recognize is immense. To accept and recognize all ways of knowing and feeling and to have the courage to operate with them—that is a part of artistic thinking. Often it is the

works in which the artist is somehow open, courageously open, that create possibilities for encounter.

TV: From where do you get support for being courageous and open?

LV: During the writing of the dissertation, many people said to me that "You are taking big risks, playing with high stakes. You are sacrificing your private life, and you will probably get divorced after it all." But being a couple is categorically so different from thinking about the world in dialogue. It is a different operational level.

Juha Varto has written somewhere, I remember underlining it strongly, about the "mad courage" of the artist. Maybe it is something that makes an artist.

TV: In relation to the people from whom you get feedback and so on, how important is the academic world, the world of science for you? Some scientists might be emboldened by the idea of doing things for science, for progress, and so on.

LV: When I started doing my research, my initial idea was to do a documentary film. I felt that I was an artist and thought that the artistic expression must happen in a traditional format, and that then in addition to it I have to write a report on it. But I also strongly felt that they were parts of the same process, I didn't want to separate them. I had an intuitive feeling that it must be possible to integrate the two. I followed that intuition. For me the end result is satisfactory, because I have been able to use my energies as an artist, I didn't have to give that up. Maybe it is also because I feel I have done something unique, something that nobody else could have done. From the unique circumstances in which I live, I formulated a whole in a way in which I was able to use the same skills and energies I would have utilized if I would have done a film. Some people maintain that doing things with your hands is crucial for an artist, and sometimes I miss my studio and working with paint. The everyday life up north contains much work with hands—fetching water, chopping wood—that maybe it in itself creates a balance. I'm in touch with the world through action, so I have no need to do sculptures or something like that. It is enough to work with concepts, writing text.

TV: So the skill that your research is developing is not a skill of doing with one's hands, but maybe the skill of living in the northern environment and the skill of artistic research and thinking?

LV: Yes, and they are skills that develop, they are not something that could be mastered mechanically. On needs to practice continuously.

TV: What is your view on teaching or somehow transmitting those skills? There are traditions of teaching science and traditions of teaching art. How

does one teach artistic research or artistic thinking? Can it be taught and if so, how?

LV: I think it can. One can teach how to recognize important phenomena, also through conceptual thinking, and in addition to courage one can teach self-discipline and self-criticism. Autoethnography takes courage, but also wisdom to turn the gaze from oneself towards that which one wants to illuminate. Even if one uses oneself as a methodological tool and makes oneself vulnerable, there is still the crucial movement of directing the attention to the phenomenon one is investigating. Like in my case, I'm not doing research on myself. So some things can be recognized, some skills that can be taught.

TV: Things like moving between different domains of experience and being alert to changes in phenomena, they seem to be things that one acquires through a broad education, rather than specific skills.

LV: In a sense all research is somewhat mysterious. I wonder if it is possible to teach everyone to do research.

TV: Maybe in some sense some forms of research, like surveys, are somewhat mechanical, after one has come up with a research question. The discovery of the question may be shrouded in mist.

LV: I would like to think that in artistic research there is some uniqueness. Why would one do research that anyone can do? I think that everyone doing research should try to understand their specific situation as fully as possible. That specificity may be anything, may be directed towards anything. But in the context of artistic research, everyone has their specificity. That specificity may be lost in a "standard" way of doing research. In the best possible case it can be somehow crystallised and shared. Here I see a wonderful opportunity for understanding the world, if in the field of artistic research specificity and uniqueness become central goals.

TV: Let us return to specificity and uniqueness, but I still wanted to ask about teaching and developing skills. The Finnish writer Erno Paasilinna famously answered the question of how to become a writer by saying that one becomes a writer by living a life that makes one into a writer. Is the case also that one becomes an artistic researcher by living a life that makes one into an artistic researcher?

LV: In a way. But the spectrum is very wide. One can live one's life in a small flat in the middle of the city, and find the specificity there. The specificity in my research may be so strange that it makes people think that it is impossible to do something similar. But that is not the point. Rather the point is to find in one's own way of perception and one's own way of understanding and combining things its specificity and uniqueness and to

start from that. The feature in my research that may be exemplary, is the "all in" attitude of total commitment, the continuum from traveller, to environmental artist, to being at home. In order to be able to grasp some of the dimensions that were present in my work, an intensive engagement is necessary. But engagement and commitment are possible in any environment, in any situation.

TV: You mentioned being flexible and open, being vulnerable and able to be enchanted. But there seems to be another side, too. Reading your work and discussing with you, I also get the distinct impression that you have a lot of common sense and a sturdy backbone. Maybe that indicates a skill of setting boundaries and limits.

LV: (Laughs) And keeping things in scale. That's interesting, actually. One possibility is, of course, that in a situation like mine one goes bonkers, becomes like a member of a cult [*hurahtaa*]. But that didn't happen to me. In a strange way I always have this conscious distance.

TV: Or with regard to flexibility: the situation always demands something, so if one is extremely flexible, one is always at the mercy of the situation, and gets nothing done. There have to be some limits.

LV: Yes, but I have this urge or necessity for expression; in order to be, I have to be able to produce something. In a crazy way, I feel sick if I can't produce something to the world. But that urge and mental tension means that things get done.

TV: The internal necessity collides with the necessities of life.

LV: How do you see it? Why do you do research?

TV: Well, I don't have any better explanation. I do it because I have to.

LV: The internal urge for expression is not unique to artists, but common to all creative work. Without an inexplicable internal necessity, one would not be willing to go to all the trouble, to experience all the despair. Like in my case, there is not necessarily a rational ground to it, I just for some reason have sacrificed my life for this.

TV: You mentioned being at the same time conscious of the situation.

LV: Yes, it is some kind of amoeba-like existence that still has some structure to it.

TV: Quite often in artistic research one finds a situation in which the researcher has this internal urge and an intuition of what she or he wants. So what is the step that is needed from that urge into artistic research? How does the internal necessity become research, something public and shared? For instance, how do you see the difference between working with the same topic as an environmental artist or as a documentarist as compared to working as an artistic researcher? What is the driver for the intersubjectivity or dialogical

nature needed for the research? Earlier you mentioned the will to integrate the artistic and the theoretical.

LV: From the point of view of the internal urge, I see no difference between the different formats, between a painting, a piece of environmental art, or a piece of artistic research. The reason I'm stuck with artistic research is that the life-world I'm in is best shared through that means. I feel that if I were to do a piece of environmental art or a documentary, I wouldn't reach my audience on the same level as through artistic research. What I'm saying defines the format. I couldn't say it through a painting. I discovered artistic research as a format for expression.

As a tourist in the Kilpisjärvi region I used to do landscape paintings and held exhibitions of them. I made long tours in the north and came to my studio in Turku. This in some way reflected my distance to the region. I was in the landscape, I was present in the visual. Now that I live there and the reindeer herding life opens to me through Oula, I couldn't crystallize that to a painting, I wouldn't have the tools to do it on a surface. In artistic research, writing gives the possibility to move on different levels. Language is, in the end, quite flexible, adaptable to different ways of writing. Especially when in my research I can add other materials, like SMS messages and poems to it. If I compare to communicating with an audience through the means of pictures, in a documentary film—the visual expression is so saturated with clichés that I feel that I fail by using it. Even though my MA thesis documentary is in many ways fine, I always had the feeling that the viewers saw it "in the wrong way." The clichéd Lapland came through so much stronger in the visual presentation. In the case of the written artistic research, the reader must struggle more inside the text, so the prejudices do not follow as far and as deep. Maybe I could have found a new way of working with documentary film, I could have found another genre, but the visual world with all of the reality-TV series and whatnot is so crowded. The written nature of artistic research actually gives a lot of room and possibilities that fit with what I want to say.

TV: The text makes possible a different consciousness?

LV: Yes, and transitions between different levels or domains. But that still needs a lot of further practice. The nature that I'm discussing in my research contains different levels, the practical, the emotional, and so on. For instance, how to become friends with a flower, which sounds like a fairytale—but suddenly that is something that really can happen, and that is something that can be written out in a convincing way.

TV: So artistic research is the best tool, the best method of expression, the best way to share what you are saying with others. How much is that a question of format and how much a question of forum? Artistic research has

its own format, but it also has its own audience, which is potentially different from the audience of art.

LV: It is interesting. I don't really know how it is; I presume that mainly the people that read the book are people who would have come to see my paintings, and I don't know how well the book is travelling in the academic world amongst people who don't know me. I get a lot of feedback from "ordinary people," from non-academic persons that know my previous work.

TV: In a way people who have been interested in these phenomena through art are now introduced to the same topics as seen in research.

LV: Yes. And at this point I don't know how the book is being received in the world of research. But I did have a conscious wish to have an impact on the field of artistic research. In the seminars and so on, I felt a strange tension in the question of why to do research. I had this intuition that the kind of generic research that anyone can do is not worth doing. So I wanted to inject a dose of courage. And people told me: "You will see, it is not possible."

TV: How would you now answer the crude question of how is it possible to do intersubjective research on something that is special, even unique? How can the unique be shared or be public in the way that research is generally supposed to be?

LV: That's the whole point of research, to make something unique shareable and if not commonly understood then at least thinkable, recognizable. That I see as the task of artistic research: to bring a given unique phenomenon into discussion, into view. Like a painting can bring something unique to be seen. In artistic research, each specificity needs to be presented in its own specificity. So it cannot have a standard format, "first do this, second this, and so on." Each specificity demands its own specific way of bringing it to view, of making it available for wonderment.

TV: But again, the existence and the bringing-forth of the specificity takes commitment and engagement, and we know that not everybody is equally committed to a given phenomenon.

LV: From the point of view of the researcher it means that you cannot just choose any specificity as your topic. Everyone has some specificity and uniqueness proper to them, but there is an element of fate in what that is. The topic cannot be arbitrarily chosen. It must be born from what is at hand. That limits the possibilities of this kind of research. The point of research is to give a means of access to the given specificity.

TV: How about the reader, the audience? Does the reception of the work demand some minimal level of commitment to the specific phenomenon, to some aspects of it? Or is empathy enough, thinking that "yes, that is one way of seeing it"?

LV: I think it is the responsibility of the researcher to make the research readable and accessible enough. But of course there are basic conditions, similar to any kind of research. You do not start reading research on something that you are totally uninterested in, or go see an exhibition without any reason. But the readability is the responsibility of the researcher, and she should lead the reader through the material. It is a part of the skill of the researcher to write the text so well that the reader can and will want to follow. In order to make the specificity shareable, it is very important to take the reader into account. You shouldn't demand the impossible from the reader. You must lure the reader into the sphere of influence of the text. This is a special challenge for artistic research, if we think that in artistic research the uniqueness is the point.

TV: And of course the reader also must put some effort into it.

LV: It also involves risk taking. By luring someone in, you may scare somebody else away.

TV: To sum up, we have discussed several skills involved in artistic research: sensitivity and openness, the skill to recognize the salient, the ability to move between different levels of experience, dialogue or moving back-and-forth between the phenomenon and its expression, taking responsibility for making the text accessible to the reader . . .

LV: Communicativity. The skill to recognize the unique and to stick with it is very decisive.

TV: Yes, not only to notice it, but to take time with it, put up with it, even enjoy it.

LV: The challenge is to stay with the uniqueness and not to turn it into jargon or a list of what other people have said about the topic. One must stick with the experience and work with that, not reflecting one's text only to what other people have said about it, but to what in the experience needs explication. The problem is that when you start doing research that which needs explication is not obvious, it is not given, not ready-made. There is some initial recognition, but the uniqueness is uncovered only through the research process when you have the patience to stick with it.

TV: You reflect your explication back not to other research but back to the world.

LV: In my case I reflect my explication back to the nature that it tries to explicate. It must be tested against nature.

There are these panicky moments. For instance, in my case where one of the themes is time, I started to look for what Aristotle has said about time and what Heidegger has said about time and so on, and wondered what can I add to all this? But then I realized that that is not the point of my research. Rather,

the point is to look into what time means in this given specificity of nomadic reindeer herding. So one of the skills is the skill to stick with the experiences in which one has recognized the specificity. And to test all that is uncovered in the process against the world from which the research question was born.

TV: So, again, the reader also has to have some connection to the world, in this case to the nature in which the reindeer herding takes place.

LV: Yes. To some extent. But that experience may be very different from mine or from the one I explicate. And language may be a way of transporting the reader to that world. No text has two identical readers. Like a work of art, a work of artistic research gets interpreted differently by different readers. It is not like a mathematical formula that we all accept as such. No matter how communicative and how accessible, it always contains an amount of uncertainty. And there probably is some amount of correlation between uncertainty and capacity to influence. The rules of good writing apply. A good text has an influence on the reader. So writing is one of the skills of artistic research, maybe even more importantly than in some other types of research.

TV: It seems that in all this you are your own mentor. You direct and develop your work by yourself.

LV: That's an interesting viewpoint. The teaching that I do and the contacts with the artists in residence in Kilpisjärvi are important opportunities for testing my ability to communicate. Seen from the point of view of the research world, the life in the wilderness is quite absurd. Sometimes I start doubting whether any contact is possible, at all. I feel frightened coming to Helsinki, wondering if people see me as an alien. The trips to the south also at the same time help me recognize the uniqueness of the life-world and give confidence in that there is something there, simply because those things are not accessible here. So moving between these worlds also gives me a possibility for testing my ideas.

TV: If you practice Zen or karate or something like that, you typically have a master that oversees the practice and the progress. Often skills that demand commitment and engagement, and include an element of setting one's person in play, have this element of elders, teachers. But it feels like you don't have that sort of guide for developing what you do.

LV: Yes, it is true that I have to do quite many things at the same time. But coming back to what we talked about earlier, in a way both Oula and the surrounding nature act as my supervisors. But it is quite strange how that functions as a whole. I couldn't draw a diagram of it.

TV: In methodological literature it is often emphasized that the research question determines the research method. But in your case the fitting process started even earlier, so that artistic research became the method because of the

things you wanted to discuss. So the lower level methodological choices, like the decision to do autoethnography, also happen in a different setting.

LV: It seems to me that one of the skills of the researcher is also to recognize the inevitability in the methodological choices, and to accept the directives given by the topic. The methodological road is not pre-set, rather it is a path made by walking, or rather by writing it.

TV: How does one reach that acceptance?

LV: In the process of testing the research against the world from which the questions come. There were several moments when I had to change direction, having made a wrong turn. You have to test the path under your feet, does it give way or does it hold. To be sure, it is somewhat mysterious.

TV: At the same time it is very crucial.

LV: Yes, and you also have to let go of preconceived ideas. The methodological path also has to be tested time and again, in order to conceive a kind of communicative logic. At some moments you just recognize that the thing is getting out of hand.

It is long process. When I think about the early days of doing this research, it is obvious that I was completely lost. And still, somehow, by groping in the dark I got forward, and found a way. But I had no way of foreseeing what the finished research would be like. It was a complete surprise to me. What to tell to someone in the middle of that process? It is a mystery. But on the other hand it is a matter of moving between the different dimensions in the phenomena one is investigating, and testing the preliminary ideas against the phenomena, returning the results to the uniqueness one is interested in. You have to circulate around the topic, coming to it from different angles.

Conclusion

In this book, we have reflected on research methodologies and methods for artistic research. The methodological guidelines, discussions and conversations with the practitioners are meant to provide ideas for those who want to deepen their understanding of their own artwork and its various contexts, and, following that, for those who engage with the arts without calling themselves artists. Shortly put, our aim has been to increase the awareness and reflectivity of both artists and their audiences about how to study art from the inside, that is, study art as artists, from the perspective of people involved in living, breathing artistic practices and communities.

We have maintained throughout the book that an artistic researcher has three intertwined tasks. Self-evidently, he or she needs to develop and perfect his or her own artistic skills, vision and conceptual thinking. One way or another, the artistic researcher must develop a personal vocabulary for not only doing but also writing and speaking about his or her art. This is necessary in contributing to academia and returning something to the researcher's academic colleagues and his or her "invisible college" around the world. Thus, the researcher proposes an argument in the form of a thesis, and in so doing, helps build a community of artistic research and the bodies of knowledge these communities rely on. As important as an academic community might be, there is also a larger public, including practicing artists, with whom the researcher is almost obliged to communicate, perhaps in terms of something like "media literacies" and "audience education."

As director Mikko Kanninen suggests in Chapter 11, "a researching artist" could become a new job description for all artists, and artistic research could serve as a "development forum in the field" to "challenge the entire prevailing artistic image, working methods and goals to be subject to discussion." This is, to use another vernacular, to make it both possible and probable that— returning to our shadow subtitle—the rabbit *has* a gun to begin with. The turning around and altering the positions, constantly keeping them on the move, should not be seen as a problem or a scary monster. It is the very productive moment of enjoying one's freedom and responsibility as a researcher.

Indeed, a researching artist has much to do and learn in the information-laden world with all the surrounding images, advertisements, sounds and performances. Who can better inform us than a researching artist using all the possible means and techniques available? Artistic research could then be developed as a theoretical and methodological framework, which gives context

and support for the development of artistic vision and sentiment as well as challenges all the players and participants to meet their prejudices, supposed pillars of truths and foregone conclusions.

However, as a set of interlinked and ongoing acts, artistic research must be aware and activated within a chosen—chosen by the artistic researcher—context and its particular history of effects. When starting from the presuppositions of what is necessary for the situated and committed, embedded and anchored analysis of any theme, site and event, it is important and productive to recall the basic notions of both the reflections provided by C. Wright Mills and Isaiah Berlin—each respectively articulating the issues from their particular standpoints but generating an overlapping framework for the interpretation structure. This is to emphasize the inherent need to get connected to (a) the biographical and social elements of a given site and case and (b) the sense and sensibility of the chosen time and place of research.

For Mills, writing at the end of the 1950s, it all goes directly to the very relation and confrontation between the two main elements of any site and situation: combinations, contradictions and antagonisms between a person and a society. It is about how each element, each scene, each part and each field, is connected to the others. To paraphrase, how the elements affect each other. Therefore, there are no personal issues that can be meaningfully analysed without their links to the larger scale social, political and historical issues at play at their particular structurally defined site. Personal troubles are always social troubles and vice versa. "Problems of social science, when adequately formulated, must include both troubles and issues, both biography and history, and the range of their intricate relations. Within that range the life of the individual and the making of societies occur" (Mills, 2000b, p. 226).

While Mills was demanding a seriously embedded and acted upon craftsmanship based on what he called sociological imagination, and insisting on how each and every research project must modify its own version of methods, Isaiah Berlin, in his essay, "The Sense of Reality," originally delivered as a lecture in 1953, is after the similar situatedness but from a different perspective. He claimed that no matter what the theme or context is, there are no overall a priori formulas, no solutions, no guarantees: "There is no substitute for a sense of reality" (Berlin, 1996, p. 35).

What Berlin indicates is the interplay between what he calls the upper and lower levels, the social and the personal, and also the insight from inside-in and then from a nonparticipant position. These are views and visions that are not to be taken as authentic but constantly on the move and on the make. This act of inspired guesswork, of connecting the dots, is conducted in order to get closer to what everyday life is made of, gaining both distance and

nearness to "the kind of semi-instinctive integration of the unaccountable infinitesimals of which individual and social life is composed" (Berlin, 1996, p. 33.)

In this act, a series of acts, to be precise, various types of skills are required and involved, such as powers of observation, knowledge of facts, and most importantly, experience. When brought together, we speak about "a sense of timing, sensitiveness to the needs and capacities of human beings, political and historical genius, in short the kind of human wisdom, ability to conduct one's life or fit means to ends, with which, as Faust found, mere knowledge of facts—learning, science—was not at all identical" (Berlin, 1996, p. 33).

In his text, Berlin is not only referring to the imagined experiences of a figure called Faust but also directly to the epilogue of Tolstoy's *War and Peace*— a text that is something we could nowadays easily call an essay in history of ideas or even an essay in intellectual history. Both references underline what is going on in the processes of trying to get access to that ambiguous and difficult aim of a "sense of reality"—a task that is bound to be slippery and frustrating. Nevertheless, there seems to be no other path, no other way. But this "sense of reality" is not only achieved through rational thinking, via ready-made theories, operationalisations and hypothesis testing.

It requires something else and something more. It needs a combination of hearts and minds, emotions and motions. Or, to be precise, it is emotions in motion that must be guarded, maintained, produced, supported and kept on moving and going on.

The intertwinement of the personal and the structural, and their unity in affective experience, point to the questions of power and the public. There is no way of doing research inside-in, as an engaged participant of a community, however imagined, without getting entangled in issues of power. This being the case, it is best to do it consciously by positioning oneself reflectively as a member of the public. Or, again, it would be better to talk about publics in the plural, since any piece of artistic research takes part in constructing several levels of the public, the artistic and the academic being only the two most obvious. Thus, artistic research as a context-aware and historical inside-in practice in an exemplary manner points to the need of methodological approaches that are sensitive to the ways in which knowledge creation is dependent on and influences who we are, both as individuals and as collectives.

References

Ahti, R. (2009). *Tie, köyhyys, ilo* [The path, the poverty, the joy]. Helsinki, Finland: Kirjapaja.

Aristotle. *Nicomachean ethics*. Retrieved from http://www.perseus.tufts.edu/hopper/text?doc =Perseus:text:1999.01.0054

Bärtås, M. (2010). *You told me, work stories and video essays*. Gothenburg, Sweden: University of Gothenburg.

Bauman, Z. (2000). On writing. *Theory, Culture & Society, 17*(1), pp. 79–90.

Bauman, Z. (2008). *Does ethics have a chance in a world of consumers?* Cambridge, MA: Harvard University Press.

Berlin, I. (1991). *The crooked timber of humanity*. London, UK: Fontana Press.

Berlin, I. (1996). *The sense of reality. Studies in ideas and their history*. New York, NY: Farrar, Straus and Giroux.

Berner, M. (Ed.). (2000). *Sinun, Pentti*. Helsinki, Finland: Otava.

Blumenkranz, C., Kessen, K., Leonard, S., & Resnick, S. (2012). *Occupy!: Scenes from occupied America*. London, UK: Verso.

Brodsky, J. (1997). *Keräilijän kappale* [On grief and reason: Essays]. Helsinki, Finland: Tammi. (Original work published in English 1995)

Bruton, A. (2012). *The flipped academic*. Retrieved from http://theinnographer.com/flipped-academic/

Bude, H. (2000). Die Kunst der Interpretation. In U. Flick, E. von Kardorff, and I. Steinke (Eds.), *Qualitative Forsching, Ein Handbuch*. Hamburg: Rohwolt.

Burawoy, M. (2005). For public sociology. *American Sociological Review, 70*, 4–28.

Burawoy, M. (2008). Open letter to C. Wright Mills. *Antipode, 40*(3), 365–375.

Burroughs, W. (1993). *Spare ass Annie and other tales*. New York: Island Red Label.

Calvino, I. (1998). *The cloven viscount*. London, UK: Vintage. (Original work published in Italian 1952)

Calvino, I. (2009). *Why read the classics?* London, UK: Penguin Classics.

Cazeaux, C. (2008). Inherently interdisciplinary: Four perspectives on practice-based research. *Journal of Visual Arts Practice, 7*(2), 107–132.

Chase, S. E. (2005). Narrative inquiry, multiple lenses, approaches, voices. In N. K. Denzin and Y.S. Lincoln (Eds.), *The Sage handbook of qualitative research* (3rd ed., pp. 651–679). London, UK: Sage.

Coetzee, J. M. (2008). *Diary of a bad day*. London, UK: Penguin.

Derrida, J. (2004). *The last interview*. Retrieved from http://m.friendfeed-media.com /1a5bc7e65ea7a00a0fcfda2ad242360ed9f2d3c4

Dilthey, W. (2006). *Entsthedung der Hermeneutik* [Origin of hermeneutics]. Göttingen: Vandenhoeck & Ruprecht. (Original work published 1900)

Dilthey, W. (2012). *Der Aufbau der geschichtlichen Welt in den Geisteswissenschaften* [The Formation of the Historical World in the Human Sciences]. Berlin: Directmedia Publishing. (Original work published 1910)

Donachie, J. (2008). El mal. *Art Monitor, A Journal of Artistic Research, 4*/2008, 35–58.

Dumas, A. (1844). *The three musketeers*. Retrieved from http://www.gutenberg.org/ebooks/1257

Ellison, R. (2001). *Invisible man*. London, UK: Penguin. (Original work published 1952)

Eskola, A., & Kurki, L. (2004). *Miehestä mittaa* [Taking measure]. Helsinki, Finland: Kirjapaja.

Feyerabend, P. (2010). *Against method* (4th ed.). Introduced by Ian Hacking. London, UK: Verso.

Foucault, M. (1978). *The history of sexuality, vol I, an introduction*. London, UK: Penguin.

Foucault, M. (2000). *Power. Essential works 1954-1984*. London, UK: Penguin.

Gadamer, H-G. (2006). *Truth and method*. London, UK: Continuum.

Graeber, D. (2011). *Revolutions in reverse*. New York, NY: Minor Compositions.

Grierson, J. (1971). *On documentary* (F. Hardy, ed.). New York, NY: Praeger.

Habermas, J. (1962). *Strukturwandel der Öffentlichkeit: Untersuchungen zu einer Kategorie der bürgerlichen Gesellschaft*. Frankfurt am Main: Suhrkamp.

Hannula, M., Suoranta, J., & Vadén, T. (2005). *Artistic research–Theories, methods and practices*. Gothenburg, Sweden: Gothenburg University Press.

Jay, M. (2006). *Songs of experience, modern American and European variations of a universal theme*. Berkeley: University of California Press.

Kirstinä, V. (2005). *Kirjailijan tiet* [The roads of the writer]. Helsinki, Finland: Tammi.

Kuhn, T. S. (2002). *The road since structure: Philosophical essays, 1970-1993*. J. Conant & J. Haugeland (Eds.). Chicago, IL: University Of Chicago Press.

Kuhn, T.S. (1962). *The structure of scientific revolutions*. Chicago, IL: University of Chicago Press.

Kurlansky, M. (2008). *1968–vuosi joka vavahdutti maailmaa* [1968–The year that changed the world]. Helsinki, Finland: Like.

Kvalöy, S. (1993). Complexity and time: Breaking the pyramid's reign. In P. Reed & D. Rothenberg (Eds.), *Wisdom in the open air: Norwegian roots of deep ecology* (pp.116-146). Minneapolis: University of Minnesota Press.

MacIntyre, A. (2006a). *The tasks of philosophy, selected essays vol I*. Cambridge, UK: Cambridge University Press.

MacIntyre, A. (2006b). *Ethics and politics, selected essays vol II*. Cambridge, UK: Cambridge University Press.

MacLaverty, B. (1998). *Cal*. London, UK: Vintage. (Original work published 1983)

Marcuse, H. (1978). *The aesthetic dimension–Toward a critique of Marxist aesthetics*. London, UK: Houghton Mifflin.

McLaren, P. (2012). Objection sustained: Revolutionary pedagogical praxis as an occupying force. *Policy Futures in Education, 10*(4), 487-495.

Merleau-Ponty, M. (2005). *Phenomenology of perception*. London, UK: Routledge Classics.

Mills, C. W. (1958). *The causes of World War Three*. New York, NY: Simon & Schuster.

Mills, C. W. (2000a). *Power elite*. New York, NY: Oxford University Press.

Mills, C. W. (2000b). *Sociological imagination*. New York, NY: Oxford University Press.

Mills, C. W. (2000c). *White collar*. New York, NY: Oxford University Press.

Mills, C. W. (2008a). Listen, Yankee! The Cuban case against the U.S. In J. Summers (Ed.), *The politics of truth* (pp. 243-254). Oxford, UK: Oxford University Press.

Mills, C. W. (2008b). A letter to the new left. In J. Summers (Ed.), *The politics of truth* (pp. 255-266). Oxford, UK: Oxford University Press.

Naukkarinen, O. (2012). *Mihin humanisteja tarvitaan?* [Why do we need humanists?]. Helsinki, Finland: Aalto University Press.

Nisbet, R. (1976). *Sociology as an art form.* Oxford, UK: Oxford University Press.

Rafferty, T. (2006, August 20). All for one. *The New York Times,* http://www.nytimes.com/ 2006/08/20/books/review/20pevear.html?ex=1313726400&_r=0

Ricoeur, P. (2007). *From text to action, essays in hermeneutics.* Evanston, IL: Northwestern University Press.

Rorty, R. (1991). *Essays on Heidegger and others, philosophical papers vol II.* Cambridge, UK: Cambridge University Press.

Rorty, R. (1998). *Truth and progress, philosophical papers vol III.* Cambridge, UK: Cambridge University Press.

Ross, A. (2003). *No-Collar: The humane workplace and its hidden costs.* London, UK: Basic Books.

Rushdie, S. (1992). *Imaginary homelands, essays and criticism 1981–1991.* London, UK: Granta Books.

Rushdie, S. (2002). *Step across this line, collected non-fiction 1992–2002.* London, UK: Jonathan Cape.

Salama, H. (1973). *Siinä näkijä missä tekijä* [Seer/Doer]. Helsinki, Finland: Otava.

Self, W. (2012). *Umbrella.* London, UK: Bloomsbury.

Slager, H. (2012). *The pleasure of research.* Helsinki, Finland: Academy of Fine Arts.

Street, B. (2001). Contexts for literacy work: The "new orders" and the "new literacy studies." In J. Crowther, M. Hamilton, & L. Tett (Eds.), *Powerful literacies* (pp. 13–22). Leicester, UK: NIACE.

Sylvester, D. (1988). *Brutality of fact, interviews with Francis Bacon.* New York, NY: Thames & Hudson.

Terkel, S. (2003). *Hope dies last, keeping the faith in troubled times.* New York, NY: The New Press.

Tolstoy, L. (2008). *War and peace.* London, UK: Vintage Classics. (Originally published in 1869)

Tuhiwai Smith, L. (2012). *Decolonizing methodologies* (2nd ed.). London, UK: Zed Books.

Valkeapää, L. (2011). *Luonnossa: Vuoropuhelua Nils-Aslak Valkeapään tuotannon kanssa* [In nature. Dialogues with Nils-Aslak Valkeapää's oeuvre]. Helsinki, Finland: Maahenki.

Varto, J. (2008). Taiteellisesta ajattelemisesta [On artistic thinking]. *Synnyt, 3,* 46–68.

Weber, M. (2009). Science as a vocation. In H. H. Gerth & C. Wright Mills (Eds.), *From Max Weber: Essays in sociology* (pp. 129–156). New York, NY: Oxford University Press.

Žižek, S. (2007). Why Heidegger made the right step in 1933. *International Journal of Žižek Studies, 1*(4), 1–42.

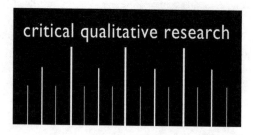

Shirley R. Steinberg & Gaile S. Cannella, *General Editors*

The Critical Qualitative Research series examines societal structures that oppress and exclude so that transformative actions can be generated. This transformed research is activist in orientation. Because the perspective accepts the notion that nothing is apolitical, research projects themselves are critically examined for power orientations, even as they are used to address curricular, educational, or societal issues.

This methodological work challenges modernist orientations and universalist impositions, asking critical questions like: Who/what is heard? Who/what is silenced? Who is privileged? Who is disqualified? How are forms of inclusion and exclusion being created? How are power relations constructed and managed? How do different forms of privilege and oppression intersect to affect educational, societal, and life possibilities for various individuals and groups?

We are particularly interested in manuscripts that offer critical examinations of curriculum, policy, public communities, and the ways in which language, discourse practices, and power relations prevent more just transformations.

For additional information about this series or for the submission of manuscripts, please contact:
Shirley R. Steinberg and Gaile S. Cannella
msgramsci@aol.com | Gaile.Cannella@unt.edu

To order other books in this series, please contact our Customer Service Department:
(800) 770-LANG (within the U.S.)
(212) 647-7706 (outside the U.S.)
(212) 647-7707 FAX

Or browse online by series:
www.peterlang.com